"Jason Diamond's memoir tells a **heartbreaking story** of crummy parents, restless youth, imposter syndrome, and the movies that help him make sense of it all. **This book makes me want to tell my parents and children how much I love them**, drive around suburban Chicago in a station wagon, apologize to everyone I've ever done wrong, and then curl up on the couch and watch *The Breakfast Club*."

—**Emma Straub,** author of the *New York Times* bestsellers *Modern Lovers* and *The Vacationers*

"Jason Diamond writes with equal parts **wit and candor** about what happens when life diverges wildly from the suburban fairy-tales made popular by John Hughes. Diamond **passionately** conveys how **lovely** it is when we find less cinematic but harder earned happy endings on our own terms."

—**Maris Kreizman,** author of *Slaughterhouse 90210*

"Oh look, it's **all my favorite things in one book**: Chicago, New York City, punk rock, food, and existential crises. I absolutely adored Jason Diamond's **bittersweet, charming, and hilarious** memoir, *Searching for John Hughes*. It details the longing and struggle of an aspiring writer with **clarity, wit, and heart**, and is perfect for anybody who grew up in the suburbs and longed for something more."

—**Jami Attenberg,** *New York Times* bestselling author of *The Middlesteins* and *Saint Mazie*

"With geniality, humor, and charm, Diamond explores the ways in which cinematic fantasy can influence, overshadow, and help us to escape reality. This book is for anyone playing out an eternal adolescence."

—**Melissa Broder,** author of *So Sad Today*

"Both funny and heartbreaking, Diamond's memoir is not just an account of how one director's films impacted—and perhaps saved—his life. It is also a memorable reflection on what it means to let go of the past and grow up. A quirkily intelligent memoir of finding oneself in movies."

—*Kirkus Reviews*

Searching for John Hughes

Or Everything I Thought I Needed to Know about Life I Learned from Watching '80s Movies

JASON DIAMOND

wm

WILLIAM MORROW

An Imprint of HarperCollins*Publishers*

The events are portrayed to the best of the author's memory. While all stories in this book are true, some names and identifying details have been changed to protect the privacy of the people involved.

SEARCHING FOR JOHN HUGHES. Copyright © 2016 by Jason Diamond. All rights reserved. Printed in the United States of America. No part of this book may be used or reproduced in any manner whatsoever without written permission except in the case of brief quotations embodied in critical articles and reviews. For information address HarperCollins Publishers, 195 Broadway, New York, NY 10007.

HarperCollins books may be purchased for educational, business, or sales promotional use. For information please e-mail the Special Markets Department at SPsales@harpercollins.com.

FIRST EDITION

Designed by Diahann Sturge

Library of Congress Cataloging-in-Publication Data has been applied for.

ISBN 978-0-06-242483-9

16 17 18 19 20 RS/RRD 10 9 8 7 6 5 4 3 2 1

To Emily. Thank you for making me see there's a life in me—it was dying to get out.

Isn't it odd how, when one looks back at that time, it seems to have been all summers?
—Sydney Freeman-Mitford, Baroness Redesdale

If there's nothing here then it's probably mine.
—Rites of Spring

I wasn't paying attention to the people waiting in line for cupcakes; I was just looking up at a night sky dotted with flurries of snow bravely falling onto rooftops and parked cars. Their only purpose in this world was to make things more magical to those queued up for an authentic Magnolia Bakery experience. I thought hard about the short lives of the snowflakes to help me pass the time. I tried to see how many I could count, timing them to see which ones lasted the longest before turning into little streaks running down the glass window of the bookstore across the street, and looking at the faces of people as they stretched their necks upward trying to catch flakes on their tongues, but I just wanted to go home.

Normally I did my job on autopilot. I'd see one person walk out, and I'd let in another one, maybe two in at a time. I didn't have to talk to anybody if I didn't feel like it; most of the time I'd just stand there and

get lost in thought. Spending my evenings standing outside of a bakery made popular by a few seconds on a premium cable show about a writer who has a massive apartment, countless pairs of obscenely expensive shoes, and one column that had recently finished its run. Interacting with other humans every now and again helps the time go by, but I would try not to.

This was not one of those shifts; instead, the line was filled with happy people spending their Thanksgiving holidays in New York City, many of them lured to the bakery because they wanted to live that *Sex in the City* life if even just for a few seconds, with or without the actual sex part ever coming into play; they just wanted to feel as though they were part of their Carrie and Samantha's world, and I guess I couldn't fault them for that since they made the city seem like it was all cocktails and sex and brownstones the size of castles. Many brought their parents who'd come from all points north, south, east, and west, ready to celebrate their great lives with their great children, and, oh, how I hated each and every one of them. So, no, I didn't want to make small talk. I didn't have recommendations on where they might spot a celebrity like Nathan Lane or Uma Thurman, or a place where they could drink a wildly overpriced cosmopolitan and say "Fabulous" among like-minded believers in the New York City dream of living in a huge apartment and buying expensive shoes all by writing one single column for a newspaper. I shrugged whenever a customer asked me which cupcake I thought Sarah Jessica Parker liked. I didn't even bother saying "Vanilla top, vanilla bottom." Though I knew that was the one since I'd once had to escort a customer out after she threw a punch at another customer for grabbing the last (after repeatedly telling her friend while standing in line she needed a double vanilla since that's the one from the show). I didn't want to be part of these peoples' per-

fect weekends, I wasn't part of the tour, I had nothing in common with the people that dress up like the Statue of Liberty and stand still until some unsuspecting person from Kansas walks past them, or the Naked Cowboy. I just wanted the shift to end so we could count the tip jar that I knew for sure the cashiers were stuffing extra money into.

I was quietly following one snowflake's journey when a voice interrupted my reverie. I squinted, adjusting my glasses. The face looked familiar, but this is New York, where a thousand nameless faces fly past you on the sidewalk but you can barely remember your latest roommate's name since you seem to have a new one every few months.

"Dude! Dude! Bro! Holy shit! Bro," he shouted as he rushed past the rest of the people waiting in line, many checking their watches as we inched closer to closing time. My professional impulses kicked into gear, and I almost began to deliver my typical warning: "There are plenty of cupcakes for everybody, so go back to the end of the line." But I knew who the voice belonged to and I could feel myself begin to shake with rage even though I couldn't place the guy's name: it was one of those damn popular preppy kids from my high school, one of the people I hated the most growing up, the type of guy whose only purpose in life it seemed was to make mine miserable, date all the best-looking girls, and go on to be incredibly successful after graduation. Back then those guys didn't even have to *do* anything; just knowing they were around made me feel terrible about everything.

"How the hell are you?" His tiny palm slapped my back. I couldn't recall his name for the life of me—but I remember people always whispered about his unusually small hands, which looked like they'd stopped growing around six years old. He was tall and built like a tank, and nobody dared to make fun of him

to his face. "I always wondered if I'd run into you again. It's been forever." Our eyes locked for a second, until a girl walked past and my former classmate fixed his wet-eyed gaze on her slim legs and spike stilettos. "It's been forever," he repeated.

I didn't share the sentiment. I'd hoped to never see him, or just about anybody I went to high school with, ever again. That's a big reason you move to a place like New York City: your chances of being known shrink significantly. Running into people from your hometown is not high up on the list of things to worry about once you end up about five hundred miles away from where you're from. You're supposed to worry about rent, rats biting your ankles, and crazy people pushing you onto the subway tracks, but there we were: two adults in the West Village, my nightmare come to life. He acted like the past was behind us and I just stood there clenching my teeth. For him it was good clean fun and all that jazz, like we'd been in the war together and this sidewalk was our VFW hall where we could just reminisce. I just stared at his expensive trucker hat and popped collar polo shirt and thought, *You were terrible when we were in high school in 1998, and now in 2003, in New York City, you're being nice to me and I hate you more than ever because of that.*

But still I was so taken by the moment and the chance encounter. Maybe people could change? We could both be totally different people now; we weren't teenagers anymore. I'd grown up, right?

"It's so funny you'd move to New York," he told me, not really giving any indication as to what, exactly, was so funny. "Like, you were always the type. It's like that song."

I shook my head. Was I supposed to just pick any tune from the Great American Songbook? George Gershwin? Perhaps it was some song from the 1990s with lyrics that seemed nonsensical to

everybody except this guy who *totally got it*. No, it was probably Bob Marley. Dudes like him were always quoting Marley, usually missing the meaning of the guy's lyrics altogether, like thinking "No Woman, No Cry" is supposed to be about being fine with not having a girlfriend or something dumb like that. I gave up and asked what song.

He laughed. It came up from the belly. He seemed satisfied that he'd stumped me.

"Man. It's *ironic*." He nodded his head in a way that made me think I should agree with his assessment that the moment was like an Alanis Morissette song, even though I didn't want to be that person again who had to explain that this moment, just like a few of the instances in the song "Ironic," were really just coincidences and not in fact ironies. And what did he mean by *I was always the type*? I could only assume that the "type" he was referring to was the me he barely knew when we were younger. The "type" who guys like him would shoulder push into a locker yelling, "Watch it, fag!" and then go high-five his other friends as if they'd just launched a rocket to Pluto.

We were all types then. He was a cool rich kid with blond hair that always looked like it was freshly cut and styled before he showed up to school and a wealth of ski lift tags hanging from the zipper of his North Face jacket as if they were trophies from days spent hunting rare game on the Serengeti plains. I was definitely not one of those guys; I maybe could have been if I'd tried a little harder, but I was one of the weirdos, a term I embraced with pride. And I took every chance I could to remind people that I was so cool with being different, from dying my hair blue with Kool-Aid to carving a Dead Kennedys logo into my desk, and telling kids in punk band shirts I knew they purchased at the Hot Topic in the mall that they were "poseurs,"

because I considered myself such an authority on genuine punk at fifteen. Yet even though I wouldn't admit it then, and tried everything in my power to make people think otherwise, deep down I secretly wished I could be like him and his friends. I was under the impression that things always turned out right for people like them. I didn't necessarily have to be one of the guys wearing school football jerseys in the halls, dating cheerleaders, and all that stuff popular guys do. I didn't need all of that back then. But I would have liked to feel as if I had it all together after high school and college, settled into some sort of normal rhythm, some life where I didn't have to eat mostly cheese-and-white-bread sandwiches, and didn't have to stand in the cold earning minimum wage by letting people in and out of a trendy bakery.

I never had money, hated my job, and had no idea how to change those two things. Yet there I was with this guy, acting like we were old chums and equals, just shooting the shit under the city lights. I tried to recall his name and past transgressions against me.

He didn't live in Manhattan—at least not all the time, not yet, he told me. He had just closed on an apartment a few blocks away, which he described as "the size of a bathroom," since he had business in the city a lot. He split his time between Chicago, New York, and his family's place in South Carolina. The travel killed him, he said.

"A few blocks from here," I repeated with a little laugh. "From this very bakery. That's . . . really amazing stuff. Really awesome to hear," I said while forcing a smile so hard I could feel the skin in my cheeks stretching beyond a normal point, the skin on the side of my mouth starting to crack.

I recalled he had some job working for his family's business.

What they invested in I didn't know, and I only knew that be-
cause I sometimes enjoyed getting drunk and seeing what people
I hated in high school were up to as some sort of therapy, scroll-
ing through their profiles and looking at how happy they seemed,
and I remember coming upon his for a second and thinking, *Oh
yeah, that jerk,* and moving past to the next profile. But the idea
that he bought a place in the West Village just to pop in and out
of when he was in one of the most expensive cities on the planet
made me feel a new kind of terrible, the likes of which I had not
yet felt in my two years in New York City. Up until that moment,
I was just fine scraping by, acting like I was really suffering for my
art even though I had no art to speak of. Before that moment I
could live knowing that I might not have been groomed to take
over my dad's company like he had, gotten into law school, or
done anything that would have earned me a salary, but at least I
had gotten out of the suburbs. Sure, I was an elitist for thinking
that claiming residency in a city made me better, but I didn't care:
my escape felt like a monumental accomplishment, as if I'd made
it out alive and was on my way to something better. That was
until this guy—who probably drove his dad's BMW to school
when his brand-new tricked-out Jeep was in the shop—soured
New York for me on an otherwise lovely night.

"So, do you work here or do you just hang out to meet the
ladies?" he asked with a laugh. "I bet you pick up so many drunk
girls here."

When faced with horrible questions under such uncomfort-
able circumstances, you can stand your ground and be proud of
your place in life, or you can lie. Not wanting to be the butt of too
many jokes when he told people he ran into me, I chose the latter
and what felt like the more dignified approach. I told him I was
a writer, that I was undercover at the bakery, and that it was still

important to keep it all quiet because it was part of a really big feature I was working on, a piece about why people wait in line for a cupcake they could just as easily make at home. "You can just buy a damn box of Betty Crocker and it's pretty much the same thing," I said. I told him it was about the media and consumerism, about how New York City was changing. The words just tumbled out of my mouth and I actually thought, *Damn, that sounds somewhat believable.*

"Dude, totally. That's such an awesome idea. I mean, what are cupcakes even *about*?"

That's what I was trying to get to the bottom of, I told him. What they were *about*. The deeper meaning, capitalism dressed up with some sugary frosting on top, I told him. It felt good that he thought something I was doing was cool, that I had him right in the palm of my gloved hand. Which would have been absolutely impossible when we were younger. The best part was that I wasn't totally lying to him: I wrote. I was a writer. Maybe not technically—professionally—on paper, or even off it, and maybe I had spent more money on notebooks and pens than I had made for my words, but I filled those notebooks with sentences and paragraphs and doodles of blob monsters. I wrote all the time, and although I had no real idea how I'd make any money doing it, I was still a writer because I wanted to be one. It was an admirable profession, one that even this schmuck would've heard about and have some vague idea as to what it entailed, but would be impressed regardless, because people knew writers, they could see their work when they opened a magazine out of boredom in the checkout line at the grocery store or while waiting to get their teeth cleaned at the dentist. That, I figured, was a profession everybody could respect and, in nameless classmate's case, something just out of the reach of the non-creative financial types; it

was something he couldn't be, I reasoned. He wouldn't ask me questions because he didn't want to be showed up by the big-time public intellectual. The ball was back in my court.

"Where can I read you? *New York* magazine? The *Atlantic*? The *Times*?" He looked off behind me. For some reason at that second I noticed his heavy peacoat didn't have a stupid lift tag on it, as if he'd grown out of that phase when he realized people already knew he spent weekends skiing or hanging out in his beach house. He shuffled his feet and rubbed his tiny, gloved hands together, the cognac leather making soft whispery sounds. He blew out a breath that turned smoke-gray in the cold.

I just shook my head, a little bit taken aback by the fact that he mentioned even a few reputable publications. It was hard to believe that this jerk, whose group of friends was notorious for "booking" the most kids in our grade (slamming their books out of their hands as they walked to their next class), actually knew of magazines not exclusively devoted to women in bikinis.

"Or do you write fiction? I knew this girl—I was hooking up with her until she started acting crazy—she does something at the 'French Review.'"

"The *Paris Review*," I corrected him—positively glowing—in the light of his mistake, even though I knew he'd gotten the best of me yet again. I didn't know anybody, anywhere.

"Sure, whatever. I could get you her contact, but you probably shouldn't mention my name; I slept with her roommate, and things got a little ugly. You know how that stuff goes."

I didn't, but I nodded my head like I did.

He looked for a card but couldn't find one. "Just find me on MySpace, I'll hook you up," he said. I thanked him as he walked into the bakery. Maybe bumping into him wasn't so bad—he could tell everyone we used to know how well I was doing. I was

impressive enough. I totally nailed that interaction. It was sort of like a great job interview. Damn, I felt good for a second.

"Hey, cupcake bouncer," some guy from the back of the line yelled, interrupting my moment of triumph. "Do you let all your friends cut to the front of the line or are you just really bad at your job?"

The entire throng seemed to laugh in unison.

One of my coworkers walked to the door and flipped the closed sign around.

The laughter from the crowd turned to boos. Loud boos. The boos of disappointed people who had stood in the cold just so they could get a damn cupcake and now had to go back to their overpriced apartments or hotel rooms.

I made my way inside, away from the angry crowd that had come for frosting but were now out for blood. The bastard had *talked* his way past me. I had one job and I'd failed to live up to my cupcake bouncer duties. My honor was essentially ruined.

My night was already dead in the water, there was nothing left to do but go home and sit on the couch and think about what everybody else was doing with the New York City night. As I boarded the already crowded L train at its starting 8th Avenue stop, I looked down at the pint of banana pudding I'd taken with me and all I could think about was how if John Hughes had written this scene, things probably would have gone a lot differently. That was usually how I comforted myself, but it wasn't really working this time. I started spooning the banana pudding into my mouth as the train pulled out of the station. Within five minutes, thanks to a sudden stop and a passenger's bag hitting me at the same second, I was covered in the stuff.

Best night ever.

THE APARTMENT WAS mine for the weekend, free of my room-mates who had gone to see their families, using days saved up from their own jobs they didn't like. This was how I'd spent all of my major holidays as an adult: alone with the apartment to myself, the Chinese food delivery guy the only human I'd talk to for a good twenty-four hours. The initial sadness that came with hearing about other people seeing their moms and dads, sweet old grandparents, annoying siblings, and aunts and uncles with their drinking habits and thoughts on politics had dulled over the years into a sort of cynicism that I embraced when the calendar brought me to another point in the year when I had to think of how happy everybody else was.

I decided to cook myself a lone turkey leg that came in a vacuum-packed bag, a box of stuffing, and a can of cranberry sauce—the things I'd missed the most since my own family din-ners weren't really celebratory affairs, sorely lacking in the comi-cal bickering that inevitably led to darker and angrier, but totally hilarious, conversations that were forgotten the next day; ours were more screaming-from-the-start events. But what we lacked in togetherness, at least we made up for with food. There was always a turkey and sweet potatoes with gooey baked marshmal-lows on top. Now, in my twenties and with no family inviting me over, I'd usually settle for whatever was in the fridge. The year before, my first in the city, I'd gotten takeout, a turkey-and-Swiss cheese sandwich from a bodega, and I thought about how I wouldn't mind going back there again so I could at least listen to the guy behind the counter talk about how much better and vibrant the neighborhood and city used to be before Giuliani and certainly before Bloomberg. He said we'd have to vote Bloomberg out of office in his first bid for reelection that next year otherwise

the city would only be good for tourists and rich people. I prob-
ably would have gone back there even though I already had my
dinner, but sadly, the landlord didn't renew the bodega's lease and
they'd closed a few months earlier. All that was left was an empty
storefront they couldn't fill.

The food was a sideshow. The main attraction was the annual
viewing of the last VHS tape I'd ever purchased, a copy of *Planes,
Trains and Automobiles*. I also had it on DVD, but bringing out
the old copy I'd found in a thrift store for fifty cents made it feel a
little bit more special, as if it was a ceremony that only took place
once a year on the fourth Thursday of November, something re-
served for a holiday, like a special bottle of Scotch or a really ugly
sweater that you think is both festive and funny. I watched John
Candy's Del Griffith try to help Steve Martin's Neal Page make it
home to his own family on a videotape that, though rarely used,
grew more warped each year.

I first saw *Planes, Trains and Automobiles* on network televi-
sion around Thanksgiving when I was ten years old. It was edited,
devoid of any curse words, and awkwardly interrupted by com-
mercials every few minutes. It wasn't even the full movie, a few
minutes cut out here and there to fit into the network's tight sched-
ule, and the last few seconds bled into an equally edited network
television version of *Beverly Hills Cop*, but there was something
about it that was just so genuinely appealing to me and at ten
it was hard for me to figure out what it was. I watched it several
more times to try to figure it out, with the bulk of my viewing all
on that one specific day. Eventually it went from being a movie I
liked (laughing at John Candy playing the air saxophone to "Mess
Around" by Ray Charles while he was supposed to be concentrat-
ing on the road) to something deeper and more important than a
comedy to be watched casually.

I popped open my second bottle of cheap red wine and rattled off to an empty room an anti-toast that I dedicated to all the jerks from high school. They'd probably have a good laugh about me at my crappy job when they had their annual meet-up at some loud sports bar after eating Thanksgiving dinner with their families. Too pissed off to brood any longer, I just drank all the wine I could and watched my movie. I forgot about my turkey leg and burned the stuffing. All I had was the cranberry sauce, and that I ate straight from the can, with my old fictional friends who I saw every Thanksgiving, and a reminder in blue ink on my palm to take a few Advil before bed because I anticipated that I was going to have a wicked hangover when I woke up. As I felt myself giving in to sleep, sitting in the dark on my couch, I decided to rewind *Planes, Trains and Automobiles* for a second viewing, and was out within five minutes.

I recognize that there is something strange about watching a film that I already knew was about a lonely man who has nobody to spend Thanksgiving with while I was myself actively being a person who also has no people or places to go to for the very same holiday for another year. At twenty-two, the annual viewing was one of the few things I could always count on, save the rent increase on my Brooklyn apartment. It was my Thanksgiving equivalent of Bing Crosby singing about how badly he wants a white Christmas, or Linus hanging out in a pumpkin patch waiting for the Great Pumpkin. It's my one tradition. I watch the movie and I'm happy for a little bit.

Except at the end. There's something about the end that has always bothered me.

Not to spoil anything, but at the end of *Planes* we see Del going to Neal's home. Having figured out that the overweight buffoon with the big heart wasn't telling him the truth, Neal goes

and finds Del waiting for a train and invites him to his house for the holiday warmth and smiling people. Putting their hellish journey squarely behind them, everything turns out fine in the end; Del has a place to go to for the holiday. Everything is supposed to be totally fine now, but I always let the tape run out thinking how I wanted to know more. I've always wondered what was next and what came before.

Would they invite him into their house so he'd have some sort of family or support system? Would they try to set him up with somebody? Get him a better job? I felt as if having Del under their roof would get old pretty soon since Neal and his wife seem incredibly uptight, and the sloppy but loveable Del would probably begin annoying them once December 1st hit. I wondered these things because I didn't know if I'd ever have a real home of my own to go to again, one filled with people who were happy to see me, and watching *Planes, Trains and Automobiles* took me away from that for a short time. It had been a long time, and although I probably couldn't make it selling plastic shower curtain rings or anything else, since I'm a terrible salesperson, the idea of trying to move on from your past, and forward into a future, appealed to me. I'd watch *Planes, Trains and Automobiles* and wonder if things really do get better if you just let people in, if maybe that was the secret. I could relate to Del not having anybody to go home to, nowhere to be. I longed for somebody just to invite me into their home for the holiday. I cared so much because I was scared of permanently becoming Del.

After a decade of being estranged from one of my parents or, as it was that Thanksgiving, both of them and their sides of my family, I had grown a thick shell, like the chocolate around a peanut M&M; I was a little, lonely peanut protected by a delicious chocolate coating that cracked easily and was given to falling in

between your couch cushions and being forgotten soon after. So I got drunk and watched *Planes, Trains and Automobiles* because it made me feel sort of warm knowing I'd have some friends like me—alone, but still on the road, still up and on their feet.

It's a master class in the buddy comedy. Martin and Candy turn in a great dual-comedic performance, two of the best ever working together at the peak of their powers. But they aren't why *Planes, Trains and Automobiles* is the one movie I've always gone back to year after year. The real reason why the film remains so beloved to me is simple: John Hughes wrote, directed, and produced the movie. That is what sets it apart and makes it special. John Hughes created Del, Neal, and their story just like he had with so many other characters and tales that, to me, are more than just movies; they've served as blueprints for how I'd wanted life to be.

I know exactly where to find the house Neal lived in, and I know all the neighborhoods Hughes used for his movies because, although I didn't realize it at the time he was making them, I grew up on his sets. I could have been a passing character in his films, a nameless face with no words, no credit, and no screen time.

Chicago's North Shore technically starts when you get out of the city itself. People from all parts north, and even some from Indiana, will tell you they're from Chicago, thanks in part to the designation of most of the land around the city being known collectively as "Chicagoland." When you go from Rogers Park and cross into Evanston. That is where the Windy City ends, and where the North Shore begins. I was born a little to the left, in what was once known as "The World's Largest Village," Skokie, Illinois. I, of course, just tell people I'm from Chicago. If they ask me what part, I just tell them the North Shore. If they ask me which part of that, I go down a laundry list of places I've lived because that list of places goes up close to the border with Wisconsin. If they need any more info, then I break into the real semantics.

There are many technicalities when talking about

the North Shore: *technically* the area is made up of nine communities from Evanston to Lake Bluff, all along the lake, and each described as "affluent" when you look them up on Google. Although Skokie doesn't touch the Great Lake, and the census always shows that the median family income doesn't really qualify it as truly affluent, it's *basically* part of the North Shore; it just isn't *technically* included. Just like neighborhoods farther to the north, like Waukegan or North Chicago, both of which really should get official North Shore status since they lie along the lake. But they don't have the big houses, big incomes, and big populations of white people. Neighborhoods like Long Grove or Glenwood have more than a few big houses but require a decent drive if you want to see the water. I have heard those neighborhoods referred to as "North Shore," too.

So that's the North Shore—the area that John Hughes used as his inspiration: close proximity to the water, lots of money, and lots of family trees with roots planted firmly in America. Skokie doesn't have a lot of that, and although I was born at what was then known as Skokie Valley Hospital (also known as "Death Valley" because it's a hospital and lots of people die there), my first memories were of the North Shore, and most of my childhood and teenage years were spent there.

My family didn't really fit the mold of a proper North Shore family: we were Jews, and my father and what was left of his family had immigrated to America after the Second World War. My mom's family had stuck to Chicago proper, in a building on Kedzie and Touhey that was affectionately termed "Cabrini Greenberg," a riff on the Cabrini-Green housing projects, then nationally synonymous with urban violence, gangs, drug dealers, and in 1992, the movie *Candyman*. My grandparents rarely crossed city lines into the suburbs because the general feeling

among the grandparents was that Jews still weren't accepted there. Sections of the suburbs had large Jewish populations, such as Highland Park where, according to my father who wore his self-hatred on his sleeve, there were just *too many* Jews for us to have lived there. It just didn't seem normal to my parents to start making money in America, only to move into another shtetl—a shtetl with nice McMansions, rabbis who drove German cars, and no czars or their goons to worry about. But, in my parents' mind, it was still a shtetl if all your neighbors were members of the local synagogue. Besides, it was the 1980s. Surely things weren't the way my grandparents remembered them. We beat Hitler! Anti-Semitism was dead and buried. Everything was totally fine! Right?

Well, not especially. Just four years before I was born, in 1976, the Nazi Party of America infamously launched a campaign to march in Skokie wearing armbands and carrying banners with large swastikas on them, *just like the good old days* in Germany and Eastern Europe. At the time, about forty thousand of the suburb's seventy thousand residents were Jews, and five thousand of them (including relatives of mine) had just barely made it out of Europe after the Second World War. Residents lobbied for a court order to halt the march, but the American Civil Liberties Union stepped in, representing the Nazis, and the case went through all the highest courts, until finally reaching the United States Supreme Court, where it was concluded that, yes, the Nazis had a right to march because this is America.

And so they did. They marched through Skokie. People protested as the Nazis turned the place into a symbol of *never forgetting;* never, ever, *ever* forgetting, and also the basis of the great "I hate Illinois Nazis" scene from 1980s Chicago-based comedy *The Blues Brothers.* Yet my family's distrust of the suburbs started even

before the Nazis came to Skokie. There was a small stack of notices that had been collected over the years, like trophies, from various country clubs, telling family members that although we may have met many of the right financial, educational, or career require- ments to join their clubs, our "people" weren't welcome to play golf on their greens. That was the representation of all that was wrong with the suburbs: if we weren't allowed to play tennis and drink gin and tonics with the Johnsons and Smiths while wearing our whites before Labor Day because we were Jews, then damn it, the suburbs would never be safe. *We'd never be accepted*—and that was basically the closest thing we had to a family motto. No matter what I did—if I straightened my hair, never publicly ad- mitted to loving smoked fish, changed my name to Thomas Jones the Third, and took up playing badminton—as a Jew, according to my grandfather, I was unacceptable by default. "You'll never be like everybody else" was something I heard a lot as a kid.

Things are supposed to change, people evolve, and by 1983, the suburbs outside of Chicago had become the gold standard: clean, full of wealth, and baby boomers and their spawn. It was the epitome of normalcy and living in certain suburbs was a sign of success. My father was successful, and he wanted people to know it. The company he and my grandfather founded—a candy manufacturing business, of all things—was flourishing, churning out wafers with chocolate and peanut butter flavored spread in the middle from a factory on the border of Skokie and Rogers Park. The factory was dark inside with large machines. Some made evil clanking and banging noises, while others shot small flames and sparks. I wasn't scared of any of it; I'd run around, sticking my fingers in the large stacks of candy that had yet to be cut down and packaged. They were towers of sweetness for me to sample, and nobody stopped me.

My parents had two cars, an attached garage to fit both of them, a house with a playroom filled with my toys, and it had all been built with money made from rotting the teeth of children who could only afford to spend a quarter on snacks. I'd climb into the gray Mercedes, the smell of diesel mixing with the leather seats and my dad's Ralph Lauren Polo cologne from the green bottle, and we'd take the long way to the preschool that cost a lot of money for me to get into. Some Billy Joel tape would be playing as we drove, and everything felt great and endless.

The idea that things could change or go sour was impossible for me to contemplate at that age. Whatever problems families around me may have had seemed to be carried out to the backyard and buried under the neatly manicured lawns with the hope that they wouldn't seep to the surface; but they often did come back like zombies raised from the dead. I'd hear whispers about one of the husbands, a dentist, cheating on his wife with hookers, and how a lady down the street stayed in and drank all day. I didn't know what any of it meant. I'd just sit on the floor playing with my toys and absorbing the words, happy that, as far as I knew, my parents were above it all.

There was soft talking between the mothers of the block in the daytime, but when both of my parents were alone together in our house there was always yelling. It was something I just accepted as normal since it happened so often. Voices would go from indoor volume to loud and angry in a few seconds and without warning. I just assumed all families were like this.

At the dinner table, they'd slam down silverware. "Fuck it" ringing out as one of them stormed out of the room with the other chasing after. My mother would cry, my father would kick something, glass would break or there'd be a loud thud like something that wouldn't bend was being hit with human skin and

bone. When it started, I'd run to my bed and hide under my covers just hoping it would stop, listening for a door to slam or a car to peel out of the driveway, some signifier that it was over.

It all ended the day my father kicked down a door that was the only thing between him and my mother. I walked out from playing with my toys to see him, eyes wide, spit shooting from his mouth. He yelled at me to go to my room. A loud crash, the door bursting open, and my mother's crying.

A few days later, my father moved his things out of the house, *our* house, the one he had built for his family. I followed him around in silence as he took shirts and suits and put them in a pile, never asking him where he'd been the last few days and where he was going. My mom had locked herself in my bedroom while he moved about the house with precision, piling boxes into the trunk of his Mercedes. He didn't take that much but to me the house looked totally different when he was done.

After that day I was shuttled weekly between my father's new house and the house where I had lived in my entire short life with both of my parents, the one that my mother told me we'd have to move out of soon, that it wasn't going to be our house anymore. In no time, no place felt like home. The only thing I could depend on was my trips to the mall every Wednesday, Friday, and Sunday.

WITHOUT TRAFFIC IT takes less than twenty minutes on the Edens Expressway to get from the open-air mall Old Orchard Center in Skokie, where my grandma got her hair done, to its all-indoor counterpart to the northwest, Northbrook Court. Those were the designated drop-off points; one parent would let me out of the car and I'd walk to the spot where the other parent was parked, like a hostage being traded back to his country. They'd park far away from each other so they wouldn't have to make eye contact

or occupy the same airspace. We'd say good-bye, and I'd get into the other car and go off to one of the houses of my divided family, in what felt like two totally different countries, but were actually thirty minutes away from each other.

Not long after the drop-offs started, I began spending even more time in the area that served as a no-man's-land between my mother's and father's houses: the various offices of doctors who insisted I could tell them anything.

"This will be good for you," my mother said. "You need it."

Dr. Gold had an office right near Old Orchard. After a few times seeing him, we started going to Dr. Goldman, whose office was closer to Northbrook and who had several thick nose hairs that would jolt out of his nostrils whenever he spoke. Then there was Dr. Cohen. I liked her because she wanted to watch me play with toys instead of talking. There were about eight more doctors within a year (the kind who didn't put a stick in my throat or look in my ear), and all of them were within close enough proximity to the two malls that my parents would always have a parking lot–sized drop-off zone nearby if necessary. I'd go to each of the doctors for a few sessions, talk about how I was feeling, and then the next week there'd be a new doctor. My parents couldn't agree on just one, so I started to feel as though every session with a doctor could be my last, even if it was my first time seeing them and it went well and I liked them. If my father picked the doctor, my mother would say it wasn't a good fit; if my mother picked, my father would say the doctor was putting stuff in my head.

All of the offices were similarly furnished in hues of orange and brown, cutting-edge for the decade prior, but a throwback in the neon-colored 1980s I walked in from. Each of the doctors looked as if they might hang out at my grandparents' pool in the summertime and that made me feel comfortable around them.

Some were talkative and friendly, others said nothing at all, and one of them fell asleep while I was talking; but they all agreed on one thing: I had ADD.

"Jason, you're different than other kids," my mom told me when she tried to explain exactly what ADD meant. "You know how you can't sit down for more than a few seconds? That's ADD."

I was five. All I heard was "you're different than other kids." It didn't sound good.

My parents continued to shuttle me from a Dr. Spector one week to Dr. Fegelbaum the next. There were disagreements over methods, locations, and ideas for treatment (Special schooling? Medication? Psychotherapy? Or my father's unqualified diagnosis of "It's all a crock of shit."), and after a while, I began to think there wasn't much point to any of it. One doctor sent me to another doctor who actually looked like a real doctor in his white lab coat; he stuck a bunch of wires on me and asked a few questions, then made me jump up and down. After that, he and a nurse held me down and jabbed a needle into my arm to draw blood when I wouldn't sit still. Another told me to draw pictures for an hour, saying I was just creative and needed to channel all that energy, while another told my parents that old-fashioned discipline never hurt anybody.

All the time I couldn't understand what was wrong; all I knew was that I cried almost constantly and over the tiniest occurrences, leading my father to ask one of my doctors if there was a cure for a boy who wouldn't stop crying "like a little girl." He stared at me with eyes that told me I had disappointed him in some way. All I wanted to do was know what was wrong with me, but nobody could explain it to me in a way that made sense.

Soon they'd add a new letter to my diagnosis and tell me I now had ADHD. I could see my parents becoming increasingly frus-

trated with the frequent meetings they had to have at my school. My mother would yell at me all the time, while my father took to calling me his "little retard." Teachers would constantly kick me out of class for being a disturbance, and I felt as if I didn't fit in and that I had nobody to turn to. All I could do was cry. When a parent would yell at me to stop, I'd cry more. And by six years old, I started to have a feeling that this wasn't the life I wanted.

WHILE MY PARENTS were using its parking lot as a place to unload me, Hughes chose to film part of *Weird Science* in Northbrook Court, probably at the very same time I was telling Dr. Silverburg what made me sad in an office a few feet away.

Hughes utilized the area in almost everything he directed. Scenes from *Uncle Buck* take you from Evanston to the forest in Wheeling, the *Home Alone* house is in Winnetka, and the Glencoe church was where he filmed the wedding scene in *Sixteen Candles*. He was taking a lot of what I was seeing from car windows and giving it to the world in movie form. His movies offered the sense that things were supposed to be normal where I grew up, that the road could get bumpy but ultimately it would get better. It was boring, and that was just fine. That's why my parents moved out there in the first place; they dreamed of normalcy but found out it takes more than just the proper setting. Things didn't turn out as planned, but when re-watching any Hughes movie, I can see why they thought *this* was the place where they wanted to make things work.

Movies can't show you everything, and Hughes was trying to tell stories, not paint every minuscule detail of the landscape. He never shows the expanses in between, the large plots of land between subdivisions and new neighborhoods that were being developed; big, eerie gaps of nothing where something must

have once stood, and where something would eventually go someday.

By contrast, places like Lake Forest and Winnetka had been building up slowly since the Civil War, welcoming politicians, lumber barons, meatpacking magnates, Rockefellers and other people with familiar last names, and captains of industry who wanted to get away from the noise and dirt of the city. On any given day, you can still drive through these areas and see plenty of the splendors of the Gilded Age in the stonework of stately old houses. You can also see the progression of American architecture, from the Louis Sullivan disciples like Frank Lloyd Wright, who saw the natural beauty of the area and designed homes in places like Bannockburn, Glencoe, and his Emil Bach House just a mile into the city, to the mid-century modern structures that look to be made entirely of glass and steel beams. The most well-known of all of them, and possibly all of suburban Chicagoland architecture, is the four-bedroom Ben Rose House designed by A. James Speyer. Set above a wooded ravine in Highland Park, this is where Cameron famously destroys his father's 1958 Ferrari 250 GT California, "erotically red" as Hughes specified in the *Ferris Bueller* script. Watching the film, it's almost impossible to imagine an architect seeing this spot and thinking a house like that would work so well there, but it does, perfectly. Glass panes and steel beams in the middle of all those trees. The industrial set against the pastoral, the perfect meeting of Midwestern brawn and design with the natural world.

The first memory I have of truly appreciating the beauty of the area is from when I was six. Before any painting or poem took my breath away, I found myself looking up at the weeping willows and ash trees to see bits of sunlight sneaking through, all slowly moving to the soundtrack of the quiet stream of breeze

brushing past me, a cricket warming up for its nighttime perfor-
mance, and bobolinks singing along with other birds like eastern
meadowlarks and Savannah sparrows, which I learned at camp
only came to Chicago in the summer to make babies, although
I wasn't sure exactly how they did that. It was glorious. I didn't
have much God in my life growing up, but I felt something
deeply spiritual and peaceful as I walked alone on the sidewalk.
Cars passed, but nobody stopped to ask why the little kid in the
cotton shorts and the green day camp T-shirt was wandering
around, all by himself.

My father had screamed at me to get out of the car. He was
angry because, just like the expensive Montessori school a few
years earlier, I had been kicked out of day camp for causing too
much trouble and he had to leave a meeting to come get me. I had
failed him. I was a failure. "You must be the dumbest fuck ever,"
he muttered as he steered with one hand and slapped me on the
head with the other.

I spent the first few minutes of the ride holding back tears
while my father told me I was worthless. Even at that young age,
I'd trained myself to take his words in and put them somewhere
where I didn't have to think about them. I was used to it, being
told I was going to be a bum when I grew up, that I sucked.
Sooner or later I knew there would be calm and quiet again. My
silence angered him more, but it was really a combination of sur-
vival instincts and pure fear of what was going to happen. I could
smell Johnnie Walker and see little beads of sweat on his fore-
head, even though the air conditioner was blasting on high.

"You've got nothing to say, you little shithead?" he yelled as
he hit the brake suddenly, whipping my skinny body forward,
then back against the leather seat of the German status symbol
my father had recently bought. I could feel my baby teeth rattle.

"Get the fuck out," he yelled. "Walk home, asshole!"

Somehow still holding back my tears, I opened the door, got out, and stood there as he peeled off, the tires kicking up little bits of gravel and dust that hit me in the legs and got into my eyes.

He had done this before. Sometimes he'd just sit there for a moment, the car idling until he rolled down the window and told me to get back in; other times we were just down the street from our house. I'd walk home, thinking the entire time about what was in store for me when I walked through the door. Sometimes getting kicked out of the car meant I'd be spared the other punishments. Those usually involved one of his belts, each of which he gave names to—nothing too clever like the name you'd give a dog or a prized automobile, but it felt as if he picked specific ones according to the situation, like the color or type of material fit certain punishments. But more times than not, getting kicked out of the car was really just the calm before the storm. After I got home, my father would order me to go to my room. It took him about ten minutes; whether he was making me think about what I did wrong or stewing in his own anger I've never been sure. Then he'd walk into my room, tell me to take off my pants, and the hitting would begin. Over time I realized that my crying only made him angrier, causing him to whip harder, as if it reminded him of something he hated about me. So I learned to suffer in silence. I held it in, the tears that I wouldn't let fall down my cheeks welling up in my eyes made my head hurt worse than my ass did.

Eventually I came to see punishments as almost a part of my normal daily routine. I didn't know how to stop myself from getting in trouble with my mom and dad or my teachers; I didn't know how to be good. Both parents doled them out in their own ways, my mother with the silent treatment. But there was something even more terrifying about getting kicked out of the car,

and wondering if this was the time he wasn't coming back to get me. It was an empty feeling, those first few seconds just standing there wondering what to do next. It was a feeling of pure hopelessness in the pit of my stomach.

Yet on that beautiful day, even when I couldn't see his car anymore as I walked down the sidewalk with the perfect summer sun directly above me and a cool breeze blowing past, I felt an odd sense of happiness, as if I could just lie down in the freshly cut grass if I wanted to, look up at the perfect cloudless sky, and I'd be safe. It felt as though all would be just fine, because that's the way the suburbs are supposed to make you feel.

It FELT AS though my grandfather's prophecy that I'd inevitably be a suburban outsider was coming true. My parents' custody battle had me moving between houses, starting at one school for the first half of the year, then ending it at another, turning me into a total stranger. By the time I was seven, I'd been to four different schools, a situation that made it difficult to make and keep any friends. That, and the fact that I was the weird kid: the one nobody knew, who would make fart noises in the crook of his arm when he wasn't running around or scribbling all over his desk with markers when he should have been listening to the teacher, then crying for no reason the next moment. I was the one other kids didn't speak to because they feared they'd be considered weird by association.

The loneliness continued at home. I was a latchkey kid starting in the second grade when I went to live with my mom. I'd walk the half mile along the lake to our house, turn the corner at the big oak tree that I'd heard was older than the State of Illinois, take the keys that hung around my neck on a string, and unlock the door to silence. The sun at my back left the front room gray

and dark when I walked in. I'd yell "Hello!" as a matter of formality, knowing nobody was going to answer. I'd take off my pair of red-and-black Air Jordans. A few of the other boys in my class seemed interested in me when I walked into class wearing them on Monday, leading me to believe that I'd found my in thanks to a pair of new sneakers, only to have things go back to the way they were by Tuesday. I'd go home and read and reread comics. I especially liked the X-Men; they just wanted people to accept them for who they were, but nobody did.

The weekends were my refuge. There was no school and I loved knowing there'd be a babysitter over because it meant I had somebody else around. My father, who often went out of town on business, left me with a number of different sitters, mostly teenagers, all of whom I was fascinated by. They had their own language that I heard them speak on the phone with their friends. Some were rebellious, asking me to keep secrets and not to tell anybody I'd caught them drinking beers from our fridge or that they had invited their boyfriends over. I wouldn't dare squeal because I was so happy to be around people who seemed to like me, even though my father was paying them a few dollars an hour to spend time with me and make sure I went to bed on time even though I never did.

My favorite was Rachel. She was sixteen with crimped hair and smelled like watermelon bubblegum and hairspray. She spoke with a slight Valley Girl affectation even though we lived thousands of miles from the malls of California. She had Converse sneakers, stonewashed jeans, and wore a letterman jacket, just like I'd seen in the movies. She was the epitome of coolness, playing in my father's stereo tapes with songs by bands called the Smiths, New Order, and (the one I found funniest) Echo and the Bunnymen. I imagined that one as characters from some car-

toon, but was surprised when I was drawn to the slightly dark and gloomy sound coming from the speakers. I couldn't know how much those lessons in music would impact my taste in the years to come.

Rachel watched me on Saturdays for a few months after I turned seven, usually the night my dad and future stepmom he'd met on a trip to Florida would go out on dates. We'd watch some TV, and then a movie until it was time to go to bed around midnight. Usually I'd get to pick, but one night Rachel brought a movie of her own from the local rental place.

I looked at the box. "*Pretty in Pink?*" It didn't exactly sound like the sort of thing I liked. It didn't look like *Ghostbusters* or *The Karate Kid*.

"Give it a try," Rachel said with a soothing smile. "Just don't let your parents know I let you watch it. It's more for adults."

I didn't want to let her down, so I agreed to watch it.

Here's the thing about *Pretty in Pink:* although some people might consider it part of the canon of great Hughes films—and it *is* a great film—it deviates a bit from the formula of Hughes having total control as writer, director, and producer as he did with his other iconic teen films from the era. He did write and produce this story of a poor girl, the boy from the nice part of town who likes her, his jerk of a friend, and the weird dude that loves the girl and hates the rich kids, but he didn't direct it. Like *Some Kind of Wonderful* two years later, Hughes gave the job of directing to Howard Deutch, who, in his defense, made some great films; but there's just something missing from the films where Hughes didn't sit behind the camera.

I was too young when I saw the movie for the first time, not really old enough to pick up on its exploration of social cliques in high school. An inquiry into socioeconomic status is really at

the heart of the film: rich vs. poor, us vs. them. I didn't get that then; I just thought it looked great. I instantly connected with the characters. Jon Cryer's Duckie showed me that you could be weird and goofy and still be cool. I *needed* to see Duckie. He's in his own little world and maintains a funny balance of acting as if he doesn't want anybody to notice him, but also wanting everybody to pay attention to him, and I could relate to that. He was confused about everything except one very important part of his life: he lives for Andie Walsh, played by Molly Ringwald.

Teen heartthrobs come and go. But Molly Ringwald is iconic, an actress who was capable of conjuring up every feeling a high school–aged person can have, from sadness to that innocent-yet-crazy kind of hormone-driven excitement only somebody around that age can feel. She didn't look like the teen dream type, but that's what makes her timeless. She's Molly Ringwald, and I had a crush on her well before I even liked girls, when they were still "gross" to me.

"*Every* guy likes her. I don't get it," Rachel said as we watched Ringwald navigate teenage life.

I was transfixed. The music, the way they dressed, and the way they talked—watching *Pretty in Pink* made me *feel* good. It made me happy that, despite the fact that I wanted Andie to end up with Duckie, at least he had the beautiful girl credited as "Duckette" trying to get his attention. Andie ends up with Andrew McCarthy's handsome and rich Blaine, they tell his awful friend Steff (played to jerky perfection by James Spader) to kiss off, and we're led to believe everybody will live happily ever after.

Although I was familiar with the concept, this idea that you could one day be happy and have what you wanted, it seemed so foreign. It was usually the kind of thing I'd read about in fairy tales, something about some prince or princess, people I couldn't

really relate to. They didn't seem real to me; they were cartoons or made up stories. But here, right before my eyes, were these kids only a few years older than me, things turning out right for them after all, and they seemed real to me. As if I could be them someday.

A week later while at the pharmacy that doubled as a video store, picking out a video for my Saturday night, I saw the familiar face of the girl from *Pretty in Pink* on the shelf. I looked down at the clunky box holding the VHS tape with cartoons on it that I had originally picked out, then again at the redheaded girl standing between two guys, gazing off into the distance. I decided I wanted something different for a change. I took the copy of *Sixteen Candles* off the shelf and never looked back.

There's that famous Philip Roth quote that everybody seems to like until they find themselves relating to it: "Old age isn't a battle; old age is a massacre."

I really think the same thing applies to being a teenager, with the casualties beginning to mount once the clock strikes midnight on your birthday and you're no longer twelve years old. Things get messy. Every encounter with another human is a chance for awkwardness. Older people are constantly telling you what to do, while also reminding you that you're at the age when you're supposed to start finding out who you really are. Meanwhile, you're a ball of hormones and weird feelings that you can't understand, and you're trying to tell those old people they're wrong and their ideas are outdated and stupid.

That's not how I expected it to be. In my naïveté, I approached turning thirteen thinking it was going to

be like it was in the movies or TV. I expected some heartbreak and bad moments here and there, but I truly believed adolescence was going to be this magical time where everybody looked good. I thought turning thirteen was when my life would start to look like a John Hughes film.

THE CHICAGO SUBURBS became Teenland, USA, at the same time I was growing up in them. If you are in close proximity to the lake, you run a good chance of finding yourself looking at a place used either in a Hughes film, or one of the other films of the era that turns an eye on Chicagoland teenagers.

Cinematically, it started in 1980 with *Ordinary People,* which went on to win the Oscar for Best Picture. Robert Redford's directorial debut is about a Waspy upper-middle-class Lake Forest family trying to cope with the death of their handsome and popular oldest son. The parents, played by Donald Sutherland and Mary Tyler Moore, try their best to not think about the tragedy while the surviving son (played masterfully by Timothy Hutton) is crippled by it, feeling as if the death was his fault and it should have been him, not his idol, who went down in the rough waters of Lake Michigan. His survivor's guilt drives him to attempt suicide, while his parents try once again to act as if everything is just fine; but of course, that never really works. Slow moving and depressing, it is a very realistic portrayal of what it was like growing up in the area—at least compared to what came next.

1983 saw two more films about suburban Chicago teens screwing up and trying to figure out what they're going to do once they're no longer legally considered children. The somewhat forgotten *Class* may rightfully be the beginning of what *New York* magazine writer David Blum would later dub the "Brat Pack." Starring Rob Lowe and Andrew McCarthy, as well as Alan Ruck

and Evanston-born John Cusack in his first role (his sister Joan Cusack starred in another early Chicagoland teen comedy a few year's earlier in 1980's *My Bodyguard,* a film that featured Daniel Stern, who would later star in *Home Alone,* narrating the trailer nearly a decade before he'd do the same as the voice of older Kevin Arnold in *The Wonder Years*), the plot finds McCarthy's inexperienced character sleeping with his prep school roommate Lowe's married mom, initially unaware of who she is and not revealing his own identity. Lowe's Skip eventually finds out McCarthy's character is sleeping with his mom, they fight, make up, and I think we're supposed to walk away believing that everybody has grown up from the whole messed-up experience or something. While it isn't exactly *The Graduate,* it isn't totally terrible. It has its charms and comes with a number of great shots of the North Shore and the city itself.

And who could forget young Tom Cruise turning his parents' Highland Park home into a brothel in *Risky Business*? If you squint hard enough it almost looks as if it could be the story of Jerry Maguire's high school years as Cruise plays a teen who gets caught up in the skin trade, renting out his family home to prostitutes so he can pay for the repairs on his father's Porsche that he ruined after getting into a fight with Rebecca De Mornay, who goes from the woman he pays to have sex with him to his business partner to something like his girlfriend by the end. Just like with nearly every movie from the decade, there's a lot that one could deem problematic from watching the film, but somehow the movie Janet Maslin called "part satire, part would-be suburban poetry and part shameless showing off" ultimately works really well. Maybe it's the dreamy soundtrack filled with songs from Tangerine Dream, or possibly it's because some scenes look as if they could have been filmed in my backyard in early fall

when the leaves are just starting to turn brown and you aren't sure if you should take a jacket or if a sweater will suffice. Whatever it is, *Risky Business* is another film that proves, at least according to Hollywood, teens were up to no good. It didn't matter where they were from or where they were, whether it was the horny creeps at school or summer camp in gross-out movies like *Porky's* and *Meatballs,* helpless nerds like future *People*'s Sexiest Man Alive Patrick Dempsey's Ronald in *Can't Buy Me Love,* Lucas in the 1986 suburban Chicago movie of the same name, or California stoners like *Fast Times at Ridgemont High*'s Jeff Spicoli, teens were almost always portrayed as trouble or troubled hornballs. Movies taught us that teens were untrustworthy, and that films for and about them somehow couldn't convey the complex emotions that run through the body and brain of somebody that's fifteen or sixteen.

And then came John Hughes who, before making movies, spent his days sitting behind a desk as an ad man at Leo Burnett Worldwide, writing jokes for comedians and *National Lampoon* on the side. The satirical magazine liked his work so much, that they gave him the opportunity to write the 1979 television show *Delta House,* based off the hugely successful 1978 film *National Lampoon's Animal House*. While the show lasted less than six months on ABC, Hughes showed promise and was given another shot at writing a *National Lampoon* film, 1982's *Class Reunion*. Another flop.

Things started getting better in 1983. Another movie he wrote, *Mr. Mom,* starring Michael Keaton, opened to wide release at number three (going up against *Risky Business,* no less) that August. But it was *Vacation,* a film based off a Hughes short story called "Vacation '58" that appeared in *National Lampoon,* that really kick-started Hughes's ascension. The film's success showed

that the Michigan-born, Chicago-raised writer had what it took to make stories and create characters people could laugh at and relate to. The story of Chevy Chase as Clark Griswold, a very simple guy from the Midwest who just wants a chance to show his family the country on a road trip to a California amusement park in the hulking Wagon Queen Family Truckster, and the hilarious pitfalls they encounter along the way, was the first hit with John Hughes attached to it.

He worked like a man possessed, and by 1984, after establishing himself as the kind of writer studios, producers, and directors wanted for their scripts, Hughes moved on to bigger ideas; namely getting behind the camera to direct his own movies. So by the time theaters were showing the Griswolds barely making it to California, Hughes was already at work on his directorial debut, one that would drastically alter the landscape for how teens are portrayed on film: *Sixteen Candles*. It would turn him into what David Kamp of *Vanity Fair* would one day call the "Sweet Bard of Youth," and over the decade he would become to the 1980s what J.D. Salinger had been to a previous post-war generation: an adult giving voices to teenagers.

WHEN I THINK about seeing films Hughes wrote or directed for the first time as a child, I remember snippets and minor details. In the first *Vacation* movie (also the first time Hughes and Anthony Michael Hall would work together) Rusty wears a Chicago Cubs shirt very similar to one I had as a kid. Hughes was a fan of the South Side's baseball team, the White Sox, so my guess has always been that director Harold Ramis, who grew up in the same part of the North Side where my mother's family had settled, picked out the shirt because as any Chicago sports fan knows, you're either a Cubs fan or a White Sox fan; you pick one. Despite the

fact that Hughes probably would have rather seen his character
wearing his favorite team's logo, the Cubs shirt really signifies
where the Griswolds hail from, because—sadly—the Cubs have
been so historically bad that you really have to be from a certain
part of Chicago to really love them. You're probably from the
northern part of the city or the suburbs.

Hughes probably didn't envision Rusty in a Cubs shirt when
he wrote him, but it still represented something he helped estab-
lish throughout Ronald Reagan's administration: the Chicago
suburbs were the center of the teenage universe. Sure, you had
Valley girls out in Los Angeles and good-looking prep school
kids back East; but Chicagoland was the home of the *real* Ameri-
can teenager—at least that's another thing Hollywood had you
believe.

I was three years old when *Sixteen Candles* came out. Had I
seen it upon release, I couldn't have fathomed why Molly Ring-
wald's Samantha Baker runs out of the gym at the dance when
she makes eye contact with the guy she has a crush on. Most of
the jokes would have gone over my head; although three-year-old
me would have probably laughed at the outlandish and exagger-
ated Long Duk Dong. (I was too young to realize what an of-
fensive character that was, a crude mishmash of Asian stereotypes
and one of the only non-white characters featured in any of the
Hughes films.) I'd also have no way of knowing it wasn't whimsi-
cal or funny to have the most popular guy in school tell some-
body he could violate his girlfriend who had passed out cold from
drinking too much.

No, when I was a kid, the only thing I would have been able to
understand or relate to in *Sixteen Candles* was Samantha's snotty
little brother sitting at the kitchen table wearing—you guessed
it—a Chicago Cubs shirt. Hughes might not have been a fan,

but he knew if you were a kid growing up in the part of the Chicagoland area he portrayed, you rooted for the Cubs, not the Sox. In 1984 I wasn't even in kindergarten yet. Being a teen felt like a million years away, but I got the Cubs since that was my team's family. And when *Sixteen Candles* was making its theatrical release, the team was attempting to erase the World Series victory deficit that was then at just over seventy-five years (and would eventually climb past the century mark as I approached my thirties). That run is still one of my earliest memories, and I quickly came to learn that there was no reason to cheer for the Cubs unless you were born into it. The team would inevitably fail, my first sign that to be a Cubs fan is both a birthright and a curse. Eventually getting swept out of the playoffs at the hands of the San Diego Padres, it was the first real taste of bitterness I'd experience as a child. I was crushed, mimicking my family who had never witnessed a Cubs championship either, but it was something that took my mind off the other pressing issue of the day, like why my parents were no longer living together, which was another thing that, at that age, I couldn't possibly begin to accept. The idea of my mom and dad not being in the same house made no sense to me, and nobody could adequately explain to me why it was happening.

While they all have their problems, and all of them have to deal with the same teenage malaise we all feel growing up, the happiest and most well-adjusted kids in John Hughes's films are the ones from normal families. By "normal," I mean the parents are living and functioning together under the same roof. I know there's hardly such thing as a family who could be described as totally natural and regular, that something is probably lacking beneath the surface. But for what it's worth, Ferris Bueller seems as if he enjoys life, and Samantha in *Sixteen Candles* has it all to-

gether, aside from her parents forgetting her birthday. Their families might be a little dim or absent-minded, but we're not given any indication that there's anything off about them.

And then there's John Bender from *The Breakfast Club*. His situation seems pretty horrible, and he wears it on his sleeve, routinely letting people know how pissed off he is because he has a bad home life. There's also Cameron talking about how unhappy and abusive his parents are, telling Ferris and Sloane they shouldn't get married solely based off how much his father and mother hate each other and how miserable that makes him. Hughes had his broken kids from broken homes, but he also offered up one of the few exceptions to the rule in *Pretty in Pink* with Molly Ringwald's Andie. Her mom is gone, she ran off, away from her husband (played by the great Harry Dean Stanton), and left him and her daughter to their own devices. For a girl with very little resources or support, Andie is confident and cool while her dad has totally fallen apart. He can't get over his marriage failing and is unable to do anything beyond getting out of bed to mope around the house, missing the woman who left him and his daughter behind. We have to assume he's getting some sort of benefits or unemployment, but Andie's after-school job at the record store may be the family's main source of income. She makes her own clothes from stuff she finds in the sale bins and it might look cutting edge and chic by 1980s standards, but it's really about survival. And even though she's from the wrong side of the tracks (they literally make a point to show us that she lives on the other side of the train tracks from the wealthy families), Andie's a good student who's obviously on her way out of her bad situation. We know she's going to rise above everything, and that's why Andie was the first John Hughes character I wanted to be. Getting through all the crap

and coming out awesome, to me, was the coolest thing anybody could do.

Turning from twelve to teen was the moment I had been waiting for; I was a man—at least according to my rabbi. And although I didn't really feel much of a change during my last year as a non-teen—my voice had deepened only enough so that I couldn't do my Bart Simpson imitation and hair had only just begun to sprout from places other than my head—I thought things would be magically different overnight. The fighting would stop because my parents would start to give me space and begin to treat me like an adult. Maybe when I turned thirteen I wouldn't have to lie to my teachers about why I couldn't grip my pencil, after my father squeezed the tips of my fingers into my palms until I'd cry or pee my pants—a form of punishment for being too loud. Or I'd be able to stay at one of my parents' houses long enough to actually start making some friends since I really didn't have any of those.

But it didn't get cool. It got worse.

I'D BEEN HIT so many times—by my father, by bullies, in hockey practice—that it felt as though it was a normal part of life; I could sometimes see the shapes of the bruises on my backside if I looked in the mirror at the right angle, and I'd laugh just to see if I could still feel the pain sticking in my ribs from the most recent blowup. I always knew that I was going to get hit and that the only thing I could count on coming next was probably more hitting. The yelling and the insults, those things echo around in your brain forever; it takes a lot to not hear a voice—the voice of somebody who loves you, or is supposed to love you—somewhere deep in the back of your head telling you that you're still that worthless kid. That's what I think about as *The Breakfast Club* ends; I like to imagine John Bender got on the right path after that Saturday

detention, tried to straighten himself out, did something with his life, and sought out some sort of peace. Otherwise, I knew that he's always going to be angry, and that he's always going to hurt.

But this wasn't a movie. It was a real life as the doctor asked me to tell her if this hurt and if that hurt. She took X-rays, and I remember her smiling sweetly, running her two fingers down my nose, then just staring at me. She had green eyes. I only recall that because it was the first time I remember ever really looking somebody in the eyes. "Your nose is broken, tough guy," she said. I thought she was pretty.

"I skateboard," I said to her. I think back on that and I can't recall if I was trying to hide what really happened or if I was trying to impress her. That's the mind of somebody on the verge of becoming a teenager.

"You didn't get that skateboarding, though." She called my bluff.

There was a beeping somewhere, I wondered if it would flat-line like it did in the movies and somebody would yell, "Clear!"

I told her that, no, I didn't. She wrote something down and walked out of the room.

Some summer vacation, I thought as my mother drove us home from the hospital. What did I do over the break? I received a broken nose, a cracked rib, a bruised kidney, and a few weeks of taking it easy ordered by the doctor with the green eyes. But I didn't want to waste any of the free time. The days were precious and fleeting, and I wanted to use them all up instead of sitting around the house doing nothing because summertime is all you have when you're a kid. Everything else you owe to adults; the rest of the year belongs to them.

We drove through Evanston, past the Grosse Point lighthouse. My mother was taking me to see her lawyer, the little manila en-

velope with my X-rays sitting in my lap. I looked out the window and saw kids in their bathing suits walking toward the lake and could smell the breeze wafting into our car as we sat at a red light. I was thinking about how fun it would be to go swimming when my mom broke the silence to tell me that if I went back to my dad's house that she feared he could kill me. Those were her exact words. I would be over. She'd told me my father was dangerous, but suddenly I was faced with one of my parents telling me the other parent could maybe end my existence.

She must be telling the truth, I thought as we drove to the police station to file a report. *She must be serious.*

A week later, in a courtroom in the city, it all happened very fast: my father, stepmother, and grandfather all walked in together. I was told not to look at them, so I didn't. The judge talked for a few minutes, and the three of them walked right out.

"We won," my mom said as the large wooden door that looked like it belonged in a castle closed behind them. I looked around— everything else in the courtroom had probably been added during some redesign in the '70s except for the large door that my father, stepmother, and grandfather had exited through. My mother began to explain that my father had lost all visitation rights and wasn't allowed to get in contact or come near me until after I turned eighteen. But I was having a hard time understanding what that meant, how things would be from that moment on, and if I'd ever see my father again. I'd be OK, she said. Everything was going to be fine, the lawyer assured me. He had a five o'clock shadow, wore a gray suit that needed to go to the tailor, and desperately needed to comb his hair.

Ask him what the hell that means, I thought. *What did we win?*

"He can't hurt you anymore," my mother said without looking at me.

On the way home, she and I took a similar route, the city limits dying away in the distance with every inch of concrete we drove over. I turned around and watched as Chicago grew smaller until it was finally gone, its skyline and high-rises had totally vanished from my view, replaced by the big brick houses of Evanston that led us back to the Grosse Point lighthouse. We sat at a light and I played on a loop in my head my mom saying we'd won, trying to figure out how we had anything to celebrate. It didn't feel as if a great thing had been accomplished; nobody had handed me a trophy, and in that hollow way only an adolescent can feel, all I saw was that my future was fucked—a feeling I'd become familiar with, that everything's just rotten and bad. When we get older, we act like these feelings are silly in retrospect. We call it "teen angst," adults make fun of it as if it's this totally hilarious thing because we just didn't know any better when we were young, but when we sit down and actually think of how terrible we felt when we were teens, it's chilling.

Years later, I'd read a Hughes quote: "At that age, it often feels just as good to feel bad as it does to feel good." I wish I could go back, write that down on a piece of paper, and somehow pass it to young me sitting in that car. It was advice I could have used, starting at the very moment when I saw that group of kids, running and laughing in their bathing suits, on their way to the beach. I wanted to be with them, having fun in the hot summer sun. Instead, I was in the backseat of my mom's car, not quite an orphan and not coming from a funeral, yet still feeling like someone or something had died, as if I was being driven down a road to nowhere. Despite everything, I still wanted things to go back to the fucked-up way they had been just a few days earlier. At the very least I wanted to know it was OK to feel so bad.

HIGH SCHOOL STARTED just as I found myself finally starting to adjust to my new life. There was a time when I wanted to be the Jake Ryan of my class, even though I knew I probably couldn't look like him. My hair was a frizzy mess that couldn't decide if it wanted to be straight or a Jewfro; it would never smooth down and fluff up in the right places like Jake's. My orthodontist said that at the slow rate my teeth were straightening out, I might never get my braces off. But when the first day of classes did arrive, on an August day that was bright and shiny, I walked on the grass, kicking the heads off dandelions with my ripped-up Chuck Taylor sneakers, carrying my skateboard under my arm. It was the beginning of what I had built up to be the most magical four years of my life, but on that first day, it just felt as though it was a continuation of the same old shit. I didn't want to be Jake Ryan anymore. I wasn't sure who I wanted to be or who I was, and I tried to act as if I didn't care. I just wanted to get in and out as soon as possible.

Everybody had his or her place, just like in a Hughes movie; I learned that right away. There were updated Samanthas from *Sixteen Candles,* the ones who nobody paid any mind to. They slinked through the halls, walking close to the lockers at a slow and leisurely pace. They seemed safe because they were invisible. There were those who didn't seem bothered by the fact that people made fun of them, like Eric Stoltz and Mary Stuart Masterson in *Some Kind of Wonderful,* who proudly walked around with their hair dyed different colors, knee-high socks, and clothes they'd purchased at the Salvation Army, I liked them the most. There were jocks, Emilio Estevez as Andrew Clark in *The Breakfast Club* types. They walked straight down the middle of the hall, sometimes making noises like those you'd hear in the primate

house at the Lincoln Park Zoo. Some were chiseled and hand-some. The others, the acne-scarred offensive linemen and the guys who played the games with the sole intent of protecting the better, more athletic, and usually better-looking players, were the ones you really had to worry about. They'd grab you and put you in a headlock, yelling, "I bet this hurts," or they'd pull down the pants of some unsuspecting kid in glasses who'd then just stand there for a minute, totally stunned with shame. It was a tradition that every player had to follow at least once a season. If they pulled just the pants down, you'd hear hoots and hollers all the way down the halls, but if they got everything including the underwear, it was as if they'd just thrown an alley-oop pass to Michael Jordan who slammed in the ball to win another championship.

There were a few Jake Ryan stand-ins who actually did have the perfect hair, the expensive shirts from Abercrombie & Fitch, dated the best-looking girls, and were already talking about the cars they were promised when they turned sixteen. But they were too cool to care about anybody else. The ones you had to really watch out for were the Steffs from *Pretty in Pink*. Specifically a guy named Dale that I went out of my way to avoid.

He wasn't a star on the football or soccer team, but his father was a well-known philanthropist, his mother's family had build-ings in the area named after them, and his older brother was extremely popular. From his first day in high school, Dale was automatically cool and knew all the seniors because they wor-shipped his older brother and treated Dale as his heir apparent. The guy was untouchable from day one; a simple wave of his hand could get your ass kicked by one of his brother's massive friends. If he didn't like you, he let you know it; and while we used to be friends, by the time the leaves started to turn, it was obvious that he *really* didn't like me.

I kept to myself, save for the two or three other kids who hung out by the bank—the one with the good curbs we could wax up to skate on after it closed. I had my hair cut in a short surfer style up the back and the sides. I really wanted that wispy part that would hang over my eyes like Jared Leto's hair in *My So-Called Life,* but I had to settle for something more along the lines of a punk rock Brian Krakow, the show's hopeless nerd. I'd started skateboarding the summer before to bond with a group of kids who lived up the street. I could ollie and kickturn, but that was about it. I tried skating a half-pipe a few times, but only went back and forth, never attempting any tricks. I wasn't any good and had no plans to get any better, but I carried my skateboard to class with me, and on the first day of freshman year when I walked into seventh-period social studies, Dale yelled, "Skate or die, dude," prompting the rest of the class to laugh. It was embarrassing for a second, but it made something happen: I became a skateboarder. That was my place, and that was who I was. In Hughesian terms, I was a cross between Duckie from *Pretty in Pink* and Allison from *The Breakfast Club.* But Dale and his friends kept making fun of me, always threatening to kick my ass but never quite following through. It began to feel like a badge of honor. I got more into skating and the culture around it. I bought a Misfits shirt that I wore at least three times a week, ripped-up baggy jeans, traded in my beat-up Chucks for a pair of Vans, and bleached my hair. Soon enough, I wasn't just a skater; I was a punk. That was my identity according to my classmates, and I wore it like a shield, just walking through all the bullshit that was being tossed my way. I wanted everything to be like a John Hughes film, but it didn't take long for my mind to start concocting ways to get back at my tormentors, cursing them under my breath at every opportunity, and sometimes relating more to 1988's *Heathers* than Ferris Bueller lip-synching to

"Danke Schoen" on a parade float or any of Molly Ringwald's characters.

SOMEWHERE BETWEEN THIRTEEN and fourteen, after my mom got full custody and I was her responsibility, things escalated between us. The volume of the yelling got louder and our relationship started rotting out. Maybe it really took off when I slammed a door so hard it fell off its hinges, or when my mom threw a book at me. It was bad before I yelled "Fuck you" at my mom for the first time, and definitely after I kicked a hole in my wall and was caught shoplifting. But when was the beginning? I don't know what set it off, but things inside my house were terrible and only getting worse, as though removing my father from the equation had unleashed something hidden beneath the surface. My mother and I were never that close—it couldn't have helped things that she had to spend any free time she had either telling her hyperactive little kid to shut up or going to meetings at my school to figure out what to do with me. Even when I was only nine and ten years old, she'd tell me that I was just like my father. I knew it was the greatest insult she could make without outwardly admitting she couldn't stand me.

"I *don't* like you," she finally told me one night after we started arguing over something trivial. It was always the tiniest things that turned into the biggest blow-ups.

"Well I fucking *hate* you," I yelled back before trying to go back to studying for a test.

"Get out," she yelled, chucking a plastic cup filled with ice water in my direction for good measure.

"Great," I said as I grabbed my backpack and my coat, not worried that it was the start of winter and I had nowhere to go and only a five-dollar bill in my wallet.

I walked for an hour until I found a twenty-four-hour diner. I ordered a coffee from the waitress, told her that no, I wasn't too young to drink coffee, and finished my homework. When I looked up at the clock and it read 11:00, I thought I should probably leave.

The streets were quiet and dark as I walked home. The wind whipping past me made a ghostly echoing sound that stretched way into the trees, cars would zoom past just a few inches from where I was walking on the shoulder of the road, and I tried to recall what urban legend was supposed to haunt the woods I was skirting the edges of. I felt a little frightened by the sounds of the natural world, having gotten so used to walking nearly everywhere with my headphones on. It was a nice way to tune everything out, but now I had no choice but to listen for wild animals creeping up on me and for some local ghoul I heard about once in a story.

When I finally did make it home, I felt around in my pockets and looked in my backpack only to find I'd left my keys inside the house. Nobody had waited up for me and I didn't feel like facing my mom, so I walked around to the side of the garage that wasn't connected to the house, did the trick with the knob that opened the door without using a key, found an old blanket in a box, and slept in the backseat of one of the cars.

The fighting escalated over the next two years, and by fifteen, I was sad, angry, or a combination of the two, at all times. At school I'd roam the halls with my head down and my headphones on. I didn't really want to look anybody in the eyes or talk to them. I had a few friends, the school's token group of weirdos and outcasts: the two other skater kids, another who tried his hardest to look like Brandon Lee in *The Crow,* and a couple of burnouts who would sneak off during gym class to smoke weed

in the woods. But for the most part, I had this deep resentment toward just about everybody I saw: the teachers, the cool kids, the jocks who I used to play baseball and hockey with in what felt like another life. When I'd tried to feel like everybody else.

I relished the fact that people thought I was strange. I stole hair dye from the store at the mall that had switched from selling hemp necklaces and Grateful Dead stickers to spiked cuffs and Ramones T-shirts because I thought it was corny that they were cashing in on punk being popular and considered it my duty to shrink their profit margins. I sewed patches on my hooded sweat-shirts with phrases like "No Gods, No Masters," etched the Black Flag logo into my arm by rubbing an eraser into my skin until I had four perfectly peach bars, and was openly hostile to anybody who tried to be nice to me. I didn't want to interact with people, and kept telling myself that I just needed to get through it. I would get into college and move into the city or somewhere with a cool scene like San Francisco or New York, away from all the screaming at home and all the kids I didn't like. That was what I cared about: finding a scene. Somewhere out there, there were people I could connect with. Where I could go see bands play and meet photographers and musicians and, most important, writers. I wanted to meet writers. The only thing I was interested in was writing little short stories in my notebook.

I couldn't shake the nagging feeling that I might never be happy again. I was always down. Nothing felt good. I couldn't understand why and nobody had an answer for me. Several differ-ent doctors thought they might, but like snowflakes, it seemed no two recommendations were alike. There was the one who thought Prozac would do the trick, and then the one who prescribed a combination of Prozac and Ritalin to calm me down and help me concentrate. There was one who said Adderall, then the one who

suggested Dexedrine for my ADHD. They both seemed to pro-
duce similar results, but the doctor who prescribed the Adderall
was located twenty minutes closer, so we said no thanks to the
Dexedrine, and decided the closer one was right. There was Well-
butrin, Zoloft, and Fluoxetine. SSRIs, NPRIs, and NPRAs and
all sorts of other letter combinations floating around that I didn't
get. The pills were white, pink, and yellow. I was able to swallow
them without water, sometimes crushed them and snorted them
if I felt like they were losing their effect, and at one point I started
selling them to the burnouts for five dollars a pill. I could see my
body, but couldn't feel it save for the shakes. I had dry mouth and
felt sick from time to time. Some days everything seemed to have
a gray tint to them, but then others were totally fine.

"Jason, do you know what depression is?" one doctor asked.

I had a vague idea. "Getting sad a lot?"

"Yes, but it's a little more than that," he told me as he began to
explain chemicals and neurology. I lost him until he said, "Since
you suffer from depression . . ."

Oh, cool. I'm depressed. That's neat. I'm *sure* more drugs will
cure that.

Then a few months later, at another new doctor's office: "Do
you know what obsessive-compulsive personality disorder is,
Jason?" asked the doctor with a full head of tousled gray hair and
a short beard to match.

"Sure," I said. I didn't, but I just wanted to get out of his office.

"You get angry or upset because things feel out of your con-
trol," he said.

"I'm fifteen," I said. "How much control do I have?"

He laughed, but didn't answer. And with that, I had another
diagnosis to add to my list and a little script with another drug
that was supposed to lead me down the road to the cure. I was

racking up prescription slips like Boy Scout badges. What *didn't* I have?

The problem was that I was getting nowhere except learning about new maladies and getting new prescriptions written. I grew frustrated and hopeless, so given all those unfinished bottles of pills that accumulated with each new doctor, it's strange that I chose the Advil in the medicine cabinet as my poison for what I wrote in my suicide note was my last act, but it would do. I was sick and tired of everything and everybody and wanted people to know that. It didn't dawn on me that it wouldn't do me much good if they figured that out after I was dead since there's not really much thought that goes into half-assed suicide attempts. But something about the Advil seemed safer to me, like maybe it wouldn't kill me, but instead it would just get people to notice. I could take just enough of the pills and the yelling might stop.

I did it on a sunny day. I had threatened in fights that I was going to kill myself just to see the reaction, but they had been hollow words. That day, however, I just walked into the bathroom, feeling as though I wanted to prove something; I might die doing it, I thought, but whatever. I started feeding myself one pill after another, slowly, as if I was leisurely eating grapes, then put my head under the sink to wash them down with cold water. After I finished what was left in the bottle, I quickly felt buyer's remorse—I didn't really want to die. I never wanted that. I stuck my finger down my throat until all the little pills popped back up as my mom banged on the door, screaming to find out what I was doing in there. I walked out and proclaimed, with some sick bit of pride, that I'd just tried to kill myself. That wasn't what I wanted to really do, but I did want a way out.

A few days later, my mother came into my bedroom and told

me that I'd be going to a new school for a semester, a "day program," starting the next Monday.

"I had to call your asshole father to make him pay for it."

What my mother actually meant was that she had to call her lawyer and have him get in touch with my father's attorney to take care of the bill. The monthly child support was sent automatically, one of his checks that I assumed he had signed off on long before it ever had any use, the ones that the secretary would fill out the details on later when needed. I always imagined he didn't know where check 0058 was going to, it could have been paying a vendor or a delivery guy; I was totally out of sight and out of mind to him, a line item on his yearly taxes, I thought to myself. Medical expenses such as my doctors and the drugs they prescribed me were also just sent to my mother's lawyer, then to my father's lawyer, and finally to whomever paid the bills.

"Well, maybe I should try and kill myself more often," I said. I thought it was funny and cutting, but my mother just stared at me, sobbing a little. I looked at her. She shook her head and got up to leave the room without saying anything to me, initiating a period of near total silence between us that would last for several months.

The next Monday I was picked up by a nondescript van and driven into Evanston to what one of the four other students explained to me was "a hospital for rich kids whose parents didn't want to screw up their chances of getting into a good college." It was discreet, it was loose, and we had all of our schoolwork sent there to be done over the course of the semester with nothing being noted on our permanent records. When I started, there were a few other kids in what they called "the program"; there were no jocks, no teachers, nobody who knew anything about you, no high school bullshit in there. In a lot of ways it was sort

of like a warped version of *The Breakfast Club* with all the high school cliques and stereotypical designations removed since we were all in a hospital for damaged kids.

It felt like a clean slate and it was the happiest part of my high school experience.

There was Sheila, whose parents thought she had a drug problem ("I did Special K once or twice and smoked weed every day. So fucking what?"); a girl named Tina who would just say "I don't know" or "I don't care" whenever somebody addressed her (she confided in me that she'd been in two different programs before and it was easier to get through it if you just didn't say anything); Mike, who asked us to call him Twitch—he wore black lipstick, black nail polish, and told us how his parents made him go to the hospital after he came out to them; and there was a guy named Scott who never said a word the entire time I was there. We all had our problems: One of us wore them as slice marks on her wrists. One of the girls walked around with a plastic Super Mario Brothers lunchbox from the 1980s, never letting us see what was inside. And another threatened to kill himself because he told us he was in love with a girl staying in the in-patient program on the top floor, and threatening suicide was a first-class ticket into at least a week of 24-7 hospital living. We had group sing-alongs in which nobody wanted to participate, but the good-natured therapist strummed her guitar, singing the lyrics to Des'ree's "You Gotta Be." And she kept smiling even when we yelled out requests for Nirvana songs. We'd do a little schoolwork, but mostly we just sat around and talked about how we were feeling, meditate once a day, play basketball, make pottery, and spend an hour talking with our assigned therapist.

Mine was Coral. She didn't seem that much older than me,

and reminded me of the babysitter, Rachel, who had showed me *Pretty in Pink*.

"What do you like, Jason? What makes you happy?" Coral asked me during our first session. "You said punk rock. Like Skinny Puppy? Nine Inch Nails? All that stuff?"

I usually had a hard time opening up to people, especially doctors. After the cavalcade of different psychologists and psychiatrists and neurologists my parents made me see, and the social worker who went to both my mom and dad's house and had promised me that my parents wouldn't find out about anything I told her—until they did, I really didn't trust anybody I was supposed to spill my guts to. They just always seemed to be working for somebody, and would end up betraying me in the end.

But Coral was different. Even though she rattled off bands I didn't really like, I wanted to tell her everything. I'd been needing somebody like that in my life, and her welcoming face made me think I could trust her, that she'd understand and never judge me. I liked how she didn't write anything down. It felt more real to me than any conversation I'd ever had with an adult.

"I like punk like Bad Religion and Minor Threat. Stuff like that," I told her.

"I'll check them out next time I'm at Best Buy," she said with a smile, as if she was dead set on really checking out the music I was into.

There was a silence. I looked around at her diplomas: University of Illinois and the University of Michigan. There was a picture of her and a guy: they were sunburned, standing on a large rock, wearing shorts and Patagonia vests. Their large smiles looked genuine, as if they'd just accomplished something huge.

There was another picture in a frame next to it, a familiar

one that, once I focused my eyes, I realized was the shot Annie Leibovitz took of the Breakfast Club, the one with Judd Nelson as John Bender almost hovering over the other four, and Molly Ringwald's Claire Standish lying across the bottom.

"Do you like that movie?" I asked, pointing at the picture.

She smiled and told me it was her favorite.

"I wrote a paper on it for a psychology class and I've been re-watching it over and over ever since," she said. "It's a really important movie because it shows what people your age really feel."

I found myself agreeing with her. I'd watched the movie a few months earlier on a Saturday morning, curious from the second I'd flipped the channel to the opening scene of kids getting dropped off at a school. It undeniably looked as if it was somewhere close to where I lived. I watched the entire thing through, and the next time it was on, I was ready with a VHS tape to record it.

"I really like his movies," I told her. "John Hughes is my favorite director."

It was the first time I'd ever said that.

"Ah. A future auteur, perhaps?"

"Yeah," I replied, not really sure what that meant. "Or maybe a writer."

MY TIME IN the program came to an end just as the summer began, and I vowed every day was going to feel like *Ferris Bueller's Day Off:* total freedom. The first Monday of vacation, while all the adults were at work and the world seemed calm, I got stoned with a few of my friends on a hill underneath some railroad tracks. We just sat on the rocks for hours, the creek a few feet below us and our laughter the only noise except when a train came rumbling overhead every hour or so. I spent forty-five minutes staring at and contemplating a wall with "Boredom Is the Doom of Youth"

painted on it in blue graffiti. It felt almost religious to me, as if there was some deep message I needed to decode. I had moments like that from time to time when I was a teenager—almost all of them while high—but this was something different. I just stared at the wall thinking that whoever wrote that really got *it*. Exactly what I thought "it" was is up to interpretation, but I'd been desperately looking for guidance and inspiration from anywhere I could find it, and this slogan spoke to me. I was always bored except when I took rides out of the suburbs and into the city. My friends and I would go see bands play at a broken-down old bowling alley that was dusty and smoky and looked as if it hadn't been working for over a decade. Sometimes we'd hang out near Wrigley Field, trying to get the crust punks begging for change outside of Dunkin' Donuts (everybody called that branch Punk'n Donuts) to let us pet their dogs. We'd go to house parties on the South Side, get really wasted, and pass out on the floor. I smoked weed out of an apple bong with a toothless guy who my friends said used to be a semi-famous skateboarder in the 1980s, and drank beers in the woods. I didn't feel good or any better than I had before I went into the day program, but when you're a teen in the summertime, you don't need to feel much of anything; you're just supposed to live.

Things at home were calm because my mother still wasn't talking to me, but the lack of yelling made me uneasy. I escaped it by staying out as late as possible. My curfew never even came up anymore, and sometimes I just stayed over at other houses for days at a time without even a call home. If I wasn't at home, I think my mother and I both intuited that we couldn't fight, that things wouldn't get thrown or broken, and as long as I was staying out of any real trouble that she had to know about, I was probably better off anywhere but there.

Scribbling little drawings and writing stories in my notebooks or reading paperbacks I bought for a quarter each at the Salvation Army were my main ways of passing the time, but my favorite thing to do was walk around aimlessly with my skateboard, hardly ever putting the wheels to the pavement, and just look around. I walked everywhere, for miles at a time without even giving it much thought. The suburbs, even if they're littered with big-box stores and ugly McMansions, are expansive and offer very little to teens before they have cars. You either let that get to you and bring you down, or you get creative and figure out how to think beyond the tiny chunk of the planet that is your neighborhood. And that is what makes Ferris Bueller the patron saint of bored suburban youths: He isn't the quarterback. He's handsome, but hardly a classic hottie, and he doesn't have a car. He's bored going from home to school all the time, and just wants something a little more. He gets that people want to hold him down and keep him from doing that, namely Dean of Students Edward R. Rooney. His parents want him to be a good student and eventually go to a good college, as most parents do. His sister wants to bust him for playing hooky. And Rooney just wants to exercise the little bit of power he has in this world by teaching Ferris a lesson. But Ferris rises above all that, and he takes his girlfriend and his best friend along for the ride. He outsmarts the adults not because he wants to prove a point, but because he knows he doesn't have many chances left to have perfect, carefree days like this one.

I thought about that at some point while staring deeply at the blue graffiti on the wall beneath a bridge. I got what Ferris was doing, and it was really punk rock to me. Before I started in the day program, I was just beginning to take an interest in literature. I was proudly proclaiming myself an existential-

ist while butchering the pronunciation of Albert Camus's last name, writing bad teenage poetry, and taking black-and-white photos of tombstones with a cheap used camera I'd purchased, with the totally original thought that those images were deep and profound. I was looking to make and also experience art that could help me make sense of things, and teen movies such as *Ferris Bueller* and *Pretty in Pink* really spoke to me. I started seeking out Hughes's movies and watching them any chance I could. Some would be on TV, others I shoplifted from the local big-box store, slipping them up the sleeve of my hooded sweatshirt, casually walking out, and justifying it by saying, "Fuck big corporations." Soon enough, I had the entire little library of Hughes's teen movies at my disposal for whenever I needed them, and I watched a few of those VHS tapes until I wore them out. I started using them for guidance, road maps to the places I wanted to go and primers on how to become the best me. It all seemed within reach when I watched his work.

Long before I obsessively started spending money, I didn't really have to collect records and books by certain authors and bands. I geeked out over Hughes's films because they spoke to me when I needed something to connect with. Sure, I watched and really liked other movies; I gave *A Clockwork Orange, The Warriors,* and the 1979 cult classic *Over the Edge* serious teenage critical appraisal by deeming them each "really cool." Mostly any movie portraying teenagers destroying things amused me. Hughes accomplished the almost impossible task of making me feel inspired. They made me feel as if I could get out and be better. I related to the teens in his movies, their happiness, their sadness, the anger, angst, and longing.

I didn't realize that, before long, I'd find myself relating to another Hughes character. This one a little younger than I was.

FIRST THERE WAS the cartoon Disney version of Peter Pan and the Lost Boys when I was a little kid, and then in the second grade, the Boxcar Children, a family of orphaned children who take refuge and thrive in, yup, an old boxcar, captured my imagination. They made it seem so easy and exciting: Parents are dead? You're on your own? How fun! Even after I'd read *Lord of the Flies*, I felt like, yes, maybe not the way I would have wanted things to turn out, but I figured I could do a better job running an island after most of human civilization was wiped out.

"I'm moving away to South Carolina. You can come with me if you want," my mom told me out of the blue one day when I decided to come home for a change of clothes. "But I'd rather you didn't."

I was eating a cold slice of leftover pizza with hot sauce dripping from it and washing it down with root beer when she approached me. I was ready to just say, "Cool," and walk right back out the door, but I was trying to figure out if she'd said exactly what I thought I'd heard. She was moving? South Carolina? Why?

It had been a long time since we'd exchanged that many words to each other without the volume being raised, at least since I'd gotten out of the hospital. Often we would go long spells without even crossing paths, I'd spend almost a week at a time staying with friends. If it was a school night, I'd wake up extra early to take the "L" deep into downtown to the grand and cavernous Union Station where I grabbed a Metra train filled with sleepy and silent morning commuters on their way to work to get me back home.

When she stopped me in the kitchen, I'd been away for several days, sleeping at a friend's house whose parents were out of town for the summer. We used some of the grocery money his parents left him to buy pot that was stronger than the skunk stuff I bought

from the hippies I went to school with. We'd been waking up, getting stoned, and walking around by the water, eating sugary cereal from a Ziploc bag we'd brought with us. Before I'd left, we'd smoked the last of the weed the dealer had called "Vietnam," so I was still really red-eyed and high when I got home.

We just stood there for what felt like an hour, with her waiting for my response. If you removed the pot from the situation, it was probably more like a minute. She finally spoke.

"I need to know your decision," she said after all that nothing.

That sobered me up, shooting a rush of adrenaline through my body. I wanted to ask what I was supposed to do if I didn't go with her, but I thought that would show weakness and that I couldn't take care of myself, so I nodded and we left it at that. She told me on a Wednesday that she was leaving on Friday, which meant she'd been planning it for weeks. She never really told me why she had to leave, but I could sympathize. She saw too many ghosts everywhere she went: failed marriages, bad relationships, my grandfather passing away, and me. I was probably a big part of it.

You can tell a kid that it isn't their fault, that they didn't do anything wrong, that kids can't understand or cause adult problems, but that's not always the case. What we had went beyond a child and parent fighting; we were at war. We didn't like each other; she would say I was just like my father and I'd say she was a bad mother. She'd throw something at me, so I'd pick up something and smash it on the floor to retaliate. She'd call me an asshole. I told her I hated her. Sooner or later something had to give. She wanted to get out and cut ties with her past, the failed marriages, the bad jobs, and, I believe, the teenage son she couldn't even look at. Part of me understood that. I suspected she didn't want me to go, so I decided to stay behind. Everything would

work itself out, I told myself, it would be good for the both of us. Maybe we could start getting along if we had distance; maybe I could be better if I was on my own. I told myself I could handle it, the freedom I'd wanted all along.

I slept in my own bed the Friday after she left, and awoke with a strange feeling. It was beautiful out, and all I could think of was how I had my old place for another day or two. But then I had to be out because the house no longer belonged to her; I'd be a squatter in the place I used to do my homework, and I knew that wouldn't end up well, not in the suburbs. I didn't know what I'd say to friends or their parents about my situation. I reasoned that I'd figure it out along the way. I had the summer to myself to get situated in my new life, and it would be an adventure like Peter Pan, the Boxcar Children, or Macaulay Culkin in *Home Alone*.

I soaked in the first days of having nobody to tell me what to do; thinking that all my problems would be solved with both my parents gone, I had no idea I had actually reached the end of my childhood. I was still a teen according to my age, but things were about to go very off script.

I FOUND MYSELF on dozens of different beds, couches, futons, floors, and sleeping bags in tents, vans, houses, apartments, high-priced high-rise condos, garages, basements, punk squats, and motel rooms during my high school years. Some were for a single night or a few days, others for a week or two. Sometimes people were friendly and didn't ask questions, other times I could hear parents talking about me through the walls, calling me creepy or wondering if they should call my parents.

And then there was Big Tommy.

"Just remember to never call him 'sir' or 'Mr. Callahan'; always call him 'Big Tommy,'" my friend Beckett told me of his father

when I accepted his invitation to stay with his family. Beckett wasn't named after the famous Irish writer, but after a beloved Labrador retriever his father had adopted and eventually had to put down after it could barely walk. The funeral, held in the family's backyard, was rumored to have come complete with the traditional hired Irish bagpiper playing "Amazing Grace" as Big Tommy shoveled dirt onto the corpse of the beloved pooch, and a few weeks later came the tombstone with Beckett's name on it and the words "Beckett Callahan: Greatest Dog Ever" at the bottom. Once a year the family—that eventually grew to seven children—would gather around the grave, Big Tommy would say a few words and a prayer, and the children would take turns placing a single red rose on the dirt mound. The room I slept in overlooked the solitary monument to the dead dog, with a spotlight that automatically started shining on it as soon as it got dark.

For reasons I still don't understand, Big Tommy thought I was Irish Catholic like them. And during my first weekend living with the family, when he asked me what parish my family belonged to, I panicked, and told him it was on the North Side. Beckett's dad just smiled. "You seem like a good kid, but parents gotta keep their kids in the Church. It's not your fault you don't know the name of your parish, but parents need to step up on this. How is a kid supposed to grow up without Christ and faith?"

I smiled and said I wasn't sure.

"That's all right," he told me, cracking his knuckles on fingers that looked like fat pink sausages, adding that I was welcome to join his parish. "We'll get you straightened out."

Across the table, I could see Beckett, eyes opened wide, jerking his head in the direction of the kitchen.

"We'll go get the ham," he said to his parents.

I followed him into the kitchen. Just as the door closed, he

grabbed me by the sleeve and aggressively whispered into my ear, "Dude, act Catholic. My dad doesn't like Jews, or black people, or really anybody else that isn't Irish Catholic."

"How the hell do I act Irish Catholic?" I asked.

Up until sitting down to dinner at his family's table, I had thought that it was pretty obvious I was Jewish. I was almost a little flattered.

"Come on," I said with a laugh. "Your dad seems like a good guy. He likes me."

"Dude, seriously. Just make sure he doesn't find out."

We walked back into the dining room. His mother had prepared a special meal for the whole family to celebrate my coming and staying with them, and they were all waiting for us to sit down before eating. She didn't speak a word to me or nearly anybody else. Big Tommy did all the talking, taking shots at nearly every group of people from Jews to black people to Mexicans, and also the Albanians who worked for him. He seemed to be really disgusted by them, though I wasn't sure he knew exactly where Albania was on a map. It sounded like his ideas for getting certain ethnic groups out of certain neighborhoods was typical dinner-time conversation, so I kept my mouth shut the entire time. As I forked a piece of potato into my mouth, I decided it was best if I left in the night while everybody was asleep. I snuck out a little after one in the morning, and spent the night in a twenty-four-hour diner, listening to a dubbed cassette of Pavement's *Crooked Rain, Crooked Rain* on loop, writing in my notebook, and drinking one cup after another of coffee, trying not to pass out in the booth, as I tried to plot out what to do next.

COFFEE SHOPS THAT never closed offered refuge when I didn't have many other options. They were the closest thing to discreet

as I could get, all of them usually packed full of punks, theater kids, and other assorted outcasts. We had somewhere to sit for as long as we wanted and it only cost two bucks for a bottomless cup or a plate of fries. I usually kept to myself and didn't talk to anybody. I was too busy trying not to nod off, the only thing the management usually frowned upon. Foul language, drug use in the parking lot, I even heard a couple boast to their friends that they had just had sex by the dumpster out back at a Denny's; that was all OK. Hardly anybody ever got kicked out, save for the really obnoxious drunks who sometimes showed up after the bars closed, but sleeping earned you an automatic "This isn't a hotel," and somebody telling you to order something or get out. That was the cardinal sin.

A few nights after Big Tommy's, I found myself sitting in another coffee shop trying to figure out what the hell I was going to do next. The weather was starting to turn outside and I was struggling to finish homework as people around me chatted about role-playing games and how some once-obscure punk band had started to suck when their new music was put out by a major label. I just couldn't focus on anything except for the awful feeling that came with the first chills of autumn and the worry of what I was going to do when it really got cold outside. That, and I'd been fighting off withdrawal from the prescriptions I'd run out of and couldn't figure out a way to get my doctor to give me a new prescription without setting off alarms since I hadn't seen him more than once or twice since my mother had moved away. I was edgy and exhausted, sweating even though I heard other people complaining to the waitresses to turn up the heat. So when I heard a voice I knew calling my name from across the restaurant, the first thing I wondered to myself was if it was a hallucination, some side effect from withdrawal. I turned around and realized who was

calling to me; it was Alexis Schwerin. I hadn't seen her in over a year, and suddenly there she was in the same coffee shop with me.

I have a theory about high school crushes. You might be a Kevin from *The Wonder Years* and you have a Winnie Cooper. You and that person have something special and it might not last forever or it might not even happen at all, but they are forever burned into your memory as the symbol of being a teenager and learning about love and heartbreak. Or you're a Duckie from *Pretty in Pink* and you're mad for an Andie. They are your unrequited high school love, and they either fully realize that but don't feel the same way, or they are totally oblivious.

I was totally a Duckie and Alexis was that untouchable Winnie Cooper symbol. I wore outdated styles that I'd picked up at thrift stores, Alexis was pretty and popular. Everybody liked her, but I *really* liked her—and she knew it. She knew it, her brother, James, who had been my friend since peewee hockey, and her parents knew it, too. Everybody was very aware that I had a huge crush on Alexis, but I also looked up to her. She was effortlessly cool and just *better* than everybody else in my eyes.

I felt as if I was going to throw up right there when she walked over to my table, but I couldn't tell if that sensation was because I was nervous or because I'd been nauseated for the last day from the withdrawal. She put her hand on my shoulder and asked me what was wrong. I told her everything, the first person I was honest with; she told me I should come back to her house with her, that I didn't look too good. I had been trying to scratch the roof of my mouth with my tongue for an hour, and I could feel the puke climbing into my throat, but somehow everything felt better when we got into her car.

"Look who I found," she said when we walked into her house and greeted the rest of the family.

The Schwerins were the quintessential all-American family in my mind. Their house was what I'd imagined Jake Ryan's home looked like when his classmates weren't trashing it during a party. There was Mr. Schwerin: Robert on his business card, but he told me to call him Bob at an early age because "all his real friends" called him Bob. I liked feeling as if I meant something to Bob. With his Germanic features, starting quarterback build, and jokes about how he'd disappointed his family by going to one Ivy League school instead of the one his whole family attended, he was the perfect picture of what I thought a dad should be. Mrs. Schwerin, Barb, was of old English aristocracy, and had some portraits of ancestors hanging in the family room from the eighteenth and nineteenth centuries. There was talk of Daughters of the American Revolution meetings and the Freemasons, stuff that my family could never be involved in. There were pictures of the yearly trip to the family estate in Scotland on the walls, the restored 1965 MGB roadster in the garage parked next to the two new Volvo station wagons that always looked shiny and clean. There was a garden in the yard that everybody pitched in to tend, a dinghy tied up to the dock not far from their house, and just about everything inside their home was monogrammed. There was a study where all you could do was actually study (no talking, no television, no music), and every other weekend they went on a family hike nearby. They were, to me, the perfect family. And my jealousy ran a close second to my affection for their daughter, with her short blond hair cut like Jean Seberg's in *Breathless*. Alexis wore things like her father's old Oxford shirts with a few buttons undone at the top, khaki miniskirts, and Wayfarer sunglasses; she seemed so worldly compared with anybody else I knew. In my mind, there was a place somewhere beyond the suburbs where everybody was like Alexis. She convinced me to

read *The Bell Jar* the last time I'd seen her before the coffee shop, telling me that the only reason people call it a girl's book is because a girl wrote it. "If a man wrote it," she told me, "it would be considered just a great piece of literature and nobody could say otherwise." And she introduced me to bands like Bikini Kill and Fugazi by slipping me dubbed cassettes. A few years older than me, she didn't go to my high school; she attended a private school where, from what I imagined, she was the most popular girl in her class. It was strange: Alexis didn't really fit into any of my preconceived notions of the high school ecosystem. She wasn't a jock, a nerd, a criminal, a princess, or a basket case. Nor was she a sporto, motorhead, geek, slut, blood, wastoid, dweebie, or dickhead. Alexis was herself and she was the only person around our age I knew who seemed comfortable with being that.

She knew how much I had always had a crush on her, and maybe to alleviate some of that tension, she'd tease me about it, almost her way of setting a boundary by making sure it was out in the open, telling me I was too young for her, but I'd be a shoein if I were just a few years older. She seemed like an adult even before she turned eighteen. Her parents would let her drink wine with them at the dinner table and she would travel out of the state for weekend trips with her friends. I should have felt like a complete dork around her, but she made it easy to feel comfortable, unashamed.

Moving into the spare room in the Schwerins' basement, I knew I'd have to put my feelings for Alexis behind me. Nothing was going to happen, I told myself; I was a high school nothing and she was headed to college. I'd accepted that, and it was time to be moving on. I got settled into my new living quarters. They told me that I should feel free to move things around to make myself at home, but I didn't want to disturb anything. I learned

quickly that no matter how nice the parents were, the best thing to do when living with another family, be it for a day or longer, was to not draw unnecessary attention to yourself.

Using a phone card she'd sent me, I talked to my mom on the phone a few times during that first year on my own, quick check-ins just to say I was doing fine, school was fine, and everything was fine. By the time I'd turn eighteen, we'd completely stop talking and wouldn't speak for the next five years, but while I was still technically a child, we kept some contact either out of necessity or because we held out hope our relationship would heal. And while that contact was limited, I don't remember much else of what we talked about during the first, second, or last conversation, but I remember the third one, a call right after the Schwerins and I had sat down to eat.

The talk lasted about five minutes and toward the end she asked matter-of-factly, "Did you know your grandfather died a few years ago? Can you believe he didn't leave you any money? Figures."

I had not, in fact, known about my dad's father's death. That was the first anybody had told me of it, and the coldness of my mother's words hardly registered since the news put me in a daze. I don't remember saying good-bye, only that I kept the phone to my ear for a minute after she had hung up, trying to collect myself.

I walked into the dining room, asked to be excused from Mr. Schwerin's Saturday morning birthday brunch of pancakes and eggs that I had helped cook, and went to "my" room. I needed to be by myself, and the guest bedroom in the basement was all mine. It was my own little sanctuary that I shared with a bunch of objects the Schwerins didn't want but that they didn't want to throw away, either. Not wanting to be nosy, I never poked

my head into the cardboard boxes with "Halloween stuff," "toys," "Grandma," and "1987" scrawled on them in black marker, but I was sometimes curious about what these things were that they just couldn't part with, even if they were stored out of sight.

I didn't like it, but I was good at being alone and didn't mind the hums and cracks from the various machines and pipes that made the house run. It was always cold, there were no windows, and the walls had been painted green. It was a place to sleep and that was all I needed. I had my clothes in a puffy, sticker-covered dresser that used to belong to James, and two white Ralph Lauren towels that had been allotted to me, which I'd hung on the hook behind the door. There was a stack of a few paperbacks that I'd picked up from a thrift store, and a sterling silver Saint Michael shield on a chain I'd found on the sidewalk—a necklace that meant good luck to somebody who believed in that sort of thing, patron of grocers, mariners, paratroopers, police, and sickness.

I didn't know what I felt or believed in anymore. I'd been contemplating giving up around the time Alexis found me in the diner; giving up on school, giving up and running away for good, just saying fuck it to everything, maybe going out west or working on a farm. Living with the Schwerins gave me some sort of hope that I could still connect with people despite how alone I felt. I thought there may be a slight chance that things would get better.

But at that moment, as I tried to fathom that my grandfather— the one who had seemed like my only ally during the years of fighting between my parents—was gone, the reality of everything collided with my guts. I looked at the boxes; all this junk had a home—why didn't I? What did I do so wrong that I was down here in a windowless basement? Why didn't I have anybody to talk to? Why didn't I get to say good-bye to my grandfather?

I stopped crying, but I didn't have the energy to get up and splash cold water on my face. I was stunned. The last time I had seen my grandpa was as he was leaving the courtroom with my dad; he'd looked great, so alive. That's how he had stayed in my mind from that moment on. Then he was just gone—a couple of words, and he was dead. Of course it had been "a few years" according to my mother. But not for me.

The green walls were making me nauseated. I had to take a walk, a nice aimless walk.

As I got up to leave, there was a knock at the door. It was Alexis.

There was silence for a long second as we stood there facing each other. It was obvious that I'd been crying, but neither of us wanted to acknowledge it.

She smiled at me.

"You going somewhere? Mom and Dad were wondering why you weren't eating with us."

"I was going to take a really long walk to nowhere special," I tried to say with a smile, but sniffled instead.

"How about we go for a ride instead?" She had her car keys in her hand.

I had this theory that if you lived in the suburbs long enough they have to give you a Volvo station wagon, the way they give you a watch after you've been with a company for five years. I'd walk outside of school and there'd just be a row of them, all of them waiting to pick up somebody. The 200 models, ubiquitous in the suburbs from the Carter administration to the first Bush presidency, were hand-me-downs by Bill Clinton's; my own first car was a white one with a little rust above each of the tires, but otherwise pretty dent and scratch free. You could load up these cars to take them camping, and as I experienced a few times, they

were perfect for sleeping in. People complained about the seats, that they were too stiff ("Too Scandinavian," Bob would say with a laugh every time he got in to drive his) and there was always one spouse who hoped they could convince the other to trade in and up for something better, shinier, less utilitarian.

When the kids got old enough, they inherited one, like the one Alexis had; she called it Cookie Monster because it was blue. It was the same year as the one my family used to have when I was a kid. Alexis and I drove past the baseball diamonds and hockey rinks of my youth, past the cemetery where my grandma was buried and where my grandfather had no doubt joined her, and into Rogers Park, my family's old neighborhood since everybody had moved south, with my mom being the last to join. The swimming pool was full of kids, their parents soaking up the summer sun and their grandparents playing mahjong or complaining about somebody who wasn't there. It wasn't too hot, perfect since the air conditioning in her car didn't work. My grandparents had lived in Rogers Park for decades; my mom and dad had met in the convenience store just over the bridge that was right between the family condo and my father's factory, and I knew the area around there well. It's the closest to a true hometown as I could get, but as Alexis and I drove past, I couldn't conjure up any memories. There were no relevant spots where anything happened to me: no tree that I had my first kiss under, and no secret spot where my friends and I rode our bikes to; it was just another place where I'd once lived, another place I passed through.

"Why are we going into the city?" I asked Alexis as we hit Sheridan, and the familiar smell of the lake. She revved the engine and passed two cars.

"I'm getting an abortion," she told me without taking her eyes off the road, like it was no big deal. I looked out the window as

we passed a McDonald's I went to a birthday party at when I was a little kid. I thought about how one of the parents made me take a time-out under the monkey bars made from the shape of the Hamburglar because I wouldn't stop hitting the other kids. A bunch of leaves blew up from the ground and swirled around, and I thought how normally those early signs of autumn would make me happy, but now was not the time. I had to be an adult and say something.

"It's your body and your decision," I told her in a rushed way that sounded as if I had been practicing saying that to somebody for weeks, and was a little too excited to finally have the chance to display how evolved and empathetic I was.

"That's so kind of you," she said, letting out a little laugh, obviously amused by the line. "I've got college, and my dad . . ." She trailed off as "The Freshmen" by the Verve Pipe came on the radio.

"This song is such stupid bullshit," she said as she turned it up. I didn't know if I should agree or ask why she didn't change it, but I was sure that I didn't want to hear a slow, sad song about people swallowing pills and dying. It wasn't that it offended my teenage punker-than-thou music tastes—I kept a cassette with songs dubbed from the radio, a secret stash of alternative rock that I was too embarrassed to admit I liked, at the bottom of my backpack that went everywhere with me—but there was something about this song that just made me angry. She and I both felt the same way, but neither of us touched the dial. We rode silently and "The Freshmen" bled into "Interstate Love Song" by Stone Temple Pilots as we pulled up to the clinic. Alexis turned the radio off but didn't kill the engine.

"Looks like the other Christians took the day off," she said, pointing at the one old lady sitting in a lawn chair with a sign

that said "That fetus is your baby!" in big red letters. "That's disappointing," Alexis said dryly. I liked her sense of humor. She'd say something, pause, and then she'd grin as if to let you know it was a joke just in case you weren't sure. This time she just stared ahead.

It was quiet save for the engine still running. I couldn't take any more silence, so I asked her if she was sure that she wanted to go through with it. And if she did, she was eighteen now so it could be our secret.

She just laughed. My thoughtlessness didn't deserve an answer, and I realized that right away. It was another moment where I made myself feel foolish around Alexis because I tried so hard to do what I thought was the right thing.

"I have to tell my parents," she said in a way that made me feel as though even suggesting anything otherwise was basically criminal. "We just have this weird honesty thing, and I don't think I could look at Dad and not feel bad. They gave me this big check last week for when I go to school, just out of nowhere. He told me how proud he was to have me as a daughter, and then I go and use some of the money for this."

She sat almost totally still, her posture perfect as always. I was in totally foreign territory—going to an actual abortion clinic felt almost risqué to me since teachers made it seem like this big mark on your life if you had one—but mostly I was stunned by the things she said about her parents because I couldn't relate to any of it. I'd never felt as though I could tell my parents anything, and my mother giving me a large sum of money was highly unlikely, seeing as she was supposed to deposit part of my father's child support check into my bank account so I had a little money, but she often forgot, usually for months at a time.

At that moment, as Alexis turned off the engine, I wasn't there

for her in my head; I was too busy committing the sin of envy. I was wishing I'd had what she had with her mom and dad.

Inside the clinic, the security guard barely glanced at us as we signed her name onto the sheet attached to a clipboard that was attached to a chain that was attached to the desk.

She pulled me close to her. "Can you act like you're the father?" she whispered in my ear as we walked up to the window to give the lady all her information.

I felt a sharp sickness hit the middle of my stomach, with a voice inside my head saying, *No, that's too far.* Even though I had no problem lying to people about how some relative died so I needed a place to stay while my parents sorted things out, the thought of being the fake dad made me uncomfortable. I didn't have any reservations about Alexis terminating the pregnancy. She had a whole life in front of her that a baby could derail; I'd paid enough attention in health class to know that since they hammered home how hard life was for a teenage mother on posters, pamphlets, and in videos they'd show you. But I did feel a little strange being in an abortion clinic, clandestinely accompanying a girl whose family had taken me into their home, fed me without asking for anything in return, and trusted me not to be a crazy person. Now I felt as if I was betraying that trust just by being an accomplice. But I had to do it for Alexis.

"Sure," I said.

Alexis put her arms around my waist and kissed me on the cheek for longer than a peck.

Ten minutes later the door shut behind her. Up until that point, I had never really thought about what actually took place when a woman had an abortion, how it worked, and what happened afterward. Would she be doped up? Would she be in pain? I realized as the fake father, I had absolutely no clue what was going to happen

next. I looked around the room at the other guys, and the worried woman next to a girl I assumed was her teenage daughter. They sat in complete silence, as if they were in totally different rooms. Or on totally different planets. The mother sat upright and was visibly upset; the younger girl seemingly embarrassed to be seen with the older woman. A guy wearing an outdated basketball jersey for a player who'd been traded to another team years earlier with no undershirt stared pensively down at the floor, his face in his hands. He looked like he was praying. Another man sat across from me with his arm up on the back of the seat next to him, legs crossed, and a slight slouch. He looked like he'd been to the races before, as if he knew what was up. He caught me staring for a split second, and gave me a slight nod, almost as if to say, "We're all in this together," even though I had no idea what this was exactly. Just a few hours earlier I was trying to compete with boxes of junk for existential stability, and now I was sitting in an abortion clinic, waiting for a girl I liked, maybe even loved, to finish terminating a pregnancy that I'd had nothing to do with. Bored and contemplating whether I should ask the security guard if I could look at his beat-up copy of the *Sun-Times,* I tried to figure out what I could do other than stare at the other people in the waiting room. I was surprised when Alexis came out the same door she had walked through just a few moments earlier.

"I couldn't do it," she said.

We left without saying a word to each other or anybody else, out into the parking lot where the lone protestor couldn't be bothered to peel her eyes away from her Bible passage. The skies had gone from the sunny of when we'd arrived at the clinic to the more regionally common gray and overcast. It seemed fitting for the moment, but Alexis was in better spirits than I thought, making conversation as we walked toward her car.

"Have you ever read *Journey to the End of the Night*?" she asked.

"Wasn't the guy who wrote that book an anti-Semite?" I asked.

"There have been some brilliant anti-Semites over time, I'm sorry to say."

I didn't disagree, not because I didn't want to, but because I wasn't sure where this conversation was going. I wasn't exactly looking for book club selections, more for answers as to what had made her change her mind.

"Remind me later and I'll loan you the copy I found at the library sale," she told me. Years later I'd read the book, searching for some hidden meaning behind her bringing it up at such a strange time, and I concluded that she was just trying to make conversation.

She turned the radio back on and started searching for a station. She settled on one that was playing the end of a Nirvana song, but quickly turned into "The Freshmen" again. And just like the last time, it stayed on.

"I have to tell my parents about this," she spit out as she pulled the car into a grocery store parking lot and began to cry. I sat there totally frozen, not sure if I should try to hug her or just sit there in silence. I wanted to say I felt like crying and tell her what I'd found out earlier in the day, how I'd put aside the news that my grandpa had passed away, but now everything was rushing back. I wanted to tell her I understood she felt shitty, and that I felt shitty also, but I didn't.

"My dad always says you're like part of the family. We could just say it was a stupid mistake or something."

I could have acted like I didn't know what she was getting at, and I probably should have played dumb, maybe laughed at her to diffuse the entire idea. But her saying I was part of the family made me feel it was my duty to go through with her proposal that

I knew was ill-advised. All I wanted to understand was why she couldn't just tell her dad exactly what had happened, and why it was any different with one guy or another. Why couldn't she just be honest with her parents?

"You can only be *so* honest. I know they're going to be disappointed no matter what," she said as she cracked the window to get a little air flowing in the car. "I just don't want them to be that disappointed. They'll understand if I tell them it's yours."

All I really remember next is the solid oak dinner table. I remember looking down at it, and imagining the patterns in the wood as shapes like clouds in the sky. I recall tears, Alexis trying to explain, and moments where nothing was said. Underneath the table I twirled a bit of fabric off the pair of green corduroy pants that I'd cut into shorts.

I know I didn't say that much, only "yes" or "no" when somebody asked me a question. When Alexis's dad told me how disappointed he was the first time, I nodded; the second time, and then the third time, he told me that, I did the same.

James came into the kitchen midway into the conversation to get a snack from the cabinet. We knew there was no way he didn't know what we'd been talking about, and his mom acknowledged that by asking, "James, honey, you OK?"

He looked at me with pure scorn on his face, and answered that he was fine. I was wishing the entire time I could draw up some tears, to look sympathetic for what had happened. I couldn't, because it was all a lie, but the look James gave me almost got me there.

"We'll take care of this tomorrow" was the last thing Alexis's father said as he rose to go upstairs. Her mother sat there and said nothing, her eyes full of tears. She got up, hugged her daughter, whispered that she loved her and that she shouldn't worry, and

went upstairs, too. It was a display of parental love that felt so foreign to me.

After her mom went upstairs, it was just the two of us sitting there. Alexis put her hand on mine and thanked me.

I just smiled. It's strange, but I needed her, the one who had to come clean with her parents, to tell me that everything was going to be fine—even though I could tell it wouldn't be.

The next morning, I walked out of the Schwerins' house with my bags. James nodded at me, but had that same look of disappointment pasted on his face, his eyes saying to me, "You horrible asshole. I can't believe you'd do this to me and my family."

Oh, the familiarity of the whole scene, I thought as I walked down the path from their front door to my next destination, realizing it had gotten colder out and all I had was a thin denim jacket. The Wandering Jew was on the road again. At least Mr. Schwerin let me have a few days to figure out a new arrangement. He gave me that, even though he didn't tell me himself. Instead, he had the daughter he thought I'd impregnated deliver the message. But I didn't take them up on it. It was time to go.

MORE THAN EIGHT years after I walked out their door, James found me online. At first he just added me as a friend on social media without sending a message, but then a week later I got a message starting with "You've been owed an apology for a long time," with "Dad passed away a few years ago" sticking out somewhere in the middle. I'd known, but never reached out. I wasn't sure I should.

Alexis had told the family the truth about the whole thing, about the baby she didn't end up having, how I was just trying to be a friend and went along with her bad idea. She had, in fact, told them a few days after I left, but they didn't know how to find me.

"My father always regretted asking you to leave. I think he was just too embarrassed to reach out to you," James said. "Next time you're in the neighborhood you should come by for dinner. I think Dad would have liked that."

I found myself back in Chicago a year later, reunited with the Schwerins for the first time in a decade. I sat next to Alexis and held her newborn son. She had finished college, and was now a full-time mom. She looked exactly as I remembered, still the same person, just with longer hair. James and I talked about the changes on offense the Bears would have to make to look more competitive, and Mrs. Schwerin smiled and hugged me tightly every chance she got. On the mantle, next to the pictures of both kids in their graduation caps and gowns, photos of old dogs, black-and-white photos of grandparents and other various family members, sat a framed picture of the entire family with me at the dinner table. They had put it up when I was living there, and James swore it had never been taken down.

Before I left, James handed me an envelope with my name on it. I took it, shook his hand like an adult instead of the high-fives we'd given each other as kids, and walked to my rental car.

I went back to my hotel where it was just the letter and me.

"Dear Jason. Greetings from the hospice by the lake," it started out. The white piece of paper had no lines, but I noticed how perfect his penmanship was, almost like he'd written each sentence with a ruler underneath. Each letter and word looked lined up perfectly with the next. I kept reading. There was some talk about baseball and some minor observations, and then it went on to say, "I have carried with me for years this truly great sadness within my heart." I paused my reading for a moment to collect myself. "I don't think I could have ever been a friend to somebody the way you were to my daughter. I couldn't see it then, but I do know

now that I was deeply wrong, about you and about asking you to leave. I know you didn't have it easy for a while there."

I finished reading the letter that ended with him saying he hoped I had found peace and I could forgive him. I folded the letter back up in the perfectly even way it had been delivered to me, pressing down on the creases he'd made, and put it into a notebook. I wished that I could write him a reply saying that he didn't need my forgiveness in the first place. He was a great father to his kids and I could never blame him for that. But as I sat there, twenty-something and totally aimless, I started to think about myself and what a disappointment I was instead of mourning, all alone at the Heart O' Chicago motel on a stiff mattress in a room that reeked of chlorine.

I'd stayed at that hotel before when I had nowhere else to go, but that was before I could look up its Yelp profile filled with less-than-stellar reviews. Users noted detractors such as "It can be a bit noisy. Especially if you're not used to city noise," or "The continental breakfast consists of donuts and some very weak coffee," and "The furnishings are outdated." But the Heart O' Chicago also had its perks, with one user pointing out that "It's kitschy and fun," while another can't not mention that "My favorite gay bars are located in Rogers Park (Touche & Jackhammer), so when I come to Chicago, I like to stay somewhere within stumbling distance to my favorite raunchy leather bars: Heart O' Chicago fills the bill."

Early the next morning, I'd be on a train back to New York City. I'd lived in Brooklyn for a little while, and I said to myself that I should try to feel like a champion—it was all coming full circle with Bob's apology and me living in the big city—that I was going to be fine. Yet everything I needed was still missing, my fantasy life having been abandoned a long time before. Nothing

had turned out the way I had planned. The sun slowly gave way to the darkness outside my window. How many more times could I tell myself there'd be a happy ending?

Not ready to do a full life reassessment, I turned on the television and flipped around until I landed on a channel with my old friend Ferris Bueller. He was just about to tell me how life moves pretty fast and how you might miss it if you don't stop and look around for a while.

It had been a few years since I'd last seen this movie I loved so much, and in that time I'd seen that quote on everything from motivational posters juxtaposed with pictures of guys running up mountains, to a T-shirt at a carnival you could win if you got three of your five Ping-Pong balls to land in the glasses of water with fish swimming in them. Then, in my jaded twenties, I'd normally scoff at such a sentiment, brushing it off as the pseudo feel-good wisdom of my parents' generation. But if there was ever a moment when I needed a friend to again give me the advice I'd ignored countless times before, it was then, sitting in that cheap motel room by myself.

Life, for my first few years in New York, was largely lived in bars. Everything else was my job I didn't like which I did to make money while I wasn't trying to write.

There was Enid's on the border of Williamsburg, and Kingsland Tavern deep down on Nassau Avenue, both in Greenpoint. The former was a newer spot with pinball and good-looking, young bartenders with perfect hair who hardly cared to talk to you; the latter was an old-school haunt inhabited by a mix of local Polish and Italian residents and metalheads, with an old Art Deco bar and also a bartender who also hardly cared to talk to you. In the city I had Odessa with its weird country-western theme and a diner next door serving pierogis 24-7, and if that was too crowded, then I'd go across the street to Niagara with its Joe Strummer mural outside and weird mix of East Village yuppies and crust punks who drank for free because they knew

the staff. I went to those bars on a weekly basis. I liked the music, I liked the prices, and I really liked the people, both the ones I knew and the ones I didn't. I enjoyed the conversations I had, and the ones I could eavesdrop on, saw people from bands I liked and writers whose faces I recognized from profiles in magazines I wanted to write for. I liked to go to those bars with company, or just sit alone, feeling like an adult with my Jameson neat that I'd sip slowly to make it look as if I was truly savoring life, when I was in fact trying my best to stretch out my dollars.

They were all good spots, but one bar in particular—Royal Oak, with its handsome oxblood banquets and wallpaper that looked as if it had been stripped off the inside of a Parisian brothel from the 1920s—was the one where I spent the most money during that time. I'd park myself at the bar and make friends for life with total strangers whose names I'd forget by the time the sun came up. I had these fleeting ideas that maybe one day there'd be something written about the history of Brooklyn in the immediate years after 9/11, and somewhere my name would appear in a footnote about that writer who used to hang out there before he had some success (but was ultimately more influential than profitable).

I had a good run at Royal Oak, joking it was my Cheers, but eventually, like all good things in New York City, it changed. The situation started going downhill there a few months into 2005. It had once bred fun times: drinking with strangers who had big paychecks to blow on drinks for people they didn't know, dancing to songs you shouldn't be able to dance to, like Danzig's "Mother," at three in the morning with a bunch of bike punks, models, and various other New Yorkers you never see when the sun is up. Soon, people who had jobs on Wall Street or in law firms started showing up in cabs, ordering Red Bulls and vodkas,

and making the people who had been going there for years feel as if they were in some nightmare scenario where they were drinking alongside their childhood bullies in a place that had once felt safe. It felt as though the jerks were taking over the clubhouse. I kept telling myself that eventually they'd move on and find another bar, but on a night that was technically deep spring, but still felt like winter, I knew the bar and I were breaking up.

"Last night I dreamt I went to the Royal Oak again, and it wasn't filled with douchebags," I joked with the bartender who I knew well enough to guess he'd catch the reference to Daphne du Maurier's *Rebecca*, or at least Hitchcock's movie version, and totally get it. We'd talked about books and movies when he had downtime and the bar wasn't packed. I knew he was from Kansas, bored with Brooklyn, and was considering moving out to Los Angeles to try to break into the film business, he just didn't know in what area. "I think I'm good-looking enough to be an actor, but I'd settle for being a writer," he told me once, like we were pals. But now I only got a smile that felt forced. He walked to the other end of the bar and slowly began washing the same pint glass until he could find somebody else to talk with. I could feel my beer getting warm as I sat there waiting for my company.

I finished my second pint just as Michael finally showed up, late as usual. We'd been friends for a few months at that point, bonding over free drinks we normally couldn't afford at a fancy new cocktail bar during a holiday party for the coffee shop we both worked at. He was tall and handsome. He looked and dressed like a Blaine from *Pretty in Pink* or a Jake Ryan from *Sixteen Candles*, but thought and acted like the give-no-fuck types I'd always been drawn to as friends. Michael wrote, but I wasn't sure if he wanted to be a writer or not, because when you're under twenty-five and living in New York, it's really difficult to commit to anything, be

it a job, a relationship, or an apartment. He talked about going back to school to become a historian, but wasn't sure that was what he wanted, either. Instead, we both worked at a failing patisserie for a woman who we'd only see when she came by to take money out of the register to use to buy drugs. It wasn't a long-term plan but neither of us could figure out what we wanted to do and we bonded over that. There's something reassuring about feeling like you're going nowhere in New York City with a friend who feels the same way—at least you're going nowhere together.

"Want to go sit in the cocaine nook?" I asked Michael as he looked around the bar and shook his head, no doubt as put off as I was by the number of guys wearing tucked-in polo shirts and talked of stocks.

The area we dubbed the "cocaine nook" was a little room in the hallway between the main bar and the room where the DJ usually set up. By ten or eleven, it would be filled with good-looking people who helped this little hole-in-the-wall live up to its name. They took advantage of the tucked-away setting and blind eyes from the bartenders who knew that it was handy to have that stuff around. But before that, from happy hour until the party crowds showed up, it was the quietest place to sit and talk, and you didn't even need to do drugs.

"So I think I'm going to start writing about the suburbs," I said as I pushed a little plastic baggie that had been left on the leather seat from the night before onto the floor.

Michael looked mildly interested.

"Like John Cheever?"

Not like that, I told him. Something weirder that I'd started working on a long time ago, some stories that I'd written when I was a teen. I was thinking of revisiting them.

"I bought some movie scripts from that guy who sells them

from out of that old bus he parks near NYU. You know him? I bought *The Breakfast Club, Ferris Bueller's Day Off,* and *Adventures in Babysitting.*"

"All John Hughes movies," Michael said.

I corrected him as I stood up to get another round. "No. He didn't have anything to do with *Adventures in Babysitting.* People tend to think he did because it's about teens in the Chicago suburbs and the soundtrack sounds like songs he'd pick."

I came back with beer and shots that the bartender had given me as a buyback and told Michael how readers had started following my blog a little more. It was a stupid little nothing that I'd started out of boredom, but I had a handful of readers and that, to me, was something. My post that broke down the design of Ferris Bueller's bedroom, with the big British flag and posters of post-punk and industrial bands like Cabaret Voltaire and Killing Joke, had started a lively conversation in the comment section among six different people, while my piece trying to make the case for 1991's *Curly Sue* not being as horrible of a film as people made it out to be didn't do too hot. I focused a lot on Hughes and other teen movies from the 1980s and even some from the '90s, but I really took an interest in talking about the suburbs that spawned so many of those films. I'd been going to the library and checking out any books I could find on the subject, reading about the history of the American suburb, and trying to write some grand post about how the movies Hughes made ended up being the last days when we thought the suburbs were great. Because when I really thought about it, a lot of the best movies that came out after Hughes had his main run, which ended in the early 1990s, featured characters who would have also been in high school around the same time as John Bender and Andie Walsh, but they were in the big cities and not the suburbs I was familiar with. Those kids

moved away, they left their hometowns and ended up in college towns, or in places like Seattle or San Francisco.

There weren't really that many more good suburban stories after Hughes; you couldn't have set *Singles* or *Reality Bites* among the McMansions along Lake Michigan, they just wouldn't have worked. I wanted to explore why that was through a pop culture lens—what was so bad and weird and suffocating about the suburbs. But I thought it would take more than a blog post. Maybe I'd write a book about it, I said to Michael. He was drunk by that point. It took him a second to compose an answer.

"Why don't you just write a book about John Hughes?" he asked. "You know everything about his movies, and your blog is called 'Holiday Roads.' You've got a blog named after a song from a movie he directed. I hear about all these people selling books because of their blogs. Be the John Hughes guy."

"He wrote *National Lampoon's Vacation*. He didn't direct it. I doubt he would have asked Lindsey Buckingham to be involved if he had," I said, referring to the song that introduces us to the Griswolds, which is basically just the Fleetwood Mac member singing "holiday road" over and over.

"Whatever. The point is, I've never seen a book on John Hughes. Maybe you could write a book of criticism or something like his biography."

"A *biography*," I snorted. "I want to write stories; I want to write *literature*." I threw back the last of my whiskey in an exaggerated motion. It didn't dawn on me then that I was the worst person in that bar for that minute.

"A biography *is* writing. You research a bunch of stuff and basically transcribe what you've researched into your words."

Like I said, when you're twenty-three and living in New York, it's hard to commit to anything. You want to be creative,

but you also really want to drink and have sex. You'll do whatever work is necessary to pay the rent, but you just want things to just happen, and it didn't sound as though much really happened by spending your time on a biography. I wanted to write and be a hotshot who got invited to parties in incredible Upper East Side apartments with people who take off their glasses, hold them in their hands, and wave them around like a wand while they say really heavy things about the world, and eventually I wanted people to throw those parties for me and my books. A biography just didn't sound as sexy when you're twenty-three and you think you're sexy, or you at least want people to think you are. Of course, you do and think a lot of stupid things when you're twenty-three, so this train of thought was completely invalid and silly of me; that's obvious now, but didn't even cross my mind at that very second.

As I stood up to leave, I realized how drunk I'd gotten in the cocaine nook. We were on our way to a party some girl we both knew was throwing in the loft apartment she lived in by the water. Her landlords had sold the building and told her she had until the end of the month to leave, so she'd sent an e-mail to her friends with the subject line "BURN THIS MOTHERFUCKER DOWN." We were going to buy beers and walk there, but first I wanted to go and look at all the people dancing to music I didn't really like in the room next door. I told Michael I felt as though I had nothing in common with the bar's clientele anymore, that it was just a bunch of guys with a lot of money who dressed in vintage shirts purchased at expensive boutiques but were really just poseurs, and I never wanted to come back.

"You sound like you're in high school," he said to me. "Who calls people poseurs when they're adults?" He laughed as he walked away to go outside and smoke.

I was going to follow him out the door, but a familiar song came on: "Holland, 1945" by Neutral Milk Hotel.

I stood there for a few seconds, watching all the happy people dance, gyrating and jumping around as though Jesus had possessed them at a Deep South tent revival.

"THIS SONG IS ABOUT ANNE FRANK, YOU MORONS," I tried yelling over the fuzzy and upbeat indie folk song. Nobody heard me since they were all too busy enjoying themselves.

"Fuck this place," I yelled as I walked out the door. "I'm never coming back."

MRS. DONOVAN WAS THE first person who told me I could be a writer if I really wanted to be. She taught me to truly *read* a book and not just see the words as parts of sentences, and the sentences as parts of a story that exists only for your entertainment. She looked over the short stories I wrote, giving me notes and advice, and I really think she saved my life.

"This isn't a video game or television," she told me a few weeks into our first class together, after I said I didn't enjoy reading a big book like *Great Expectations*.

"Whatever," I mumbled.

Mrs. Donovan had a reputation around school. Kids whispered about her and how she was a former nun, but now she lived alone in the woods because they kicked her out of the convent for a number of transgressions. They made fun of her long skirts and cardigans, the way she wore her glasses almost at the very edge of her nose, and how she was always trying to get people to read books. That, more than anything, was her greatest crime. Who wanted to read books when you could be making out in the dollar theater or getting high and playing

Mortal Kombat or pinball at the bowling alley, or just walking around the mall?

Yet when I looked at her, I couldn't help but notice how much she resembled Meryl Streep, just a few years older. I could look at her and see exactly how she might have looked when she was young. I thought that if we were kids at the same time, I probably would have had a crush on her. But then and there, inside the high school, she was a teacher, I was a student; I wasn't supposed to get along with her, that was common knowledge. Teachers were put on this planet specifically to make sure students didn't have fun. They were the worst kinds of adults because, unlike parents, somebody was paying them to hold us down.

Of all the adult jerks in Hughes's movie, there's one that stands out: Dick Vernon. In his cheap suit that John Bender points out looks as though it was taken out of Barry Manilow's wardrobe. He is possibly the greatest example of the divide that supposedly exists between students and their teachers. The evil vice principal in *The Breakfast Club* takes almost a serial killer's pleasure in torturing those kids, sometimes crossing the line into abuse. He hides his own failings and bitterness behind the guise of an educator who just wants what's best for his students, but you know he can't stand watching them walk out the door with their diploma, either going out to fail like he assumes Bender will, or succeed like any of the others could. They're all going somewhere, but not him. He might become principal one day, maybe get a raise, send one of his kids to college while another one is a complete failure, pay off the mortgage, and that would be about it. He'd never break through the cheap stucco ceiling of Shermer High School, and he loathes that fate. I imagine he couldn't kiss enough ass to make it to superintendent, so he's stuck in that role forever, like academic purgatory. That's why he's the überteacher:

Dick Vernon has pretty much gone as far as his life will take him, and he hates it. He knows it, the kids know it, and it's really easy for the viewer to spot. Of course, that isn't every educator; a lot of educators love what they do. Instead, Vernon is a symbol, the embodiment of not just the teacher, but the adult with a little bit of power that he abuses any chance he gets. He is the walking example of everything teens should hate. Unlike Edward R. Rooney, Dean of Students, who tries to follow Ferris Bueller and his gang around like a bumbling Inspector Clouseau, Vernon is mean to the core. He's hardened from years of hating his job more with each new crop of snotty freshmen.

I went into high school with an "Us vs. Them" mentality because of what I'd learned from *The Breakfast Club* and *Ferris Bueller,* that it was the kids against the teachers at all times. Yet deep down I really liked Mrs. Donovan. I knew I couldn't show it because that went against everything I knew to be true. It felt as though she was genuinely interested in teaching, and seemed passionate about books. Whereas other, more popular teachers would say, "You don't want to learn calculus? Fine by me. Good luck on the exam," Mrs. Donovan cared. She pulled me aside after class one day and pulled an old paperback from her desk drawer.

"Try this," she said as she handed me Franz Kafka's *The Trial.* "I think you'll connect with it."

"Oh, like Kafkaesque?" I asked.

She smiled and said, "Yes, like Kafkaesque."

After I finished that, we started to read *Jane Eyre* for class. I told Mrs. Donovan my thoughts on Jane's growth as a person, and she said that she would be curious to hear my thoughts on the author's sister's book, *Wuthering Heights,* and so I read that over winter vacation as the snow piled up outside. In the spring, I told her Falstaff in Shakespeare's *Henry V* was a great character, so she

gave me an old, beat-up paperback copy of John Kennedy Toole's *A Confederacy of Dunces,* and said I had to read *Don Quixote* after I finished that, but that it would be a much larger undertaking since it was more than eight hundred pages. Mrs. Donovan helped me find the reader inside of myself. One day, after months of trying to keep my living situation a secret, she took me aside in the hallway and asked me if I still liked reading.

"I do," I said.

She said that I probably didn't have much time to read anymore since I was so busy moving from place to place.

I went cold. I thought she was going to tell me the police were on the way to take me away to an orphanage—like from one of the books she'd given me.

"Jason," she said. "I have a guesthouse on my property. If you'd like." She paused. "You really should let people help you out."

I broke down crying. The last few nights had been spent trying to sleep on a cold basement floor. I'd been off my medication for months, approximately the same amount of time since I'd last talked to my mother. Communication with her just stopped. It felt as though I was at an end with no other options, so I said yes, I'd come stay in her guesthouse.

A week after she invited me into her house, I moved my duffel bag and small box of things into Mrs. Donovan's guesthouse, which was bigger than some apartments I'd seen. I realized I'd known her for almost four years but hardly knew anything about her life. I assumed there was some truth to the rumors about her, but it turned out she was not, in fact, a former nun, a lesbian, a crazy cat lady, or any of the other things kids guessed. She was a widow. Her husband Howard's picture hung in the hall in a wooden frame. It was one of the first things you saw after you made your way up her long driveway almost completely canopied

by trees and into the stately brick home that looked as if it could have housed a family and a couple of maids and cooks. He had passed away unexpectedly, a few months before I started my first class with her.

"The house actually used to have servants right after it was first built," Mrs. Donovan told me. "In the early twentieth century. When Howard's grandfather built this as a home away from the family's place in the city." After her kids grew up and moved out, and after Howard passed away, it was just her and a black Labrador named Scoop. The place was large and eerie, with some rooms that I imagined hadn't been visited much in years. As she told me the history, I joked that she was sort of like Miss Havisham in *Great Expectations,* alone in her big house. I was trying to lighten the mood, but it took me a split second to realize what a terrible thing that was to say, comparing her to the character Dickens said looked like "the witch of the place," but Mrs. Donovan just smiled and told me she'd thought that herself before, only there was no cake crawling with spiders anywhere on the premises—that she knew of. I could tell how much she loved and missed Howard whenever his name came up or she looked at something that reminded her of him, which was nearly everything in that house: the old grandfather clock that she said he used to hum along in harmony to when it chimed; the old leather chair in the living room, right next to the window that looked out at the front lawn, which she said was his favorite spot in the house; the fountain pen that she kept on the table where he used to do crossword puzzles, telling her he didn't need a pencil, confident he'd never have to erase his mistakes. They'd been married over thirty years when he passed away, but she said he was there with her all the time. She told me how she came from a "good family," and he came from old money that stretched back to the early nineteenth century. Lumber and

then law. "His father got this house and his uncle got the one that looks almost exactly like it up in Michigan," she told me.

I couldn't imagine such a thing: a house that's part of the family and their story, something that Mrs. Donovan would one day pass down to one of her kids who, even though they had their lives in big cities, she knew would come home one day. A place that felt permanent, where the residents knew the whole history of what happened under that roof.

And there was a lot of history in the house, according to Mrs. Donovan. Mayors and two governors visited, and F. Scott Fitzgerald had supposedly stayed nearby when the house was still young.

"Fitzgerald had a girlfriend who lived near here," my new landlord told me with a smile as she looked around the house she'd lived in for decades, seeming as if she was still in awe of the history contained within it. "She was his first love."

The politicians I could care less about, but knowing my favorite writer may have stood exactly where I was thrilled me and made me feel part of some larger narrative. We had read *The Great Gatsby* during freshman year, and I was mesmerized by it. I pictured East Egg looking something like the North Shore of Chicago, with big fancy mansions along the water. Fitzgerald was the first writer I became obsessed with, thanks to Mrs. Donovan and her devotion to his work. She made me want to seek out everything he'd written and find more, his other novels, the "Gatsby cluster" of short stories that helped form his most well-known book. I consumed all of it, much like I had with John Hughes films. Fitzgerald's most important characters all seem to be chasing something they know they could never attain, but they did it with such style.

In some ways *The Great Gatsby* reminded me of *Pretty in Pink*,

with the poor girl who is head over heels into the rich boy, and James Spader's Steff working as the spoiled jerk stand-in for Tom Buchanan, who, in the book, is said to have bought "a string of polo ponies" from Lake Forest and had moved from Chicago to New York thanks to his family's vast fortune. Tom became instantly recognizable to me. I'd known and despised plenty of Steffs and Tom Buchanans in my own world.

It came as a shock to me when I picked up *This Side of Paradise* for the first time and realized the last name of the book's protagonist, Amory Blaine, was also the first name of Andie's love interest in *Pretty in Pink,* though spelled differently. Hughes was from my neck of the woods, and so was this girl Fitzgerald was so in love with, whose name I learned was Ginevra King. On a visit to Chicago to see King, her father supposedly told Fitzgerald, "Poor boys shouldn't think of marrying rich girls," a quote that the writer put in his journal and was uttered in the 1974 film adaptation of *Gatsby*. I could easily imagine hearing the same words in a Hughes movie. Maybe from Steff or one of Jake Ryan's friends, or from Molly Ringwald's Claire in *The Breakfast Club*. I spent hours in Mrs. Donovan's old study that had been unoccupied for years just reading and thinking about all of these things. It was the first time I could remember being able to do that, no yelling, no stress, and no worry about where I was going to stay next.

I never came in too late, but if I was out past midnight, I found somewhere else to stay so as not to disturb my host. I never did anything illegal on her property, finished all my schoolwork, and spent most of my free time reading with a little FM radio playing on low volume next to me. Instead of the stuff I normally listened to, like the Ramones or the Slits, I let the little radio hum out old electric blues that you could usually find on the lower end of the dial, a staple of nearly every Chicagoan's musical diet. If not that,

then I'd put on a classical station. At some point I began writing down my ideas about what I was reading in a notebook. Other times I'd just put pen to paper and jot down my thoughts. There were bad attempts at poetry, the type of angst and ache only a teenager can churn out. But most of the time I'd write stories. I'd write them fast and wouldn't really look at them again. I never thought about asking anybody to read what I was putting down, but it felt good. Every little thought or feeling, I tried to find a way to write it out, sitting at the big oak desk that must have weighed three hundred pounds. Sometimes I'd read and then try to copy the style, something I'd read Hunter S. Thompson used to do when he was trying to learn to write. I tried to mimic some line from one of George Orwell's books, Dorothy Parker's humor, then James Baldwin's character dialogue, or something else I read that really stuck with me. That's how I became obsessed with writing: staying up until it was time for me to get ready to go to school, just scribbling away. Pen after pen, one sheet of paper after the next, and writing with reckless abandon because I had nothing else to do.

It was the one thing I had that really felt as if it was mine. But eventually it started to feel as lonely as everything else. I loved to write, but I longed to feel as though I was interacting with people. Inspired by a handful of self-produced zines I'd been picking up at punk shows, I decided to make my own little version; I did the layouts myself, cutting and pasting words and images, then printing them up at a friend's house or in the school. They were filled with short, blabbering personal essays, reviews of shows I'd seen, and even some short fiction. I never printed that many of each issue since I knew none of it was any good and free paper and ink was limited. I didn't sign anything with my name or address. I'd leave them inside the pages of magazines at the drugstore,

on train seats when I'd go into the city, or on tables when I'd go to see bands play. I'd discreetly drop them there and walk away, finding a spot where I could watch people pick up my work, leaf through it, and either put it back down or take it with them. Witnessing somebody read something I'd made, then take with them, was like a high. It was the best feeling in the world.

I had a couple of copies of my latest work with me that I'd planned to debut at a show featuring a hardcore band that sang mostly in Spanish. The zines were tucked away in my backpack in the trunk of my friend's car when he decided we should get stoned and then pick up a bunch of junk food before we hit the highway.

"OK. Just don't let me forget to grab the zines," I said, knowing I had a tendency to forget things when I got high.

The pot was much better than the cheap stuff I bought from a kid at my school who kept a few extra baggies in his Hacky Sack and it didn't take long before I was completely blazed. The weed wasn't the resin scrapings or the skunk crap that you usually got from the locker room dealers, so everything felt great as we walked into the Dominick's grocery store, all red-eyed and slow even though I was sure everyone was staring at us, and they probably were. Me with my messy and dyed black spiked hair, a vintage pink Lacoste polo that I'd bought for fifty cents at the thrift store, my tight, ripped jeans, and a pair of black Chuck Taylors that had seen better days. My friends had piercings in their lips and noses, spiky hair, and all the things that got you unwanted attention, but we felt OK to go our separate ways. I drifted toward the chip aisle, finding a bag of Cheetos that I tore open and started to eat as I walked. I meandered down to the next aisle, filled with colorful boxes of cereal packed with sugar. I stopped and stared at all the cartoon characters on the boxes, eating my Cheetos and thinking about how one day I wanted to

have kids and that I'd never let them eat Frosted Flakes or Lucky Charms.

A man holding a shopping basket walked past me, looking at the selection to my left, which was the healthier stuff without marshmallows or chocolate coating. I got a good look at his face, and he looked familiar to me; I knew him from somewhere, but was too stoned to remember where. I kept trying to figure it out, but as soon as he noticed I was looking at him for what must have been a minute, he smiled nervously, nodded at me, and walked away. One of my friends ran up behind me.

"Dude, did you get that director guy to put you in one of his movies?" he asked as he walked toward me carrying two bags of Snickers Minis and a liter of Mountain Dew.

"Huh?" I had no clue what he was talking about.

"That was the *Ferris Bueller* guy, John Hughes. He lives around here," my friend said as he stuffed two little candy bars into his mouth. He grinned at me with the chocolate and peanuts in his teeth like a stupid child.

The half-eaten bag of Cheetos fell to the floor. I stood there, my fingers stained with cheese-flavored dust trying to process what my friend had just told me.

"*That* was John Hughes? Here in the grocery store?" I could feel myself shaking. "Why the fuck didn't you tell me?"

My friend said he was pretty sure it'd been Hughes. He lived right up the road and my friend had seen him in the store once or twice before.

"How was I supposed to know you were right next to him?" he asked.

"What was he doing shopping for Wheaties?" I asked desperately. "Shouldn't he be making movies and sending his team of assistants to do that?"

"Heh, check it out," said my other friend, who was using a Twizzler as a straw in a can of Cherry Coke, as he pointed at all the boxes of cereal and oatmeal. "We're the Breakfast Club."

I forgot why I was upset for a second as we all started cracking up in unison at his stupid joke—the way only a group of teens who had just finished smoking pot out of an old Barq's root beer can could do.

Once the laughing stopped, we were on our way to the show, barreling down the Edens Expressway toward the South Side and the promise of a hot and smelly basement filled with kids joyously screaming and dancing along to blisteringly fast hardcore until the beer ran out or until the cops were called. But I wasn't having a good time. I fell into one of my funks and I thought about the newest zine I'd been working on, titled "Hey Suburbia," based loosely on people I knew and others I didn't. I'd been staying up every night, scribbling stories about businessmen in nice suits, riding the Metra trains back to the suburbs; or kids at parties I sometimes listened to while drinking whatever cheap beer was available with a lack of funds and a fake ID that only worked in the sketchiest convenience stores. I'd taken what I heard them saying, wrote it down in my notebook, and composed stories around their best quotes. I told myself that the stories had to somehow be connected, so I wrapped them all together, making the obnoxious philandering millionaire who split a six-pack with his buddy as their train sped back to their commuter town in the first story the dad of the sixteen-year-old who skateboards two miles in the rain to buy some drugs for a party he's supposed to go to but gets lost and eventually gives up and runs away by skateboarding to California. I'd laid out the whole thing using photos I'd taken of various landmarks and houses with an old Polaroid I'd bought at a thrift store. I'd photocopy the pictures

and then photocopy the first facsimiles to give the photos a distorted view. The other zines I'd hastily slapped together, but this one I spent a good deal of time on. I had this idea of driving up to John Hughes's house and putting one in his mailbox with a note that thanked him for being such a huge influence on me. I'd gotten the idea after finding a box of old *National Lampoon*s with Hughes's contributions from before the days he made movies.

Before I'd discovered those, I couldn't tell if I wanted to write with grace like Fitzgerald or Edith Wharton. Or if I wanted to do something raw and transgressive like William Burroughs or Kathy Acker, the writers I'd started reading around that time because I kept seeing their names mentioned by members of punk bands I liked. But when I tried to write like any of them, I failed; I couldn't find my own voice, but didn't realize it was because I was so intent on mimicking the voices of others. There was something about finding those things Hughes wrote for *Lampoon* that instantly clicked with me. I didn't always find everything he wrote for them to be that funny, but it was loose and it existed to make people laugh. It was humor writing that was irreverent and juvenile. It wasn't what I wanted to write, but it showed me I didn't have to strain myself to be so serious.

I wasn't quite sure if it had really been him standing a few feet away from me in that Dominick's grocery store. As far as I knew, he was just another stranger occupying the same space in a supermarket for a moment. But as I looked into my canvas backpack at the five copies of "Hey Suburbia" I'd brought along with me, I felt as though I'd missed my chance to hand deliver one to the man himself. I told myself that one day I'd have another opportunity to tell him how much his work meant to me.

All I could do was keep writing.

P ublished Author Dennis will teach you to be a
better writer," read the ad taped to a pole in the
East Village. Published Author Dennis looked
smug and content in his half-zip sweater, not so much
a professor trying to be cool as he was the guy who
annoys everybody at the bar while he nurses a beer
and sets himself up as the expert on any imaginable
topic. I'd passed the flyers countless times, laughed,
and wondered what kinds of people ripped off Pub-
lished Author Dennis's contact info at the bottom of
the paper.

I'd always hated Published Author Dennis and his
dumb face, but as I stared at that familiar flyer taped
to the wall in my work area, I had a flashing thought of
Mrs. Donovan. We'd lost contact after I moved away,
and I always told myself I'd write her and let her know
I was living in New York, writing and reading all the
time. Maybe I'd show up in her class one day as some

of her former students had done when I was in school, walking in slowly like a scene from a movie. She was so proud of all of them, and so happy that they visited. She'd introduce them to the class and they'd always say something about what a great teacher she was, and how we should pay attention to her.

But I never did. I realized I'd waited too long after seeing a post online from one of my former classmates saying that Mrs. Donovan had passed away a few days earlier; it hadn't really sunk in that I'd missed another opportunity to say good-bye to somebody important like I had my grandfather and Mr. Schwerin. The post had said there was a memorial service, and for a second, I considered spending all my rent money to go, but I knew she would have shook her head for a second or two and said, "That's preposterous"—a phrase she was fond of. So instead, I spent a week quietly grieving.

How do you properly mourn somebody who changed your life? I wondered this over the course of a few days spent aimlessly walking around Lower Manhattan, living mostly off dollar slices of pizza. Before Mrs. Donovan had invited me into her home, I'd been messing up badly. I was doing whatever it took to stave off the depression that was always creeping up on me, drinking and smoking pot all the time, buying pills off other kids because I figured it could help calm me down when I just felt like curling up on a floor, hardly eating, and barely sleeping; I was a mess. I'd told myself that turning eighteen was the finish line, that if I made it past there, I was going to be fine. Yet the moment I moved into Mrs. Donovan's, I started to realize how close to the edge I was getting, and how somebody had grabbed me by my shirt collar and pulled me back onto solid ground. After two years of being a teenage nomad off my meds and going out of my mind, she gave me some sense of security and didn't ask for anything in

return. "Sometimes you have to ask for help," she'd said when she first proposed I come stay with her.

I looked at Published Author Dennis, pen in hand as if he were some great scribe, and that damn ugly sweater. I decided I'd ask him for help since I wasn't getting anywhere on my own. I went home and called his number and listened to him talk about how he'd teach me about process and how to find my own voice, and how lucky I was because usually his class was booked up months in advance, but he happened to have an opening starting that week.

"Oh my god, yes," I told him. "I will absolutely pay fifty dollars for a ninety-minute class. That seems totally reasonable. I appreciate you squeezing me into your very in-demand writing program." Two days later, I found myself sitting at an old green kitchen table with what appeared to be soy sauce stains all over it in Published Author Dennis's small and messy apartment in Hell's Kitchen. It was me and four other students, three of whom spoke little to no English, and another who had just finished serving a two-year stretch in prison and had started writing on the inside to pass the time. The apartment was musty, dark, and reeked of cat urine. I noticed he didn't have many books around, no computer, either. He had plenty of empty wine and whiskey bottles scattered about, so I guess he fulfilled the drunken aspect of the writerly stereotype.

"So what I'd like to do is have the two of you read the story I asked you to bring in, and if it goes past the allotted five minutes, then, believe me, I will let you know," he said. A cat jumped up on the counter and knocked over a few empty bottles. Two seconds later a banging came from below us, like somebody was hitting the downstairs ceiling. It was Published Author Dennis's neighbor.

"Don't mind her," Published Author Dennis said. "She's going to die soon."

The former convict laughed, the people who didn't speak much English bobbed their heads as if they'd gotten the joke, and I just sat there and tried to force a smile.

"And you guys just listen to these guys read," Published Author Dennis said to the three other students, two younger guys from Vietnam and an older lady from Poland, while pointing at me and the former convict whose neck tattoo looked like it was in 3-D because of all the pulsing veins it was inked over.

The former convict began to read his story. It was from the point-of-view of an inmate who snitched on somebody for selling drugs to other guys who were locked up. It was very matter-of-fact and ended with the inmate lying on the floor after some other prisoners beat him, regretting his bad decision to be a "bitch-ass narc," and realizing he's about to die.

"That was amazing," said Published Author Dennis, who never really mentioned what he had published, while urging the rest of us to clap along with him after letting the story's last words, "Fuck this shit," hang in the air for a moment. "So incredibly raw and a real glimpse into a world we never really get to see into. You write what you know. You"—he jabbed his index finger at one of the Vietnamese guys—"wrrr-ite," he said as he scribbled with an invisible pen onto invisible paper. "What you know. Write yourself. Simple as that." He pointed at me. "Your turn . . . Jared?"

"Jason," I said.

Published Author Dennis shot me a glance, and although I was starting to think I was wasting my money sitting in his gross apartment, the look in his eyes made me nervous.

I looked at the Polish woman, who seemed interested in what I had to say. She didn't speak English very well, but that didn't

matter. I thought about my high school drama teacher's advice to seek out the people in the audience who seem as though they're paying the most attention and give them a little extra, so I looked at her as I started and smiled.

I was reading a story I'd written for my "Hey Suburbia" zine a few years earlier. None of the copies I'd printed up when I was seventeen had survived past my eighteenth birthday, but the notebook with the original draft of the stories had survived numerous moves. I saved very little as I moved around, but made sure to always take the notebooks with me, some little bit of my past that I could hold on to even if I was embarrassed to read them. When I looked at the story for the first time in years, the one about the kid who runs away to California on his skateboard, I thought that if I just reworked it a tad bit, hammered out the teenager-who-likes-J.D.-Salinger-a-bit-too-much clichés, then it could be pretty good.

"This is called 'We're the Kids in America,'" I said while looking at the three people who could barely understand me, but who were the audience members that I wanted to impress.

I found the line I wanted to start with and began to read.

"Mary spilled her forty all over her mother's white carpet . . ."

Suddenly I was interrupted by Published Author Dennis's hand banging down on the table, sending everything on top of it flying up a few inches.

"No." He was shaking his head so furiously that I almost worried he was going to break his own neck. "No, no, NO!" He slammed his hand down onto the table once more just as his downstairs neighbor started banging on her ceiling again. I tried to imagine a little old lady with a very long stick, but couldn't see how she could produce such loud thumps.

"Oh fuck off, you stupid old bitch," he yelled at the banging.

Published Author Dennis was furious, the kind of anger that automatically makes me feel like I'm five years old again and need a place to hide from one of my parents after the rage bomb had gone off. I looked around for a closet but remembered this wasn't my house.

"'We're the Kids in America'? Mary spilling Olde English all over the carpet? Jeremy, what the fuck is this?"

"My name's Jason, and I believe it's a short story."

His reaction made me think it was a trick question. I was a little frightened because it looked as though Published Author Dennis's five o'clock shadow had grown thicker from the anger pulsing through his body, as if it had actually pushed up his facial hair just the tiniest bit. He breathed loudly through his nostrils. Sucking in the air, then pushing it out with great force.

"Is the rest of the story going to be about a bunch of kids? Some angsty 'Are You There God? It's Me, Holden Caulfield' sort of crap? That's juvenile; that's not *literature*."

I opened my mouth to defend myself, but was thrown off because Published Author Dennis was muttering, "Malarkey. Pure malarkey."

Still unsure what, exactly, I'd done so wrong, I composed myself and my defense.

"I think that maybe it's more like Ray Bradbury meets John Hughes," I told him, thinking he'd appreciate the story a bit more if he knew my influences.

I'd become obsessed with Bradbury after I'd learned he was originally from Waukegan, Illinois, another Chicagoland city by the lake that I'd grown up driving through. I'd read *Fahrenheit 451* in high school and liked it. But it was a beat-up paperback copy of *Dandelion Wine*—his semi-autobiographical novel about the wonders and eerie mysteries of growing up not too far from

where I was from, only fifty years earlier—that Mrs. Donovan had given me right before I moved out that I really loved. The night after I found out she passed away, I'd reread it. Inspired, I walked to the bodega and bought a coffee loaded with sugar and sat down to revise my short story under the influence of the book and its protagonist, twelve-year-old Douglas Spaulding, with his wide-eyed view of his hometown, who's so unaware of all the terrible things that await him when he becomes an adult. It's all lightning bugs, freshly mowed lawns, and the glorious summertime, but as the reader, you know there's something darker lurking beyond the edges.

"Oh please," Published Author Dennis said with a laugh. "That's not *literature*. Teen movies and science fiction? My suggestion is you go home and read some David Foster Wallace, then come back with something better next week. You'll never be a writer if you stay preoccupied with teenage shit. Grow up."

Published Author Dennis lit a cigarette and that seemed to calm him down.

"Class dismissed," he said with the wave of his hand, twenty minutes into our promised ninety-minute class, which he had made us pay our fifty dollars up front for.

It felt as though I was back in high school, the whole "Us vs. Them" thing. Published Author Dennis, who never once mentioned anything he'd ever written was my Dick Vernon or Ed Rooney, using whatever authority he thought he had as my teacher to humiliate me.

I walked out as fast as I could through Published Author Dennis's front door and made sure to pull down every one of his flyers I saw from that moment on until I just stopped seeing them altogether.

Reid and I grew up playing hockey together. We had a bond because we'd worn the same jerseys and practiced on the same ice, and Reid took that very seriously—team was family to him. Within the first few days of high school, though we drifted apart and hung out in different groups, he still treated me like a teammate, yelling my name when we'd pass each other in the hallway and raising his long arm for a high-five. I'd have to stand on my toes to reach, and on my way up I'd smell the ocean of CK One he took a dip in every morning. He was a mountain from the flatlands of Illinois, muscled and square jawed, deep blue eyes, and a Roman nose in the middle of an acne-free face. He had the cool-guy '90s haircut, short on the sides and in the back, but long on top and it fell into his eyes—like some heartthrob, named Rider, River, or Leo, ripped from the pages of *Tiger Beat* magazine. He played every sport; by the end

of freshman year, if he wanted to, he could grow a goatee that he didn't even need to fill in with a Magic Marker; he was the first kid in my grade to get his license. He was like a god at our school, respected by all four grades and every teacher. He must have felt that he and I had a bond because he started out being nice to me and treating me as an equal. To be honest, it was really my fault. I decided that Reid wasn't the kind of guy I wanted to hang out with anymore, not the other way around.

I just started to hate him. I hated him because everybody thought he was the perfect dude, I hated him because he and his friends ran the school, and I hated him because something about him made me feel inferior. I made fun of him when he wasn't around, rolling my eyes like it was a huge chore to talk to Mr. Popular. I knew I could get away with it since Reid was like a big loyal puppy who always came back for more.

Then one day, when I shook my head and didn't return a high-five, responding instead with a "Whatever," things cracked.

"When did you become such a freak?" he yelled as I walked away from him.

WE WENT OUR separate ways and I thought we'd never have any reason to talk with each other after high school. But Reid found me online and added me to whatever social networking sites we were both on. Suddenly, we were connected again. Just like that. One push of a button and there it was. We were supposed to be "friends" according to some website.

I cringed when I saw he listed New York, not Chicago, as his place of residence, but was comforted that he looked to be one of those Manhattanites who hardly went below 14th Street and never ventured into any of the other four boroughs. Reconnecting with old classmates was fine, so as long as it remained online.

A week later, there was a message from him. I opened it reluctantly. It was friendly, mentioning how we should "connect" at some point.

Give me a break, I thought. He suddenly wanted to be buddies with me? I'd probably show up and find out I was on some hidden camera show or something like that. All of my ghosts would come out from the corners and yell "Boo." No thanks, I said.

I clicked delete on the message, but couldn't help reading his frequent status updates that dripped with confidence and enthusiasm, utilized words like "synergy," used too many exclamation points, and mentioned the "rock stars" on his "team" totally "crushing it" at his suit-wearing job. I guessed he knew a lot of hedge fund guys, the kind who I served at my restaurant job in SoHo. They'd come in and say, "Give me the most expensive wine you have," not bothering to specify whether they wanted red or white or even attempting to pronounce the names, just pointing to the one that cost the most. Or the ones who started coming to a bar I liked and ordered "top-shelf Long Island iced teas," even after the bartender tried to explain to them they were wasting thirty dollars. Reid, I wanted to imagine, was just like them now.

I FELT AS though I was being haunted by the things I'd said to Michael in the cocaine nook at the Royal Oak, about not wanting to write a biography, how that wasn't literature. Would my whiskey-fueled obnoxiousness be my downfall? Did I need to find a rabbi or a priest to help me figure things out? Could a sinner like me find salvation? There were signs, possible ways back to the path of righteousness, but I couldn't decipher them.

First there was the recurring dream of me at a book party. I would be there holding a martini glass as people just kept coming up to me and congratulating me for writing a bestselling biogra-

phy. Their faces were obscured and they didn't say who the book was on. I'd just stand there in a black suit with a black tie, nodding my head and thanking them, never smiling. It was supposed to be a celebration, but it felt more like a funeral.

I normally wouldn't have given so much thought to some nugget from my subconscious creeping up on me as I slept, but a few nights after I had the second of three biography party dreams that I could recall, a girl named Beth I'd been dating on and off drunkenly convinced me to see a fortune-teller with her in the West Village. We were walking back to her apartment from Corner Bistro on one of those disgustingly hot summer nights when the city feels almost completely emptied of natives, filled only with tourists, thick humidity, and the echo of those left behind saying, "This weather is the worst." People who can afford to escape the musky mix of warmed-up garbage, bad cologne, and tar that permeates the air had escaped to their beach houses in the Hamptons; the island felt desolate. Beth and I didn't have very much to talk about: she worked as a brand consultant and was ten years older than me, and made about ten times more than I did. I didn't really get exactly what a brand consultant's job was or if you had to go to grad school to become one, but thought it was cool that she had an apartment in the city, while she thought it was "so funny" that I lived in Brooklyn and would always tell her friends that I was "one of those Brooklyn people." I drank the cheapest beer available at whatever bar we went to; she would say, "I heard that IPA is much better," and I'd tell her again that I hated IPAs. She would suggest restaurants that she'd read about and I'd make excuses not to go to them because I didn't want her paying for my half. We were in different tax brackets and I felt as though I existed a few classes below her. I pretty much knew from the start this wasn't going to work out, and I hoped that the

fortune-teller would be kind enough to say what we were both thinking to make things easier. But I would miss her air conditioner, I thought.

"You are an artist," the fortune-teller said as she looked at my hands. I told her yes, and I liked being identified as an artist, even though I hadn't really made anything and always hated it when people talked about "my art" or "my process." Something about that just sounded so off to me, but when the fortune-teller said it, I didn't mind so much. I played along.

"He's a writer," Beth blurted out with a serious trace of snark in her voice.

"Yes. I was going to say you are a writer," the fortune-teller, who couldn't have been older than eighteen, said to me as she looked up from my palms and into my eyes. "You are writing a book. A book about a man," she continued.

I looked at her. On one hand, there are lots of books about men; on the other, maybe she had somebody in mind.

"You know you must do it," she said.

"Who are you talking about?" I pleaded as I pulled my hands away from her. "Shouldn't you tell me about things like how I'm supposed to die or find love or whatever?" I asked, not even considering the girl I'd been dating was sitting a few inches away from me.

"You know the answer," she replied. "You just need to find it in yourself."

The spirit of the biography, it seemed, was hot on my trail.

I'M SUPERSTITIOUS. I look for signs in everything, and often waver between skeptic and believer. I'll blame karma or Mercury being in retrograde for whatever problems I encounter, and can sometimes convince myself that things truly do happen for a reason.

That's why when Reid messaged me again, I decided to read it and respond.

"Dude, Come on. Get back to me," it started. No "Dear Jason," or "'Sup bro?" to start it off. It ended with "Let's get dinner soon and catch up."

What the hell did he want to catch up for? I thought about just typing, "FUCK OFF I DON'T LIKE YOU," but something held me back. Something told me I shouldn't burn it all to the ground.

A few days later, I was waiting for Reid on a barstool in a restaurant where the bill would cost more than what I made in a day, but I felt I couldn't say no. My childhood hockey teammate and high school cool guy couldn't know I barely made enough to pay the rent on my tiny room and that my diet largely consisted of day-old sandwiches my boss told us we were supposed to pay half price for, so I said yes to dinner at a place on the Lower East Side that was illuminated mostly by candlelight that bounced off the gray painted walls. Downbeat music that sounded as if it belonged in a commercial for a sleek German sports car was the soundtrack for the fashionably underdressed sipping on organic wines from Oregon and laughing over plates of oysters and bacon-wrapped dates.

I looked down at my glass of water that had quickly gone from ice cold to room temperature, a victim of the stale August air that sat in the middle of the room like a smelly giant. I thought about asking the bartender why they didn't just close the windows and turn on the air-conditioning, but realized he could retort by asking why I'd been sitting there for thirty minutes and hadn't ordered anything while the people behind me who would have actually ordered the thirteen-dollar whiskey cocktails on the menu were being made to stand. I considered leaving; I could just

continue ignoring Reid's messages online like I had done before, never having to explain why I stood him up.

And then he walked in.

Childhood friend I loved, high school beefcake I despised, and now, in his early twenties, Reid was like a magnet when he walked into a room. He'd gone from a great-looking sixteen-year-old jock who I'd tried to avoid and everybody else wanted to be associated with, to a chiseled, sun-kissed, cool guy wearing a T-shirt that hugged his torso and made it very easy to tell he hardly had an ounce of fat on him. Although I'd seen pictures, they were mostly from the neck up. I'd secretly hoped Reid had suffered the same fate I imagined had befallen many of my other classmates, the one where everything builds up around the middle: the middle job, the middle of the planned community town house, the middle of the gut protruding out, all while living in the middle of the country. Of course, I was at the bottom—the middle looked great from where I was—but that didn't really matter much. As long as I had nothing to be that jealous about, then I was fine. I didn't sleep well to begin with, but before I ran into that old classmate while I was working at Magnolia, I could at least hold on to my little fantasy that all those people I'd left behind were just sad dots in the rearview mirror, that somehow my living in New York City finally made me better no matter what because it's supposed to be *the* city. That Frank Sinatra song, Fran Lebowitz's wit, hustlers out of some Velvet Underground song, the Empire State Building, Biggie Smalls, perfect slices of pizza on every corner, little neighborhoods to discover; I was in the Big Apple! I felt as though I'd found my place in the world, but as Reid walked in looking perfect, the kind of man who can have the entire room asking "Is that guy famous?" I realized how wrong I'd been about everything. There was nowhere to run.

"Hey, brother," he said as he gave me a hug that let me feel how his hard, muscled arms could squeeze the life out of me if he decided to stop affectionately slapping me on the back and apply a little pressure.

"It's been too long," he said as he took off his Chicago Cubs cap to unveil a head of hair that was perfect even after sitting under a hat during the polluted swamp air that is August in the city. It was like a magic trick. No thinning or anything.

"Good to see you're still a fan," I said as I pointed to the hat that instantly made me think of summer day games at Wrigley Field with my grandpa. The team had made a good run of it a few years earlier, looking as if they might actually break the dreaded curse that had plagued them for almost a century. But then, in what I considered fitting fashion, a guy from the same neighborhood in the suburbs where my parents had built the house we were all supposed to live in before things fell apart reached out to grab a routine foul ball a Cubs outfielder was trying to catch during game six of the championship series. That play would have sent the Cubs to the World Series but this guy had knocked it out of the Cubs player's glove, causing the team to spiral out of control and lose in stunning fashion, and for me and probably every other Cubs fan to think we were going to spend our lives suffering. I couldn't bring myself to spend a few hours watching any of their games after that, but as I looked at the big red *C* against the blue background of Reid's hat, I thought about how nice it would be to have somebody to talk to about the Cubs.

No, no, no, no, the voice inside my head said. *Don't give him a damn inch.*

"I'd never give up on them, no matter how much they disappoint me. That's just not how it works," Reid told me with a laugh.

How was he so sincere?

I was awestruck by his unwavering positivity. I was going to ask him a question about himself just to feel as though I had something to offer the evening, and then a girl walked up, put her arms around him from behind, and kissed him on the neck.

"Jason, this is my fiancée, May."

May had dirty blond hair and eyes that looked like marble, and probably not too surprisingly, she was beautiful. I couldn't help but notice she looked like Haviland Morris, the beautiful actress who played Jake Ryan's girlfriend in *Sixteen Candles*. Or was I just telling myself that? I wanted to rub my eyes to make sure they weren't messed up. Was I making it up? Reid was always the Jake Ryan of my teenage years: the perfect guy who could be careless with other people if he wanted to because he was great-looking and rich. May was obviously his equal and I started to imagine them having perfect children in their perfect future.

We sat down and ordered drinks. Reid told me about his life, how he had graduated from his West Coast university and had decided against going after a law degree like his father wanted, and instead started a nonprofit with a few friends aimed at improving education for underprivileged kids using money he'd inherited. He did some traveling one summer, and figured that he should use his trust fund for something more important than a nice car. Then his dad fell ill and Reid went to work for the family.

All I could do was sit there in disbelief. He was still rich and handsome, but now he was rich, handsome, a young philanthropist who spent his money trying to help other people, and just an all-around upstanding member of society. I, on the other hand, had forgotten to shower for two days in a row and had possibly not put deodorant on when I left the apartment. I'd know in a few seconds, I figured.

And then there was May with her perfect posture and the

smile that never left her flawless face. She was finishing up at Columbia; she was warm and funny and, I assumed, from a good family like Reid's. They looked like a catalog couple and I sat there in my damp T-shirt with a hole in the shoulder that I thought looked cool.

"Let's do a shot," Reid said, and smiled. "To celebrate." He held up his glass, leading the charge. "To old friends!"

This shot probably just cost me ten bucks, I thought as I tossed it back. There was a very specific amount in my head that I could allow myself to spend since there was no way I'd let him get the bill, and that was basically enough for a drink and an entrée. That shot had put me over budget before we'd even placed our dinner orders.

"I'm going to order some stuff. Let's do the seafood tower to start. Jason, do you like oysters more from the east or west? I tend to like the flavors you get out of ones from places like Vancouver."

Before I could say that the seafood tower, which consisted of clams, scallops, shrimp, crab legs, and a dozen oysters of your choice, cost about the same as my share of two months' worth of utility bills, Reid had flagged down the waiter and ordered one with a mix of oysters from all coasts.

"And a bottle of this," he then said, pointing to something on the wine menu.

The server said the wine's name, showing off a strong grasp of French pronunciation. I covertly glanced at my copy of the wine list to see that the bottle had already put my portion of the bill just over a fourth of my monthly rent, but there was no turning back now.

We drank the bottle fast and ordered another one just as we polished off the seafood tower, the smell of salt water, vinegar, and melted butter still in the air. The shot had loosened me up, but the wine made me feel as though there was nothing to lose,

so I just said "Sure, why not?" when Reid asked if we should get a second bottle. Feeling a little full after the wine and shellfish, we decided to just get something we could share as an entrée. Split three ways, the spicy half chicken, at forty dollars, took me to total economic oblivion; I'd have to work every day for two weeks for a chance to recover.

At the moment I could admit to myself that I was drunk, Reid said, "So, you're a writer."

I felt enough confidence to confirm that yes, I was indeed a writer.

This was when the "Have I read anything you've written?" questions and the "When I finish the project I'm working on, I'll write for other places" lie for an answer happened.

"My agent is working on some things," I found myself saying. The words just kept coming out. I hoped they wouldn't ask me exactly what it was I was supposedly toiling away on. And then May did.

"Come on," she laughed. "You can trust us."

This was where they got me, I figured. Feeling as though I'd done my duty and would never have to see them again after that night, I was unprepared to discuss anything beyond my little white lie, which covered up the fact that I had hardly done any-thing worth talking about, I figured we'd reached the moment where they both laughed me out of the restaurant after exposing my failure of a life. I was just a barista who showed up on time enough at my job that the manager had decided to give me my own set of keys and a dollar more than my coworkers. I asked her to repeat the question, even though I knew exactly what she'd asked, just to buy myself a moment. I coughed, I laughed, and even purposely dropped my napkin on the floor to give myself an extra second while I picked it up.

I did everything I could to stall, even considered doing what I did after I got my first kiss from a girl named Megan Schwartz in junior high during the movie *School Ties*. We were just two Jews, alone in the dollar theater, seeing a movie starring Brendan Fraser as a handsome high school football star whose new prep school classmates hate him because he's Jewish. We kissed, and I then immediately turned to my left, threw up all over the seat next to me, and screamed at Megan, "There were onions in the popcorn. I'm allergic to onions," and ran home crying. For a second, that felt like the right thing to do, but then, as if a spirit had entered my body and taken over my brain, I said something without even considering the words that were coming out of my mouth.

"I'm writing the unauthorized biography of John Hughes," I said with a kind of authority I didn't even know I possessed. "I've never seen a book that takes a look at him and his work, and I decided that since he's from the part of Chicago where Reid and I both come from, that I should be the person to do it."

They were silent. As if I had screwed up the plan and everybody from my past couldn't jump out from behind the curtain and yell, "SURPRISE! YOU STILL SUCK!"

That sounds really cool, I thought, the lie turning into an actual plan right there on the spot. *Really* cool.

I would write the John Hughes biography that nobody else had ever attempted. I would pay the highest tribute to a man whose work had such a huge impact on me, whose vision I had basically based my worldview on. This was my big idea, the one I came up with while drunk and lying.

"I've been working on it for a long time," I said, continuing to talk about the book that I was creating in my mind on the fly as we sat there at the table. Of course I'd make sure both May and Reid both got signed copies, I told them.

"That's really awesome, Jason," Reid said as the server dropped the check, closer to me. I looked at Reid and, maybe it was all the wine, but I didn't see the guy I'd hated in high school; I saw my hockey teammate. He reached out his arm to grab the check, but since I felt so good, I figured I'd take care of the entire dinner, so I swiped it away as fast as I could.

"Please. I insist," I said as I put my debit card on top of the bill, the hope that it wouldn't get declined slowly drowning in the pool of white wine that was serving as my fuel. I saw the looks on the faces of my dinner companions; I was the hero. I was an adult. I was the man.

"To John Hughes." May raised her glass and knocked back the last of her wine.

"To John Hughes," I repeated.

Sitting in the central branch of the Brooklyn Public Library leafing through a book that could have easily been titled *Writing Biographies for Dummies,* I thought about how I'd come such a long way—at least in terms of spending time sitting in libraries. No longer was I the teenager hiding out among all the novels I longed to read or the college student drinking countless Red Bulls and snorting whatever over-the-counter crap I could crush up to speed through a night of writing papers for classes I didn't care much about but had to take to graduate. Now I was a writer working on a big project. I felt at home among the stacks, as if I was among contemporaries working from there. I had some purpose sitting there researching the biography I'd started to tell people was my big project. Of course, at the same time I was also trying to figure out how to actually write a proper biography while furiously writing down whatever words

came to my mind, jotting down some ideas onto notebook paper, scratching others out, before going home and typing up whatever I felt was good enough. Was it supposed to be this messy of a process? I looked up at the Toni Morrison novel propped up in the middle of a display on a nearby shelf and wondered. I'd read biographies before, but was that all the education I needed? Did anybody just wake up and say, "I'm going to write George Washington's life story," and really end up doing it? I took a breath. Looking around at all of my heroes' names on the spines of their books, I told myself to do what I felt comfortable with and one day I'd be up there with them.

I fell hard for that one specific library. There was another closer to my apartment but the fifteen-minute walk from the café I worked at in Park Slope to Prospect Heights was inspiring, especially in the summertime. Despite the stifling heat, Brooklyn, especially near Prospect Park, feels like a world away from Manhattan during the hotter days, with everything green and lovely, the smell of the flowers from the nearby Brooklyn Botanical Garden filling the air. I'd make my way up the steps to the giant mass of stone that looks like a grand church for books and knowledge, with its Art Deco sculptures featuring some of the most famous characters from American literature greeting me as I walked into the great, big lobby. Even though I was probably going to have to work next to a sleeping old man who smelled like sardines, I still felt as though I should show up wearing a suit and tie. Going to that library three or four times a week made me feel as if I was going to work in the grandest office imaginable. For the first time, I felt like an adult with purpose.

My normal routine was to sit there looking up old articles for a few hours, then get up and wander around, just appreciating the decorations carved into the marble and wood, and pulling books I

thought maybe I'd want to read off the shelves. I'd drink a coffee, then get back to work finding articles on Hughes, his films, or the people who were in them. The librarians seemed wary of me, or maybe they were just sick of telling random guys to stop looking at porn on the public computers. Either way, I camped out for hours, shooting nasty glances at people who made too much noise, and watched the characters who spent their days at the library from open to close, wondering what their stories were but never asking. *No time for any of that,* I thought. I had to write.

THE FIRST READER was a poet and the second was, too. The third reader was a guy who looked as though his name should be Jonathan or Joshua. He read a personal essay that went on too long, leading first to extended coughs and loud yawns, and finally to somebody dropping a glass to the ground, letting it shatter, and exclaiming, "Whoops!" Everybody snickered because they knew the guy dropped it on purpose, but the reader barely missed a beat and kept on telling us about taking a year off from Brown to backpack through the Carpathian Mountains, and of the prostitute he gave a cigarette to in Romania who reminded him of someone he knew. Most of the essay was about contemplating the evils of capitalism during his year abroad while trying to place the prostitute's lovely yet haunted face ("Was it an ex-lover, perhaps? A picture of my mother from before I was born?"), and when he finished twenty minutes later, the nervous host stood and thanked the reader for his "brave" words. "Oh, and congrats on the Fulbright."

The reading had been advertised as starting at seven but didn't start until 8:45, and there were eight readers on the bill. I was supposed to go on fifth. Since it was already ten o'clock, I wondered if I'd make it up to the microphone before midnight.

"All right, everybody. We're going to take a quick ten-minute break. Go smoke, stretch, or buy another glass of wine to show how much we appreciate the bar letting us use their space to help foster Brooklyn's artistic community and how sorry we are to see them close next week." He pressed his palms together like he was praying and bowed his head toward the crowd and stepped away.

I hadn't read anything to anybody yet, and felt nervous getting up to share what I'd been working on with a room full of strangers drunk off the failing wine bar's "Everything Must Go" specials. Even the girl from the coffee shop that I worked with who dated the night's organizer and had helped get me on the bill wasn't there, so I stayed in my seat as the entire room emptied out onto the sidewalk for cigarettes and gossip. I looked over my essay about the Chicago suburbs and John Hughes. I felt it did a good job of approximating how I wanted my book to read, and on the way over to the wine bar, I'd imagined the looks on the faces of the people in the audience as I blew their minds. But as I stared at the opening, I started to have second thoughts.

It started with a long Saul Bellow quote from *The Adventures of Augie March* ("I am an American, Chicago born"), which only at that moment did I recognize as ill-placed. It hadn't occurred to me that using another writer's words (especially the most famous opening line written by a Nobel and Pulitzer Prize winner, the one everybody defaults to when talking of his work) to open up my own essay was kind of tacky. I scratched it out, but began to panic when I realized that the sheer amount of serial commas I had used would make it impossible for me to catch my breath. It had originally been written as a potential foreword to the biography, but looking it over as I was about to share it for the first time, I only then noticed it wasn't very good. "Writers never like anything they write," I whispered to myself as I tried to calm my

breathing, a trick a doctor had taught me when I was younger. *I'm not going to have a panic attack,* I told myself.

I took a second and kept on reading. I read the whole thing without making any changes, and only then did I understand what a huge mistake I'd made.

Wedged somewhere between cultural criticism, essay, and a manifesto, the piece reminded me of my great-great-grandfather, but not in a good way. I'd never met him, but my grandmother had called him "unfortunate." From what I gathered, he was a former religious scholar who had developed political aspirations, he was a little too intense for fellow socialists who didn't really agree with his ideas of a "Jewish Marxist messiah," so he left Russia—his lost cause—for America, hoping to spread his message overseas. "He wrote all these crazy things," my grandmother said. "Entire books. He wrote and wrote. He was *insane.*" I heard her words echoing in my head as I pictured myself dressed in my great-great-grandfather's clothes, perched atop a soapbox, pointing at the crowd of curious people standing around laughing at the man screaming for a cultural reassessment of the suburbs. But that wasn't what I wanted; I'd hoped the crowd to see how the North Shore of Chicago had shaped our current cultural landscape, from F. Scott Fitzgerald to Bill Murray, and all the other writers, Hollywood stars, musicians, and everybody else I could name, until finally tying it up with a triumphant and echoing call: "Then there was John Hughes. He was the person who showed us all how great the suburbs could be."

Oh god, I thought. *That's fucking terrible.* It read like an angry hack academic had finally gone off his rocker, mixed booze with cold medicine, and then gave a lecture he thought would really shake things up, but in the end somebody had to pull the cord on

the mic and it cost him a job he'd barely gotten in the first place. It was that kind of piece. It was really bad.

People started filing in from the break, including a handsome and prominent young novelist who was in attendance. His blond hair fell over his eyebrows and occasionally he smoothed it back dramatically with a hand just calloused enough to hint at the promise of a few (but not too many) hard days of real work. A big magazine had recently labeled him as one of New York's new literary "It Boys" for that year. He had a posse of young writers with him, some of whom I'd read online and in small literary journals, as well as several even younger female students from the MFA program where he taught. He projected an air of being too important to be hanging out here on the border of Bushwick and Williamsburg (where real estate agents and landlords were only just starting to jack up the rents) on a rainy October night, holding his four-dollar red wine in the air and periodically swishing it around in the stemless glass. My heart hurt from beating so hard. I couldn't stop myself from hoping that I'd pass out; it was terrible to think, but it felt like a viable option since I couldn't come up with any other ones.

Looking around, everyone looked smarter and more important than me. They looked as though they had it together, like they weren't worried about maybe having their debit cards rejected when they closed their tabs. As they took their seats, all I could think of was how I would embarrass myself in front of all of them. It didn't matter that they were a little tipsy. I was doomed if I read, so I had to figure some way out.

Then, as if lit up by a divine highlighter, brighter even than the seemingly sun-sized spotlight pointed on the readers when they were in front of the audience, I suddenly noticed a number of grammatical mistakes on the first page alone. Who knew what

nefarious horrors the next six would offer? Had I even bothered to read any of this crap? These people would tear me apart and I'd be ruined, excommunicated from the publishing world before I even finished my first book. I imagined my entire future as a writer dying right there in that wine bar, sweating into a puddle under that burning spotlight.

This was make-or-break with seconds to decide, I realized, so I did the only natural thing: I slowly rose to my feet, picked up my bag, and walked toward the bathroom, thinking I might just lock myself in there for the rest of the night as I had when I was forced to go to the homecoming dance freshman year of high school even though I didn't have a date or any friends also going. I was screwed, that is until I spotted a side door, its glowing red EXIT sign a beacon of hope, my way out of the mess I'd gotten myself into. It crossed my mind that I should maybe just tough it out and get through reading the small part that I did deem somewhat OK and it would be a good learning experience for me, but no; I walked quickly toward the door with my head down, tossing a twenty-dollar bill on the bar to pay my eight-dollar tab, ignoring the bartender who tried to tell me that the door wasn't to the bathroom, and stumbled into the cool night air. I kept walking, then quickly burst into a jog, without ever looking back.

DITCHING THE READING was a small part of a bigger problem: I'd been hitting snags all over the place within the early stages of my book. Nothing to worry about, I assured myself since I was making some headway in my research, but there were signs of trouble, ranging from no responses from agents I'd queried to passes, or just more silence, from the publicists of actors such as Anthony Michael Hall and Judd Nelson. Even Alisan Porter, the actress who played the tiny con artist in *Curly Sue* ("a John

Hughes formula movie where the formula doesn't work," as Leonard Maltin put it), never got back to me. To top it off, all three letters I had sent to Hughes were returned, the last because I'd forgotten to put a stamp on it—definitely an omen. My hours in the library were spent mostly reading, but it had failed to yield much good writing, and the groundbreaking information I was hoping to dig up just wasn't there. I needed to get deeper, closer to my subject somehow, and a small ball of fear started to roll around in the pit of my stomach.

Often I wondered if I'd made a bad decision and thought that maybe I should just say to hell with it, work to get my MFA, and write a novel about a sad, middle-aged Jewish man who hates his life or something like that. I'd dwell on the possibility of going down another path for a few minutes then fight that thought to the death and move on, resurrecting the voice of my eighth grade gym teacher with the Tom Selleck mustache. He had always harped on his one season playing minor league baseball as the great achievement that made him superior to us and would yell, "Keep going! Like a good soldier," as I'd try in vain to climb the rope or do pull-ups. I hadn't been a good soldier then, pretending I pulled a muscle to get out of doing drills; but I was going to be one now.

Over six months in I had nearly produced a single chapter, some proof to myself that I'd actually been working and not wasting time, in which Hughes begins to stray from his normal, nine-to-five life as an advertising copywriter for Leo Burnett Worldwide and starts sending jokes to comedians for a small fee and no real recognition, save for hearing Rodney Dangerfield or Joan Rivers make people laugh using his ideas and words on *The Tonight Show*.

I wondered what that felt like. Your idea is executed, the

laughs happen, but you're nowhere to be found. You're left to wonder what if that one moment was it. That was your shot. I wanted to know if Hughes thought every joke he sent would be his last, the way I figured this book was my one and only shot. It's the sort of thing that might sound silly in retrospect, but when something you want is so far off into the distance, grabbing it and taking hold of it seems impossible. Did Hughes feel as though he'd be some guy that had a couple of shots and that was it? This thought followed me as I worked serving coffee to people who made a lot more money than me, who had careers, and seemed about as happy as I was unhappy, when all the while I felt like I could be somebody else, somebody better. I wasted a lot of my best days—my best ideas, my best jokes, and even my ability to make latte art—on these people.

A sampling of Hughes's written gags was good enough to help him snag an entry-level job at an advertising agency after dropping out of college; that's all it used to take back then to prove you could write a snappy slogan to sell a car or toothpaste, and it paid well enough to put food on the table. He kept getting better at the work, but that didn't matter to him; some people might be fine with better, but Hughes wanted something bigger. He knew he could do more with his life than just punch in, act busy while he was actually jotting down set-ups and punch lines, then clock out and go home to his wife and dinner and the slow decline that is life, so he kept hammering away, staying up until three or four in the morning, when his wife would finally come downstairs and tell him he had to go to bed. Just writing and sending out stuff all of the time, until finally, a break: *National Lampoon* picked up one of his stories, then another. Eventually, using meetings at the agency's Manhattan office as an excuse, Hughes started to take frequent flights to New York, sometimes spending just a few

hours there to visit with the *Lampoon* people and schmooze with them, then turning around and flying right back to Chicago. He didn't like New York very much—he was a Chicago guy—but all that time spent at the *Lampoon* office would pay off in 1978, when an attempt to capitalize on the success of *Animal House* led ABC to green-light a spin-off of the movie, *Delta House*. John Hughes was the first and only choice for the show's head writer.

The show lasted for one season and thirteen episodes, but that was all he needed. It was an equation that seemed so simple to me: put your head down, keep chipping away, and eventually good things will happen. Sure, I probably wouldn't get an offer to write scripts from a major network, but Hughes's ascension was a motivator when I felt like giving up. He kept writing while mindlessly doing his job, and seemed to tune out everything while waiting for his break. I tried to emulate him with every Americano I made, every batch of beans I threw into the grinder, and every time I shook my head to tell a customer that we didn't have hemp milk. Writing helped me get through the everyday slog, no matter how low I'd feel when some guy in an expensive suit with a mismatched shirt and tie would yell at me, saying, "This is why you work in a coffee shop," because I didn't make his drink hot enough even though, as I told him, any hotter would be against health code regulations. All I wanted to do was go home and perfect my one chapter, my portrait of the artist as a bored young man.

I was writing about the holding pattern between being grounded and taking off, a moment in life that I could relate to. I would burn my hands while drowsily filling cups of green tea for customers at six in the morning, only to have them complain that the water was too hot. How badly I wanted to say, "Of course it's fucking hot, moron. It's *hot tea*! It needs to steep!" But no matter

how badly I wanted to do that, I couldn't, because then I'd be fired, and if I got fired then I'd have no money. If I had no money and nobody to turn to, I'd no doubt become one of those people wandering the streets of Manhattan just saying random things to myself like, "I am doing swell. I have rainbows in my elbows. I can make you a latte. Did you know we all come from cream cheese?" So I just smiled when they yelled because I didn't want that. I bit my tongue, put ointment and bandages on the burns, got through my shifts, and went home to write the same chapter every single night for months. One of my roommates offhandedly told me he expected that the entire thing read, "All work and no play makes Jack a dull boy," that I was slowly turning into Jack Nicholson in *The Shining*. He worried I'd be smashing through the door with an ax one night, yelling, "Heeeeeere's Jason."

I told him I wasn't there—yet.

I spent the bulk of my time on that single section because I'd read online that I'd need a sample chapter to impress editors, so I was going to make sure the one I wrote really hit the mark. I worked every night at an imposing wooden desk left in my loft apartment by the occupant before me. My entire corner of the space was structured around that desk. My roommate told me that the loft bed I slept in would probably be better used as storage, since I usually passed out in my desk chair anyways. I was paying nearly $1,000 dollars a month for a desk, a bed I hardly ever used that was only accessible by ladder, a plastic dresser, and an impressive photo collage used to cover water stains and chipping paint but that also helped inspire.

I had started the collage with just a picture of Eric Stoltz, Mary Stuart Masterson, and Lea Thompson from *Some Kind of Wonderful,* but then I started pinning and taping more things to the wall. Pictures of CTA trains, Chicago skyscrapers, a Union

Jack flag like Ferris Bueller had in his room, pictures of musicians like the Jesus and Mary Chain, Simple Minds, and Kate Bush, all of whom Hughes had used in his films. It was cluttered and messy, but I told myself I'd take it all down once I was done with the book.

Below my ever-expanding collage were two piles that were growing by the month. One was a stack of several spiral-bound notebooks and manila folders that all bore "Research" scrawled on their fronts in black marker. The other was made up of three fat black Moleskines, each filled with the same single chapter, rewritten nearly identically in what I said was my attempt to "find the book's voice." I became a vegan because it was cheaper to eat only rice and beans or slices of bread with just mustard on top, I didn't have health insurance, and I was lucky if I could make the minimum payment on my credit card, which I'd maxed out moving to New York—but I *really* needed those Moleskines. I couldn't really justify the expense if anybody asked. But the gravitas of the cool black covers was a reminder of the seriousness and utter devotion with which I had undertaken my project. I thought I must look like such a writer as I sat in the coffee shop jotting down notes to myself, playing around with my one chapter.

* * *

He sips coffee from the same brown mug before he leaves the house, says good-bye to Nancy, and wears the same variation of suit and tie to the office every day. He says hi to some guy named Frank as he walks into the building, holding his copy of the Chicago Tribune *in his hands along with his briefcase as he rides the elevator in silence with all the other ad men. He gets to his office and it's*

always the same: he looks out on the Chicago morning, all
gray and proud, the way the city always looked, sun shin-
ing or not. He stares down the Magnificent Mile with the
neo-gothic classics mingling alongside the modern glass
buildings.

"What a city," he says to himself every single day, a
mantra and a reminder.

* * *

That's how I tried to write a day in the life of Hughes. I had no
idea if any of that actually happened, but it couldn't hurt if I spec-
ulated a little, I thought. I knew he had worked for the ad agency,
but I'd made up a lot of the boring stuff because I figured a good
biographer took some creative license to better craft a story. For
instance, I assumed that the Republican-leaning Hughes read the
more conservative *Tribune* instead of the liberal *Sun-Times,* and
I wanted to give the book a natural feel. I had to envision that
time between the fall of Carter's presidency and the beginning of
Reagan-era America; my own personal politics had to be put to
the side as I tried to imagine life inside the corporate machine, the
rise of the yuppie, the last days before the Republican morning in
America and the time when people admitted that they believed
greed to be good. I had to see the Hughes before he wrote movies
as part of the problem, writing successful copy for Big Tobacco
or other harmful corporations, and I had to tell myself that's fine,
that's part of the story. I had to be OK with that even though I
definitely wasn't.

Several pages later, the story ended right in the middle of a
paragraph with a flurry of red pen, almost scratched into the
paper, I left notes for myself:

—*Check to see where Leo Burnett Worldwide was ACTUALLY located in the 1970s.*
—*Portray Hughes as modern day Romantic!*
—*He wanders/floats above the sea of boring!*
—*He's an artist just screaming to break out. Portray the SHIT out of that!*
—*Maybe talk about how he was always a fish out of water? A Republican with artistic leanings, but never a hippie? Maybe hold that for later?*
—*He never gets too close to other people, never lets on too much. Should this be something I explore in earlier chapters? Why didn't I just start this thing at the beginning?*
—*Fuuuuuuuuuuuuuck.*

I started over again on the next page; Hughes sipping his coffee from a paper cup, but this time he buys it from a vending machine. I wrote that he was "an old soul who just wasn't born for these times, but he's got to make a living." That made me feel a little bit better about having to write the part where he comes up with a famous Virginia Slims ad. He gets to LBW (which I moved to Lower Wacker after a little research), says hi to Frank (why Frank, I don't know), walks into his office ("Find out if he even HAD his own office," I wrote at the top of the page, with an arrow pointing to the word "office"), looks out onto the "concrete landscape," sees the "faceless specks," people scrambling to go wherever, and mutters "What a city," under his breath "quiet enough that nobody hears him, but audible enough that it bounces off the glass of the window and echoes in his ear forever."

The same chapter written and rewritten, chiseled out of anxious energy, fueled by the cheap coffee from the bodega on my

block, sometimes with the smallest change, other attempts with full paragraphs added or taken out. I kept repeating myself in an attempt to find perfection, looping my days as I had my book. I finished when my hand was numb, and my eyes were blurred. I would stand up slowly from my chair, squeeze past the small plastic dresser nestled in the corner and look out my small but precious window. I should have seen New York, but I could only envision Chicago and its blue-collar citizens moving slower against the marble and glass facades, the whole scene looking like some grainy 1970s television show.

"What a city," I said, my voice a harsh croak, to the early morning light.

I HAD HIT a wall with the book, unable to move past Chapter One and still not getting any responses. Things felt stuck in the mud, except there was one thing happening with my writing career that had nothing to do with the book: a magazine editor who wanted to give me assignments for his small, floundering publication. He didn't seem to mind I didn't have any real writing clips or anything else to my name, save for a couple of record reviews here and there for little blogs. But I didn't ask any questions when he offered me a shot.

I'll take it, I thought. I'd take anything.

We never met in person. A friend had introduced me to him over e-mail and I only knew his face from a photo on the magazine's masthead. What I gathered was he showed up to the office, did his job, then got the hell out of the city and back to Connecticut every night.

"He's really unhappy with his life," my friend who had facilitated the introduction told me. "He always talks about giving it up and going back to law school." Apparently hardly anybody

carried the magazine (it took me six newsstands to find it), all the good editors had been poached by other publications with more clout and that had at least a year or two left in them, and the publisher had bought extravagant dinners at places like Per Se and Balthazar, which led to budget cuts, firing of staff, and more use of freelancers like me. This meant it would never be the type of gig where I'd be able to eventually move up as Hughes did with *National Lampoon,* but it was a paycheck, and technically, it made me a professional writer. After a few small jobs, he finally assigned me my first big interview with a band who had lackluster critical appeal but big sales and a major label. I tied myself into a knot with preparation and worrying. If I screwed this up, I fretted, everybody would know and I'd be done—my career over, no book, and no getting out from behind the coffee shop counter. There would be some meeting of the secret society of people who are far more important than me, and they'd banish me to a life of cappuccinos and lattes. I'd be like Moses; I could see the Promised Land from a distance, but never quite get there. I'd die buried under a pile of espresso beans.

Thankfully, as I waited in the hotel lobby for the band, the publicist asked if I'd like a drink. It calmed my nerves a bit. A half hour passed, and the band still hadn't shown, so I had another drink. I didn't think it could do much harm. Finally, once I was day drunk and feeling generally awesome about everything, the band showed up hammered out of their minds and looking to answer all of my questions with enthusiasm. I couldn't help but envision their outrageous quotes in big bold letters on the cover of the magazine as I typed up my piece that very same night, now under the impression that this was going to be the start of my career.

A few weeks later, my hour of conversation was whittled down

to four questions that fit in a small sidebar on the edge of one of
the magazine's opening pages, but it was still my biggest article
to date, and the hundred-dollar check I got a few weeks later was
the most I'd ever made off a single piece of writing. I celebrated
with dinner at Dumont, one of the most popular restaurants in
Brooklyn, where I ate my burger and mac and cheese, and drank
beer like a man who felt as though it was just a matter of time
before he could afford nice dinners and drinks even long after the
happy hour deals ended.

Hungover, my celebration continued the next day with my
coffee shop coworker Matt at a vegetarian restaurant in the West
Village, where we dined on vegan Cuban sandwiches and took
full advantage of the establishment's very friendly BYOB rules,
going through one six-pack, and then another, as the people
behind the counter joked about joining us when we offered
them some beer.

Matt had moved to New York around the same time as me
to start his own writing career, although he'd always remind me
that he was a "totally different kind of writer" than I was. Exactly
what he meant by that, I never really figured out. But none of that
really mattered anymore. We sat there toasting every cold one we
popped to my success, and the hundred-dollar feather in my cap
was burned through almost entirely in twenty-four hours.

I asked Matt how his own work had been going. I'd always
dreamed of being a writer in New York City with a circle of bril-
liant writer friends. Matt and I were going to be part of some-
thing big, I could just feel it. All the newspapers were starting to
talk about how young writers were living in Brooklyn, and there
we were, celebrating the start of my official career. Just two scribes
getting drunk in the afternoon like Fitzgerald and Hemingway in
Paris or Paul Bowles in Tangier.

"I haven't written a word of anything except my name on rent checks in the last six months," he admitted to me as he slowly crushed a can in his hand. "What's the point? Nobody is going to read the kind of stuff I write."

It was not exactly the answer I had expected, one that led into Matt telling me how he had given up on whatever it was he'd been working on and really gotten into the idea of being a professional barista. He was learning more about beans, how water temperature can impact the taste of espresso, and saving up money to take a trip to Central America to meet with farmers. Just like me, he had started out working coffee shop and service industry jobs as a way to make money while he tried to get his career off the ground, but now he saw being a barista as the real career.

"Writing is mostly bullshit," he said as he popped the top on another beer. "Hardly anybody makes a living doing it, and publishers don't take chances on young writers unless you're some MFA golden child or something." He grimaced like he knew he'd done something wrong and then took a swig.

"But it's different when you're working on a book like the one *you're* working on. That will *totally* sell." He said it almost like an apology. "What is it about again?" he asked. I was drunk but could tell he was trying to be nice. I could sense his lack of faith.

I told him it was a biography of John Hughes, but with a critical lens on the director's entire oeuvre. My hope was to write a book that got people to start taking his work as seriously as they did that of Kubrick, Hitchcock, or Truffaut.

"And you haven't talked with him yet?"

That was a problem I was grappling with. I had a million different excuses, but I really felt as though sooner or later I was going to hit pay dirt, that either Hughes was going to talk to me, or people that knew him would start getting back to me at any

moment. *Luck is on my side,* I thought. I had momentum. Everything was coming up Jason!

"Oh, shit," he whispered as he put down his can of High Life very slowly. "This is so weird, but Ally Sheedy just walked in and is about to sit down behind us."

"Shut up." I laughed.

"No, dude, I'm so serious." Matt's eyes widened almost in slow-motion, as if the weirdness of the moment was taking its time to dawn on him. I tried to turn around to see, but he stopped me, a hand in the air. He thought she might have heard him talking about her. I put up a finger, signifying for him to hold on. Meanwhile I nonchalantly dropped my napkin on the ground so that when I went to retrieve it, I could turn around and see, yup, he was right. It *was* Sheedy, or Allison Reynolds, the "basket case" from *The Breakfast Club,* the kind of film that makes viewers choose a character they relate to. I was always an Allison, the goth weirdo who doesn't want to fit in as much as she wants people to just see her. She goes out of her way to be noticed, but retreats when somebody does. She's the kid who takes a few more than the recommended dose of Tylenol, then marches downstairs to tell her parents that she just tried to kill herself. I think we all have a little Allison in us. And now there she was, sitting right next to me. Close enough for an interview, or at least an introduction.

"You should say something to her," Matt mouthed to me. But how would I do that? Just walk up to her smelling like beer and vegan ham and awkwardly say, "Hi. I had a massive crush on you when I was fourteen and now I'm writing a book about the guy who directed you in one of your most famous roles. Do you have a second to put down your food and talk to me or maybe give me your home phone number or personal e-mail? I know you don't know me, and you might not even be on good terms with

Hughes, because I've heard that to be the case with a few of the people who acted in his films, but I'd really appreciate it."

Nope. That wasn't going to work. I needed to come up with something better.

"Call my phone," I mouthed back to my friend who looked at me as if I was insane. He obliged, reluctantly pulling out his cell and dialing my number, I shook my head at him as he started to raise the phone to his ear. I picked up.

"Philip," I said, my voice stern and authorial. Philip was the name of my fake agent. I made it up on the spot. "Yeah, the book is coming along swimmingly."

My friend raised an eyebrow. "Swimmingly?" he murmured.

"Yes. Yes. Yup. I'm speaking with Paul Gleason next week. Uh-huh. Yes. Oh yeah, Mary Stuart Masterson is confirmed as well."

My plan was to get Sheedy's attention by dropping names she'd know to the nonexistent person I was talking on the phone with. Paul Gleason didn't seem like that much of a stretch. What the hell was he up to anyway?

"All right, buddy," I said as I hung up, figuring it was just a matter of seconds before Ally Sheedy walked up to me and asked to be involved. *This is the start of great things,* I thought as I looked up at an ugly piece of art on the wall that undoubtedly had an exorbitant price tag. Maybe after I sold the book, I'd walk into the shop and buy one of the gnarly things that looked like a suburban Picasso had taken some bad acid. I would point at one and say, "I'll buy that," just for the hell of it. That was how I'd celebrate.

"Excuse me." The guy at the table next to Sheedy's piped up.

"I don't mean to be rude," the man said, "but did I hear you say you were going to talk to Paul Gleason, the actor?"

I smiled.

"I did. I'm writing a book and I'm slated to talk with him for it, it's about . . ."

Before I could finish, he interrupted.

"Paul Gleason died three months ago." He sighed. "Paul passed away from lung cancer. We were neighbors in Los Angeles. I hate to tell you, but your interview is probably canceled."

My face reddened. How could I have missed that? How did this get past me? Gleason was one of the most famous 1980s villains, a guy so bad that he didn't need a plot to take over the world to be counted among the characters moviegoers hated the most—his persona, a bully to his core, was the one people were most likely to know in real life. I was writing a book about the guy who made Gleason famous, and I didn't even know he was dead until some random guy pointed it out to me. I should have thanked him, should have acted shocked and tried to save some face even though I was likely never going to see him again. Ally Sheedy *must* have heard me since I was practically screaming into the phone.

Instead I hissed to Matt, "Let's go. *Now,*" and left without replying to Paul Gleason's kind former neighbor. I didn't turn around to see Sheedy's face to find out if she'd heard any of it. I was too ashamed.

After that, I felt as though the ghost of Paul Gleason had cursed me and nothing was going to go right ever again. Most of my inquiries about interviews continued to get "Not interested" replies, if people responded at all. To make matters worse, the Sheedy incident didn't stop me from having another awkward encounter, this time with Matthew Broderick. I passed him on the street one day, turned around, sped up to him, said hello, then blurted out, "I'M WORKING ON A BOOK AND YOU'RE A VERY IMPORTANT PART OF IT." He muttered, "Sounds

great," without looking me in the eye, and the *Ferris Bueller* star hurriedly crossed the street against a red light. A week later, I followed a guy I was convinced was John Heard for eight blocks. Just as I convinced myself it was totally wrong to follow somebody regardless of my intentions, the person turned around and I realized it had been a woman with a short haircut the entire time.

What the hell was happening to me?

I was not only failing, but also I was turning into a total creep in the process. You can't just walk up to people on the streets of a big city and expect them to want to stop and chat. That wasn't going to get me anywhere.

* * *

"If Dad hadn't shot Walt Disney in the leg, it would have been our best vacation ever!" he writes one afternoon after a meeting with millionaires who want to open a theme park on the East Coast to rival the Magic Kingdom in the west. "It would have been our best vacation ever!"

He scribbles in his yellow notepad throughout the meeting. His bosses always took that as a sign of his attentiveness and passion for the job, but in reality, he's had an idea to write a story about a family trip gone haywire, and the meeting provides him the spark he needs. He didn't need to listen to the clients talk for an hour; it had only taken a few minutes for him to come up with fifteen tags and everything else was just his company billing an obscene amount to act as though they knew what they were talking about.

The story had an opening line that he liked, but he was stuck trying to come up with a name for the dad.

It needed to be perfect, something totally middle-of-the-country.

Smith, *he writes first, and then scratches it out. It had to be the type of name you'd hear in the Midwest, in the suburbs of Detroit or Ohio. He tries Irish names, Jewish names, and the names of people he'd known as a kid in Michigan, the ones whose immigrant or first-generation fathers moved away from the factories and made enough money to give their kids a yard. Polish or Slavic surnames that typically ended with suffixes such as "-ski" or "-vic."*

Nothing works. The name has to be hilarious, *he thinks. It just wasn't possible to write about a dad shooting a beloved American figure after a long road trip, and not give him a funny name. Would the Marx Brothers be as funny if they weren't Groucho, Harpo, and Chico? Would people laugh if the Three Stooges were named Peter, Michael, and Robert? No. So this character had to be named something great that instantly conjured up images of the all-American schmuck who just wanted to show his family a good time.*

"Griswold! Get me those numbers," the client's CEO yells out across the room, snapping Hughes out of his thinking to get a look at the guy who looks exactly like the character he was trying to conjure up, all oversized glasses and a goofy look on his face.

Clark Griswold, *Hughes writes down. That's the name of the dad who takes his kids on a trip across the country, then shoots Walt Disney in the leg when they find out the park is closed for renovations. That's the name.*

Back at his desk, Hughes uses the information he knows about what the client wants, and puts down

*twenty-five tags from, "Where every day is childhood," to
"You don't have to go west for fun." Soon he'd be called
in for brainstorming meetings, but for now, his boss just
wanted some taglines to start with. In forty-five minutes,
Hughes finishes the most work he'll do for his day job all
week, and then spends the rest of the day writing a story
he titles "Vacation '58."*

<div align="center">* * *</div>

In my book, Hughes is mostly stuck in the office, writing copy
for men's razors and cars he can't even afford. Everything is gray:
Chicago, America, the world of the late 1970s. Nobody seems
happy; they're all stuck in the mire of that horrible decade and
the promise of a better America that didn't really pan out, but it's
his job to try to sell people the idea that products can change their
lives. Yet all he wants to do is write about those same people he's
supposed to be targeting. He wants to write about real people and
their funny situations; that's what's interesting to him. He thinks
about that every morning as he settles into his desk in his office
that I had decided he'd had. He definitely had his own little space
with a door he could close and everything, not just a desk in the
middle of the office, surrounded by phones ringing and people
talking. He was one of the creatives and he needed space to think.

The secretary brings him another cup of coffee, his second or
third so far, with the morning research his bosses told him to go
over. It was the same thing every day, writing ads for "Normal
Joes" as one of the more important copywriters always said, and
to teenagers, who were always treated like mindless idiots—old
enough to buy candy but not smart enough to make real deci-
sions. I envisioned how it always bothered him how much his

colleagues looked down on the people they were trying to relate to. It was the thing he hated most about his job.

When Hughes was toiling somewhat fruitlessly at the ad agency in Chicago he was in his twenties. When I was writing about him and that job and his climbing that ladder in that city that had raised us both, I was also twenty-five, just another young person looking to write chapters and chapters full of triumphs—either his or mine.

MY EDITOR AT the little magazine that was bleeding out always seemed frazzled, teetering on the brink of breakdown or, worse, losing his job. We'd talk on the phone about assignments and he'd inevitably find a way to mention death at some point in the conversation. He said the fact that his magazine was gradually laying off its entire staff made him feel like the last man standing. He was a survivor—"But even survivors die at some point," he followed up with. Even me trying to get paid made him think about the inevitable end we all face.

"You work hard and then one day you just don't wake up," he told me with a laugh, after swearing my delayed check was in the mail. "Metaphorically speaking."

I could only laugh along with him even though I didn't feel great about taking money from a magazine that was slowly dying. But Jared, a customer at my coffee shop who had once been a stringer for a big newspaper, told me that the best motto for a writer was "Take the money and run." The publications and editors would come and go, so I should never get too attached to any of them. I took the advice, but I felt bad for my first editor. He'd say things such as, "They don't teach you how to deal with failure at journalism school. They don't tell you that other people are

going to screw up and you're going to have to take the hardest hit. There's no course for understanding that at Columbia." Then he'd joke about how he should have picked another career, chuckle for a few seconds too long, and say, "Ugh. Man, fucking kill me."

That's probably why I felt especially bad when he asked me in an e-mail why I had inquired about interviewing Joan Cusack for a feature that he had never assigned.

Cusack, whose accent has always given away the fact that she's from Chicagoland, was in a new film, so I figured it might be worth reaching out and seeing if she'd be available to chat.

"This would be *great* for the magazine," I'd told the publicist on the phone after she mentioned an interview with an actress doing a voice in a cartoon movie wasn't usually the kind of story you'd see published in its pages. "We're trying new things," I'd said without missing a beat.

The magazine, which I had only been contributing to for a few months and where I had absolutely zero editorial power, was not, as far as I knew, trying new things. But who would find out? I'd simply tell the publicist that my editor killed the story, and that would be that. I always heard of writers talking about how their editors did that, it seemed totally plausible.

But that wasn't that, because my editor, in a city with over eight million people, happened to live directly across the hallway from Joan Cusack's publicist. She'd mentioned to the editor that she'd heard about the new direction I was single-handedly steering his sinking ship. So he sent me an e-mail asking why I had told his neighbor about my new plans for the magazine.

"I don't remember talking about any of this," he wrote above my forwarded correspondence with the publicist. "Give me a call when you have a minute."

I never called. I didn't do the interview, either. I never wrote for him again, losing my first job in the name of my destiny. Though at the moment the book felt more like a burden than a destiny, I soldiered along, a new notebook in hand and on my way to the library.

I had a second chapter to write.

The *Home Alone* house in Winnetka is a red-brick, Georgian-style beauty on a quiet, leafy street. People with access to a car can easily find the address online, drive a little over a half hour north from Chicago, and park in front of it for a second, imagining a young and puckish Macaulay Culkin defending his home against the two bumbling burglars played by Joe Pesci and Daniel Stern. It has become a tourist attraction, a landmark in the middle of an area where people expect privacy. Recent owners put up a fence to keep people off their lawn, but the people keep coming regardless. They come to get a live glimpse of something from their childhood, the home that Pesci's Harry calls "the silver tuna," and what they get is beauty for miles, with every road that leads to Kevin's house offering reasons to drive slowly and admire the landscape during any time of the year. If people want the scenic route, they can drive up the un-

characteristically winding part of Sheridan Road known as "the ravines." They take that all the way to the border of Glencoe, turn around, head down Green Bay Road, and drive a few minutes down to the McCallister residence on Lincoln Avenue.

On the journey, they'd notice there's something almost New England–esque about the drive that bends and shifts in ways not familiar to most Illinois residents, who are more used to the state's flatness. Large gated houses, endless foliage, and the faint smell of Lake Michigan not too far away fills the air; it's the most breathtaking stretch of road in all of Cook County, and possibly one of the best in the region, until maybe you get up into the wilds of Michigan's Upper Peninsula or any part of Wisconsin that the locals claim is "God's country." Unlike those places, however, that stretch near the lake that's so massive you could easily mistake it for being an ocean isn't some untouched and expansive landscape with a sky so big that it looks as though you can walk forward and right into it. It's a combination of pastoral and progress almost quaint and antique because it's so quiet and dominated by nature, like man only had to move a few things around and pave a small sliver of it. It's like the stormy, husky, brawling big city that Carl Sandburg immortalized in his poem is a million miles away; driving up Sheridan and then back down to Kevin McCallister's house is more akin to traveling through an Impressionist painting. It's downright pretty. One can see why people with means would want to settle there.

Home Alone also calls to mind a painter from another era, one whose name is linked to a simpler time in America, a time that Hughes might not have lived through, but was certainly fond of. Sure, there's plenty of slapstick humor and loads of schmaltz throughout the film that made Culkin a massive child star, but there's also something that's undeniably Norman Rockwell about

it. Director Chris Columbus captures something Hughes could never quite re-create when he was behind the camera: innocence and mischief, but more of the former. Of course, Columbus had the younger star to work with where Hughes had teens and all of their hormones and angst, but the setting really has a lot to do with *Home Alone*'s charm. There's Kevin in the old Hubbard Woods Pharmacy—now long gone, replaced by a Panera Bread—accidentally running off with a toothbrush he doesn't pay for when he sees his scary neighbor who all the kids call Old Man Marley, a walking urban legend also known as "the South Bend Shovel Slayer," who we find out isn't a serial killer but a nice old man who just really likes a snow-free driveway. And who can forget Jimmy the stock boy? With his perfect hair and ski lodge sweater, Jimmy looks like he just arrived in a time machine from the Eisenhower era. He dashes out the door after a freaked-out Kevin in an attempt to be the big hero. Kevin breaks away and slides across a pond of leisurely holiday ice skaters as he shakes off a police officer, then hightails it over the pedestrian bridge high above the Metra train tracks. He didn't need or want to take the toothbrush without paying, so his journey home, while a sad one because Kevin is now a shoplifter, is also bucolic and pleasant. He thinks it's the end of the innocence, but we know he's got a little ways still to go for that, and during his walk home you get to see what a nice place his town is.

To Hughes, the place where Kevin lives is supposed to represent the best America has to offer: quaint, clean, and square in the middle of everything. In *Home Alone*, we're presented with the epitome of Hughes's Rockwellian version of a place with people of a higher tax bracket. The Shermer, Illinois, that Hughes created has a population made up of almost all white people (to my recollection, the only black person we see in *Home Alone* is the

life-sized cardboard cutout of Michael Jordan that was ubiqui-
tous to the bedrooms of Chicagoland area children throughout
the 1990s, my own bedroom included), it's always supposed to
be safe, and things look perfect and gentle. In 1990, Kevin's en-
emies, the Wet Bandits, represent a cartoonish version of the one
thing white suburbanites, still warmed by the glow of the Reagan
years, thought they had to worry about: some undesirables in a
van rolling up through the neighborhood and causing chaos.

I question a lot of things while watching *Home Alone* as an
adult. I wonder why Kevin doesn't just go to the cops. If he's
able to call for pizza delivery midway through the movie after
the phone lines have been knocked out due to a winter storm,
surely he could also phone the police or receive a call from his
parents, and the other neighbors could just collect the insurance
money even if the robbers weren't caught. But then there wouldn't
be much of a story, would there? Instead, Kevin puts himself in
harm's way, taking on the two bad guys who have been terrorizing
his neighborhood, which is mostly desolate with everybody out of
town for the holidays and in Orlando or Los Angeles, or France
like Kevin's family. He's like a one-kid Dirty Harry, only more sa-
distic, torturing, nearly paralyzing, and almost killing his rivals,
all because, as he puts it, "This is my house. I have to defend it."
It isn't about what can be taken from inside of it; Kevin loves his
home, and nobody is going to mess with it. If they do, he'll burn
their heads with a blowtorch.

Some people might think it's a little much, but I can under-
stand where he was coming from. I once loved a house that much.

THE NIGHT IN November 1990 when my father and stepmother
took me to see *Home Alone* a few weeks after it premiered stands
out as one of the happiest of my life to that point. Nothing monu-

mental happened, but everything seemed to move slowly and perfectly without any of the strife I'd become accustomed to.

I'd spent the first half of the day eating Little Caesars pizza at a friend's birthday party just a little down the road from one of my favorite buildings, the futuristic-looking Edens Theater, the most modern theater in the suburbs when it was built in 1963. It would be unceremoniously demolished in 1994, but on that day, filled with Little Caesars and cherry cola, I noticed how it looked like a magnificent bird about to take flight. As my father and I drove past it after he picked me up from the party, he said that he hoped I'd saved room, because I was going out with them to dinner and a movie, not back home to a night of playing Sega and watching *American Gladiators* as I had planned.

Saturdays were normally a sacred thing for my father and my stepmom. She was kind and playful and seemed so much younger than my parents. She had just given birth to their second child together a few months earlier, my stepsister (their son had been born two years before). I was so happy to be tagging along to eat at the Japanese restaurant where they cooked everything in front of you and would pop pieces of chicken up into the air and catch them in their hats, and then to a movie of my choice.

Not that I would have minded going back home to the new house they'd moved into, the one where I spent my Wednesdays and weekends. It was at the top of a hill, and to get to it, we had to drive past two little ponds, a few stately-looking brick houses with great landscaping, and countless trees. The house was large, but not imposing, mostly brick on the outside, with a big fireplace in the living room, and dark wooden floors all throughout. The acre of a backyard ended where a dense wooded area began, and I always wondered what I'd find if I walked deep into the trees and brush. I didn't live there for the full week, but the oak bunk

bed with the cozy blankets adorned with the logos of every NFL team, the big family room with the dozen or so pillows and cushions I could pull together to build a fort, or the massive backyard where my father would lay salt blocks in the winter and we'd wait for the deer to come out of hiding to get a lick, it all felt like mine. It all felt right and what I thought a home should be. I loved that house, and as we watched *Home Alone* in the theater, about a kid around my age doing whatever it took to protect the place he loved, I thought about how I'd probably do the very same thing. I loved my house so much.

I wanted to write something about looking out the back window of my mother's car the last time we drove away from that house; how I winced in pain as her shoulder grazed my side when I'd crawled into the car but didn't want to show her the bruising that I figured had something to do with the fact that it hurt when I went to pee, and how I couldn't laugh because my ribs hurt. I didn't want to say anything, but when she looked closely at my face, at the black-and-blue around my nose, all she said was that we were going to the hospital. I could barely turn around all the way, but somehow, as we drove down the hill, I knew I should look at my father's house until it was out of sight.

"Write what you know" is a mantra I'd seen and heard more than a few times. Famous writers would say it in interviews I'd read, where they'd talk about their process and how they first got the idea for their book.

I couldn't bring myself to get personal for a post on *Home Alone* that I was preparing for my blog, although I wanted to. I reasoned that I knew the specific place where the film was made, that I was also the same age as Culkin when the movie came out, and how when you took away the guys trying to break into the house, the world portrayed in *Home Alone* looked like the

one I wanted to be in. "Write what you know," I'd say to myself as I'd stare at the computer screen. All of these new things kept popping up and holding me back from writing; my brain was chained down and couldn't work. I would type, "I had my own *Home Alone* house, and then it was gone," over and over again, only to delete it each time. I wanted to tell my story, to explain why I felt such a deep connection with that and every other film that bears the name John Hughes in the credits. I didn't care if only twenty-five people might read it; I wanted to type how the McCallister house had come to symbolize what I considered to be my suburban version of a "Mansion on the Hill," and that my father's house, which looked like the cousin of the McCallister's house from a few neighborhoods away, was the closest I'd ever get to it.

I was stuck, held back by my memories, and unable to tap the right buttons to write out an adequate starting sentence for my stupid blog that nobody read, hindered by my golden ideas of the things I wanted but never got. It was the same with the book; something was holding me back from moving past that first chapter. I tried to justify it as a case of writer's block, which all of my heroes suffered from at one point or another, but it just felt futile, as if I was going nowhere, and nobody was getting back to me. No Hughes, no actors, and none of the agents I wrote letters or e-mails to. And when the one agent I did talk to at a "Meet Publishing Insiders" event I paid fifty dollars to go to, which had been moved from a larger venue to a smaller bar with a faux-French bistro vibe, asked me why I was the person who should write a biography on such a famous and beloved director, I was taken off guard for some reason. It is such a typical question and my answer should have been something so obvious, but when he asked, I choked.

"It's my destiny," I joked to no laughs. I repeated myself, only this time saying, "Density," like Crispin Glover in *Back to the Future*.

"That's not from a John Hughes movie," the agent pointed out.

"No. No it wasn't," I said, starting to sweat a little.

"Have you written anything about him? Like any articles I may have read?"

"Nope."

"Do you write about movies?"

I told him I had a blog. He laughed.

I could tell he was quickly losing interest, so in an act of desperation, I told him about the time I thought I saw Hughes when I was stoned in a supermarket as my reason behind thinking I was the man for the job, that there was a story there; I'd had a connection. The agent didn't seem at all impressed. When I asked him for a business card, he smiled and said, "I'm fresh out," then turned his back to me, acted as though he was waving at somebody, and walked away. Fast. I couldn't blame him. I was wondering if I should come up with my own exit strategy.

Sure, I'd put together something that took the typical formula of first focusing on Hughes's early years: how he was born in Michigan's capital city of Lansing in 1950, during President Truman's post-war years, to the sound of hammers hitting steel to make American automobiles; how his early days growing up in the cozy Detroit suburb of Grosse Pointe in the afterglow of the country's triumph in the Second World War shaped the way he looked at the world; and how he wanted it to stay the same. He wasn't the son of some high-ranking Ford or General Motors guy, rather, John Hughes Sr. was a salesman who made enough to provide for his wife, son, and daughters. By writing about his subsequent move from Michigan to then up-and-coming suburban Chicago neighborhood of Northbrook and being the new

kid at twelve, I could show his development, not only as a person but also a filmmaker. Maybe Hughes found himself in the school library reading a history of his new town, and how it was originally named Shermerville but was renamed Northbrook in 1923. In my mind, I saw this whole scene of the future director scrawling "Shermer" in his notebook. He liked the ring of it, and he'd repeat it to himself so much that it would eventually open up something inside of him. For the first few years in his hometown he was bored and aimless, but then the Beatles and Bob Dylan came around, and that's when John Hughes Jr. started to see his whole future. He needed to create something, his own place and people.

Like Hughes, I had all these ideas, but they were useless without all the little things I was trying to find out, like if his father served in the military and whether Hughes was a good student. Those details that I just didn't have the resources to get were so crucial. Those were the things that made a biography.

MY BRAIN JUST wasn't clicking. I didn't have writer's block; I was drained from investing all of my emotional and mental power into trying to write about one person, attempting to get somebody to notice me, writing letters to people who would never respond, and trying to stoke whatever embers of creativity I could find. I was in a funk. Nothing felt good and I could tell a big bout of depression was coming on. I kept trying to think positive, but I knew the chemicals in my brain would win out in the end. Usually it snuck up on me, the boogeyman that I always worried would get me in my sleep, that I'd wake up one day and wouldn't want to leave the bedroom; but certain things, such as stagnation, feeling as though I was getting nothing done, could set me off like a bouquet of flowers triggers a sneezing attack for a person

with bad allergies. I told myself, as I had done a thousand times before, just bite down and it would all be over in no time. Just do your job and try not to think about your writing for a few days. Everything would work itself out, that old Hughes mentality.

At 5:45 in the morning it was already in the high eighties and the forecast called for high nineties with a light mid-afternoon sprinkling, which would essentially be like pouring a little water on a hot griddle and then placing a bowl over a piece of meat that's already frying up. Those of us left on the island and not out of town somewhere were that piece of meat. I could barely breathe, I'd forgotten the asthma inhaler that I was supposed to carry around but hardly ever needed, and as I exited the subway station, all I could feel was total dread for the long and slow suffocation I was going to feel all day. So when I finally made it to the coffee shop to find a locked chain around the handles, and looking inside, I could see that things like the cash register were gone, all the food items had been taken out, and the refrigerators that usually held bottles of overpriced water and sugary drinks claiming to be "all-natural" something or another were empty, I knew I didn't have a job there anymore. And I felt a little OK about it for a few seconds.

When it's impossibly hot in New York City and everywhere you go smells like a drunk frat boy who used a dead fish as deodorant, nobody you know is around, and you've just lost your job, the only reasonable thing you can do is get day drunk. That is the only real option. You don't go home and go back to sleep or jump right on the computer to scour for a new gig; you just kick around and wait around until you find a bar that starts letting people in around noon, then you drink as much as possible to try to put this miserable day behind you. Worried that I'd go home, make a pillow fort on my bed, and never leave it, that's

exactly what I did. I sat at a bar off the Bowery ten minutes before they actually opened and started drinking. I knew the bartender through mutual friends, and rather than letting me sweat to death outside, she passed me a shot of well whiskey and we toasted to closing the book on another coffee shop job I'd hated. I stayed at the bar until I could no longer hold up my head. Then I went home and slept until the next afternoon. That's when the depression kicked in, and while I knew it was coming, I still didn't feel like moving. No writing, no going on Craigslist to see if anybody was hiring, and really very little, save for eating peanut butter straight from the jar.

Finding a job making coffee for people isn't hard in New York City. New shops go up as fast as they close down, providing an ideal opportunity for a twenty-something just trying to figure their life, jumping from one gig to another like a caffeine-slinging journeyman or carnival worker. Once you figure out what interviewing managers want to hear (that you know how to make latte art and you think you might like to open your own coffee shop one day, stuff like that), you can pretty much guarantee they aren't going to bother checking your references. So if you got fired for spiking the cold brew iced coffee with LSD, rest assured that if a manager takes the time to interview you, they probably won't find out.

The new job was on the border of the East Village and Lower East Side, and not all that unlike the one that had closed suddenly and without warning; this one was an investment by some real estate guy from Long Island who didn't care much about the quality of the beans or where the milk came from so long as he saw profits. The manager asked me when I could start without even looking at my résumé, telling me the tips weren't great, that I shouldn't bother ever charging the Hells Angels who hung out

up the block, and that the landlord came in every day at the same
time and liked her mocha to be lukewarm and made with soy.

I'd gotten so used to acting like I cared during those inter-
views that I just said, "That's really great," in some bullshit chip-
per way, and the job was mine.

NOTHING WAS COMING to me as the rain poured outside and the
Indian summer day cooled off into full-blown autumn weather.
I sat behind the coffee shop counter thinking of that scene I'd
written with John Hughes just looking out his office window at
his ad agency. He knew he was supposed to move on to bigger and
better things but just needed to find a way. I'd watched *Sixteen
Candles* the night before, jotting down notes about how uncom-
fortable I was with the scene where Jake Ryan hands his drunk
and passed-out prom queen girlfriend over to Anthony Michael
Hall's geeky character, telling him, "I could violate her ten differ-
ent ways if I wanted to." I wondered if I actually had the chance
to talk with Hughes, even for an hour, what he would say looking
back on scenes like that. Or would I gloss over it? Would I go in-
depth and ask if he felt regrets about a lack of diverse characters,
or did he think he'd made an authentic representation of the Chi-
cago suburbs in the 1980s? If I were able to get answers from him,
what ones would I look for?

There was Internet on the computer that also doubled as a
cash register. To fill the time when I wasn't helping the two cus-
tomers who came in every hour or trying to figure out my next
steps with the biography, I'd just aimlessly search the web for
whatever I could find to read, and refresh my e-mail constantly
in hopes that maybe one of my many queries would respond, but
nobody did. Nobody cared what I was doing with my life except
some guy named Chad whose name was in my inbox. He cared.

At first I didn't realize who the guy e-mailing me with the subject line "BIG MONEY HUSTLA$$$$" was, but then after a second I realized, oh yeah, *that* Chad.

Chad was a guy I'd met through friends one drunken night. He was also from Chicago except, unlike me and just about everybody else I knew that came from within about a seventy-five-mile radius of the Loop, Chad had actually grown up in the city proper. His family owned some big company that did something with meat or food loaded with chemicals, or maybe it was feeding food loaded with chemicals to the animals that would become meat. Chad was the youngest. He was the black sheep who spent too much time and money in Berlin, various Middle Eastern cities, and now Brooklyn. His father had issued a warning that either he come back home to Chicago and get his act together, or go to law school. I assumed that would be the last time I'd ever hear of Chad since people drop in and out of your life in New York all the time. As I'd soon find out, it wasn't.

I didn't know Chad until we both ended up in New York, and to be honest, I didn't really like him all that much the few times I did meet him. He was nice enough while talking about the Bulls and the Bears, but as conversation developed, and usually as he had more to drink, he got cockier, meaner, and sometimes downright intolerable. As somebody who had been around his share of drunks, I'd developed two kinds of reactions to people who seem to gradually lose control when it comes to booze: 1.) Like I need to make sure they're OK, and 2.) I need to get as far away from them as possible before they start getting obnoxious. I knew about mean drunks, and I stayed as far away from them as possible. I sensed something I really didn't like about drunk Chad, but he usually picked up the tab, so I looked past it.

"Don't call me sir," he yelled at a busboy who had addressed

him as such when the busboy had come to clear the glasses and bottles off our table the last time I'd hung out with him. "That's my dad's name. I'm Chad. I'm just a normal dude like you." The guy had just wanted to get the hell away and to the next table so his boss wouldn't get mad. "I hate when people call me sir," Chad said to us like he was embarrassed.

He talked about eventually going back to Chicago whether he had his dad's money or not. "I can do whatever I want. I don't need money," he'd say before talking about his massive loft and all the expensive things he owned. Then he'd go on about how New York was "soul sucking," and how it was over, and how the people sucked, the parties sucked, and how it used to be better when he had moved to Brooklyn two years ago. A few months earlier, I would have probably laughed at him and said something like, "Nobody wants you here anyway, chump," and walked away, but as the drinks were settling in, what Chad was saying had started to make some sense. The noise, the smells, the rent, the constant motion; often the city felt like a bully that was sitting on my chest and slapping my face repeatedly and laughing. I was always looking for a new apartment, a new job, or a new person to share my bed with. I never had money. I was breaking down slowly. Like a million other disillusioned locals, a song that had come out that year—"New York, I Love You but You're Bringing Me Down," by LCD Soundsystem—became my anthem. And what was worse, I had charged headfirst into my book and hit a wall. Leaving didn't sound so bad; the only problem was I had no place to go.

Now I had an e-mail from Chad in my inbox. There was that, some spam for cheaper prescription drugs, a notification that I'd lost an eBay auction to win a copy of the *Some Kind of Wonderful* novelization by fifty cents, and the monthly reminder from my roommate that my rent was due by the end of the week. An an-

noying and unnecessary thing he always did five days before the rent was due. I deleted everything else and clicked open Chad's correspondence.

"I'm going back to Chicago and could really use somebody with your expertise," he said in the e-mail, which sounded a lot like the line in *The Shawshank Redemption* where Tim Robbins's Andy Dufresne writes to Morgan Freeman's Red from the outside. As if I'd been in prison for a little longer and he'd escaped to somewhere better, as though Chicago was some golden paradise compared with New York. Even if that wasn't his goal, if he wasn't trying to be clever by embedding movie quotes into his e-mail, that feeling of wanting to get far away from Manhattan came over me as I read his plan to open some sort of bar or café in some Chicago neighborhood that was seeing an influx of artists, and would eventually see an influx of people with money who would kick out the artists as well as whatever group of people had populated the neighborhood for years before anybody took notice of its spacious apartments and decent location.

"I'll give you three thousand dollars to move there and help me set it up, and a salary to be my manager," I read at the bottom without reading anything in the middle. "Come on," he said in lieu of a formal sign off, "New York is bullshit. It's done. You'll have time to actually write back home."

Back home, I thought. It had been some time since I'd called Chicago "home." I'd tried not to bring it up much, as I felt I was on my way to becoming a bona fide New Yorker. Every Sunday I'd go get a cup of coffee from the bodega that served them in the classic blue-and-white Anthora cups with "We are happy to serve you" written in gold, pick up a copy of the *Times,* walk to the park, and sit there thinking about how, yeah, things are tough, but I'm in New York City.

Besides that, I really didn't want to stick around much longer. New York City had drained me. I responded, "Let's do it."

YOU CAN GET a surprising amount of things done in two weeks if you don't have to go to work. Besides securing an apartment, as well as a car that I was supposed to pick up upon arriving in Chicago, I put most of my things into storage and sold whatever I didn't think was necessary for the locker or the trip. I made some money by picking up two shifts helping people move out of their walk-ups in nicer parts of the city than I had ever been able to afford. I visited the museums and landmarks I'd never had time to see before, and chipped away at my research and writing. I could already feel the big boulder that was blocking my path start to move, and I started to see a little light. Before I left New York, I had what I considered to be as close to a perfect outline as I could get. Twelve chapters that stretched from the Michigan suburbs to the Chicago glass box buildings, then to Los Angeles, and finally, back to the suburbs outside of the city. That was the part that I wanted to dig into the most, that period when Hughes left Hollywood and retreated back to Lake Forest. I'd focus a lot on that when I went back.

We tend to think about Hughes as one of the quintessential moviemakers of the 1980s, when the reality is that his most monetarily successful work came in the 1990s, starting off with *Home Alone,* then the sequel, and then a handful of other family-friendly movies, most notably 1996's live-action version of the Disney classic *101 Dalmatians,* and then 1997's *Flubber.* Both passed the $100 million mark worldwide, with *Dalmatians* doing well over $300 million. Just as a comparison, *Ferris Bueller* made around $70 million in the U.S. upon release, while *The Breakfast Club* made over $50 million in theaters across the globe. Ob-

viously those numbers and the continued acclaim those films garner are nothing to sneeze at, but they didn't compare to the kind of blockbuster money Hughes made in the '90s. That money made it possible for him to turn his back on L.A. and move his family to the place he considered normal, and the place he considered home. By the turn of the millennium, Hughes had all but vanished. His only contribution to cinema in the early aughts was writing 2002's *Maid in Manhattan,* starring Jennifer Lopez. It was an unceremonious good-bye, and his understanding of adolescence and his disappearance from the public eye had led some to say Hughes was to the 1980s what J.D. Salinger was to the post-war era.

Was he disillusioned? Burned out by the Hollywood machine and sick of playing by their rules? Maybe it was because of a falling out between Hughes and his muse Molly Ringwald. The young star told *Time* in 1986 that Hughes had "changed" once his movies started getting popular, that she still respected him and she'd look at a script if he handed her one, but ultimately she believed they wouldn't work together again. Maybe the answer was in the philosophies of his characters: some combination of him truly believing, as Allison says in *The Breakfast Club,* that your heart dies when you grow up, and Ferris's advice about stopping to pay attention to life since it moves so fast. Looking at the films he was involved in, there's the earlier, goofier, and more irreverent stuff like the *National Lampoon* films and *Mr. Mom,* then there's his golden period from *Sixteen Candles* in 1984 to *Home Alone* in 1990. He has a few bright spots after that: 1991's *Dutch* stands out as an underrated gem. Ed O'Neill with his unapologetic Midwestern accent as the blue-collar Dutch Dooley seemed to be tailor-made for a Hughes script, and Ethan Embry as the spoiled Doyle Standish plays a different kind of rich kid

than the Steffs and Jake Ryans; he's a jerk, but he's also sad and unpopular among his peers. *Dutch* is one of the last real flickers of Hughesian magic before he started getting paid the real big bucks from studios such as Disney.

Tracing John Hughes's career shows an artistic rise in the '80s and a gradual deflation in the '90s. I wondered if the man I was trying to find had given up on us, or if we—me and all the other fans—just asked too much of him. Maybe he just wanted to be a writer and filmmaker and be happy, away from the studio brass and the Hollywood sycophants, and we just wanted everything from him. We wanted answers to some bigger questions, just as the countless baby boomers who showed up at J.D. Salinger's home in New Hampshire looking for answers, only to be turned away by a man who just wanted to live his life. *Am I one of those people?* I wondered as my train made its way out of Penn Station, then past the city limits of the place I'd called home for the past few years. I was going back to the place where I was born, the city that I still called home despite having nobody to greet me at the station. More than anything, more than the opportunity to make a better living, to stretch my arms out just a little and not hit anybody as you do in nearly every inch of Manhattan, or to simply breathe a little easier—I wanted to find John Hughes.

MY CAR WAS a beat-to-hell blue Volvo station wagon, much like one I'd saved up and bought as a teenager that I'd named Rocinante after trying to read *Don Quixote* the first time (a task that was, dare I say, quixotic, but at the very least was a valiant attempt to fulfill a promise I'd made to Mrs. Donovan—the promise that I'd read her favorite book). This car also deserved a nickname, a christening to show it was a worthy successor. I remembered a girl I knew when I was fifteen who told me her junky little Honda

was named Leto because if you didn't give your car a name it was bad luck, so I named this Volvo Panza, after Don Quixote's faithful squire and companion, Sancho Panza. Panza and I were going to be a team. From the mileage and rust, the low price, and the weathered Grateful Dead sticker on the back, I figured that Panza and I wouldn't be riding together for all that long, but it was *my* car. On our first excursion we took a ride to a restaurant Hughes was known to visit from time to time, according to message boards about local gossip, as well as those dedicated strictly to Hughes-talk. It was quiet when I walked in; the lunch shift had wound down and the waitresses were in booths counting their tips. I sauntered up to the bar where a lumbering bartender with square shoulders and a shaved head was leaning against the counter, chewing on a red straw. I ordered a drink. I explained what I was doing, why I'd come back to Chicago, and how I was looking for any information I could find.

"So you came here to meet John Hughes basically," the bartender said as he popped the top off my Miller High Life.

"Not exactly," I told him as I began to explain the job I'd moved there for, how I needed a break from New York, and some more time to myself.

He crumpled his forehead and said, "Right."

I'd done some amateur detective work, influenced by the Dashiell Hammett books I'd been reading and the rooftop viewing of *Chinatown* I'd seen just before leaving Brooklyn, and figured if I was going to be in Hughes's neck of the woods, I should try to collect any info on him that I could. Like a real gumshoe. I'd only just decided to start referring to Hughes as "my subject" as I'd pulled up to the restaurant's parking lot, figuring that it would sound more professional. I liked hearing myself say it out loud to somebody as I fished for information.

The bartender walked to the other end of the bar and refilled the glass of Jägermeister for the only other customer there, who had just finished. The guy looked like a weathered Paul Newman, wearing a fine blue suit, and he was hammered at 3:30 in the afternoon, like some sad suburbanite out of a John Cheever story who just couldn't go home.

"I don't really like his movies," the bartender said as he walked back over to me. He propped up his foot on a shelf, grabbed a new red stirring straw, and popped it in his mouth. "Why would I want to watch movies about kids from around here and the hang-ups they have because some guy doesn't like them back or something? I have to deal with their damn parents," he said as he pointed to the guy in the blue suit, who was now snoring.

"That's why I'm writing this book," I told him. "I want people to see how his movies are about so much more."

The bartender put his foot back on the floor and walked over to the latest already-drunk businessman who had sat down on a stool. He had his tie and jacket off, his sleeves were rolled up, and there were massive sweat stains under his armpits. He yelled out his order of a Jameson on the rocks. The bartender shot him a glance, then looked at me, threw the stirring straw he'd been chewing into the trash, and said, "It sounds like this book is more about you than it is about John Hughes."

It wasn't, I assured him as I ordered another beer, since I had nowhere else to be and nothing to do, and it was summertime. I'd found an apartment online that was supposed to be ready for me to move into the day I arrived in Chicago, but when I got there it was still filled with the former occupant's stuff, as well as the former occupant himself. He still had a few days paid for and wondered if I wouldn't mind letting him stay one extra night. I said sure, and then one day stretched into a full week

until this was the last night, he promised, and he'd be out by the morning. The apartment was too hot; there was only one AC unit in the apartment, and it was in the bedroom that he still occupied. I'd come home and the bedroom door was always closed, but I could tell he was in there, either from the smell of the nag champa he was burning or the loud sex he was having with his girlfriend, who would eventually emerge, walk to the fridge in her bra and underwear, and pour herself a bowl of post-coital Lucky Charms. I knew I wouldn't get much sleep if I stayed there, so I just cruised around, passing the time through the back roads that were instantly familiar and the highways I'd gone up and down a thousand times. I had a hot dog for lunch and even ordered a pop instead of calling it soda, one of the changes in my vocabulary due to location. I stopped by a park I used to go to as a kid and sat on the swing for a little. *This is too saccharine,* I thought, but I didn't get up. It felt nice to swing back and forth and not see anybody or hear much noise except birds chirping and cars way off in the distance. When I was finally done, I drove around a little bit more until I came upon a familiar site: a twenty-four-hour diner I used to sit at until the sun came up because I had no other options. I looked at my watch and decided that the two books I had with me and unlimited coffee would get me through the night until it was time to drive back. I walked into the diner, found a table near the window where I'd always used to sit, and spent the night wide-awake, reading some, but mostly listening to the passing conversations like I used to.

The guy in my bedroom was the least of my problems; Chad wasn't picking up his phone or calling me back. We were supposed to meet on my second day in town to start going over details for the bar. *It was no big deal,* I thought. I was still supposed to be getting paid a weekly salary whether I was really doing any-

thing or not, so I tried not to worry, but not hearing anything left me concerned.

So I drove. I drove everywhere: up to my old high school, down to Skokie to see the house used in *She's Having a Baby,* into Northbrook to see where Hughes had grown up, all along the ravines on Sheridan Road, and to the *Home Alone* house. I saw places from *Uncle Buck, Sixteen Candles,* and every other movie that Hughes had shot in the area. I tried to see things through his eyes, to see an environment where he had flourished, but where I'd always felt uncomfortable and unwelcome, like an outsider. I told myself if I could understand what he saw in the suburbs, I'd be able to really start to get to the bottom of the man himself. Chicagoland, almost as much as Molly Ringwald, was his muse. The place I'd taken for granted, and frankly still felt uneasy with because I still felt like that weird kid wherever I went, had inspired him to make some of his best movies. They couldn't have been made anywhere else.

I'd driven around the suburbs a lot as a teenager when I had nothing else to do or no place else to go. I knew where things were by my own private landmarks; old neon signs advertising businesses that hardly had any customers anymore, certain malls that looked slightly different than all the other malls, forest preserves, the municipal airport in Wheeling, graveyards, water towers, used car lots I only knew about because of their commercials, spots where my friends and I had gone to smoke pot, the place where my grandma used to get her hair done in Skokie, but most of all, the houses I'd slept in.

I knew I turned left at the gazebo in Barrington ("A great place to live, work, and play" according to the town's motto) to get to Paula with the Polish last name's house. She let me sleep in the massive closet in her bedroom that already had a futon mattress

laid out in there for reasons I never figured out. Esther also had me sleep in her closet even when her dad was at his girlfriend's house. She lived a little farther north, in McHenry County, past the gas station that used to have the large selection of really good beef jerky. There was no mattress in the closet, but she'd had little plastic stars stuck to the walls that glowed green for a few minutes after she closed the closet door. So many houses; old ones, big ones, grand ones, and cookie-cutter ones that looked like every other house in the neighborhood. I attached names to each one: Brian's house where I'd slept on Halloween, Scott's house where I'd slept on a hammock in the basement, Jim's Tudor where I'd slept on the top bunk above his grandpa who had dementia. I'd never want to set foot in any of those places again, but seeing them felt fine.

How weird it was that I found myself doing the same things as an adult, taking the same type of aimless drive I'd taken countless times before. Slowly cruising down the streets canopied by lush foliage, to places that looked familiar. There was no character like that in a John Hughes movie, I often found myself thinking. I was a Lost Boy, or one of the homeless punks from the 1984 Penelope Spheeris film *Suburbia*. I drove because I was young and had a car; but I also drove because I didn't have anywhere in particular to go or anybody to go home to. It's a very American thing, teens in their cars going nowhere in particular. For me going up and down those mostly flat roads felt more like a survival technique. There was nothing fun or romantic about it. As an adult, I could at least call it research. I could tell myself it was for the book.

I HADN'T HEARD anything from Chad in almost a month. Although I stretched my money, spending it only on rent, food, and gas for driving around instead of countless expensive drinks like

I did in New York, I worried about my finances. I had nothing coming in, save for a few tiny checks in the mail for small things I'd written, but those amounted to about a hundred dollars for three reviews at around a thousand words each. Count the hours it took me to read the books and listen to the records I was supposed to write about, then the time it took me to write and edit each review, and I was making less than I was working in coffee shops. *It isn't a living,* I thought, *but at least I'm writing.*

Once the apartment was totally mine, I set up a tiny office in the living room. I'd wake up before the sun, get a coffee from the place near the "L" train stop by my apartment, where the CTA workers were usually hanging around either after a shift had ended or a new one was beginning. Then I'd go home and write for four or five hours straight through until it was time for another coffee and a walk around the block.

I knew 90 percent of what I wrote was never going to be used, but figured I'd salvage something out of it. If I wrote a thousand words about Hughes working side-by-side with Harold Ramis and Chevy Chase to finish the script for the first *Vacation* movie, maybe I'd pull fifty words out of the fire I'd mentally set to everything I wrote. Some scene about Hughes smoking two packs of cigarettes and downing cheap coffee during an all-night rewrite where he hands a final script to Ramis in less than twenty-four hours. How he had no experience writing screenplays but tried not to let the *National Lampoon*'s publishers or the film's producers know that. I was writing good stuff. I was getting somewhere. I had a few folders and notebooks overflowing with every little tidbit of info I could find and my own notes, an attempt to piece together all the important moments I could. Back in New York, trying to do anything felt maddening, but as I sat at my little desk that I'd purchased from a local Salvation Army, in my little living

room on a quiet street on Chicago's North Side right down the street from Graceland Cemetery, I felt a sense of calm I wasn't used to. I liked it.

I'd look up John Hughes on Google with any combination of words, combing for restaurants or grocery stores where he may have been spotted, but I'd only come up with a few of the same places. He was a celebrity, sure, but he worked behind the camera and had been out of the public eye for a few years. So I clung to any recent mention of him, going so far as to tack a map on my wall and try to come up with a pattern, as I'd seen detectives on *Law and Order* do to determine where a killer would strike next. Despite everything, it felt good, like I was finally on the right track.

"CAN YOU BELIEVE what they want me to go through to get a goddamned liquor license in this city? You basically have to either inherent one or have enough money to grease some palms. Have you ever greased a palm before?"

"Nope," I said.

Chad had proclaimed his bar would be "a local place for artists to hang out at during the day, and where they could get a drink at night," and that it would be "a real scene" where "things happened." I didn't know what kinds of things he was talking about, but I knew how the city's laws depended on either how much money you had or who you knew, and Chad had *some* money, but didn't really know anybody, at least not the people it turned out he needed to know to be able to legally serve booze. I also knew that anybody whose stated goal was to start "a real scene" was probably not going to do very well as a business owner, so when he finally told me there was no café, which meant no job for me, I wasn't entirely surprised.

At first, I was fine being in Chicago with no job. I'd been too busy driving within the obtuse triangle I'd built on my map: around Lake Forest, down to Highland Park, and into Vernon Hills near where I used to go bowling as a kid. Though I didn't really give it all that much thought for those first few weeks, when finally faced with the prospect of unemployment, I could feel myself begin to breathe funny. Here comes the sadness, I began to think.

"It's a bummer," Chad said as I zoned in and out of listening to him and answering "Yeah" or saying "Oh man" when it sounded as though that was what I was supposed to do. "The Spot would have been great."

There was a pause. I waited for him to say something else but got nothing.

"Did you say 'The Spot'?" I finally asked.

"Did I tell you my plan to make all the coffee cups bright orange? Every other coffee cup is white, but if you saw a bright orange one, like the color of a jacket a road worker is wearing, you'd know where it was from." He didn't answer the question, but yeah, he was going to call the place The Spot. I deserved to not have a job since I hadn't bothered to find that out earlier.

"You'd know it was from The Spot," I answered, a little relieved that Chad's incompetence had spared me from having to work at a place with such a stupid name. I'd never have to tell anybody, "Yeah, I work at The Spot."

"Fucking bingo," Chad said. "Anyway. I'll get your check to you next week. I started this new job, so I'm a little tied up." He didn't go into what the job was, but I deduced that Chad had probably known for a while that The Spot wasn't happening—at least long enough to line up a new job for himself. Meanwhile, I was still reeling from the shock that he'd wanted to call the place

The Spot, rather than totally shocked that such a flimsy plan with a guy I hardly knew had fallen through, at least not enough to call him any names. He threw some money at me for his half-assed project, and I didn't ask any questions. I'd just been looking for any excuse to get out of New York, and now I was in Chicago without any job prospects or people to turn to, and I was spending the bulk of my time just burning gas. In a lot of ways it felt like being a teenager again. There was something both thrilling and utterly terrifying about that feeling.

"And let's grab a drink next time I'm in Chicago, or if you're ever back in New York," he said just as I was ready to say good-bye.

"You're still in New York?" I asked.

"Oh yeah. I never ended up leaving," he said.

I hung up the phone and decided it was probably better not to sit around waiting for Chad's check to arrive. I opened up my laptop and starting searching for barista jobs in Chicago.

W hy do white people act like this?" my co-worker Sam asked as we watched a handful of people dance with their red plastic cups held high in the air.

"I've never been able to understand" was all I could tell him. "I'm ashamed."

I'd made the transition from barista at a restaurant in an upscale part of Chicago's North Side to daytime bartender in a matter of weeks. I didn't get the crazy shifts with the big tips, but I also lacked the knowledge to make fancy cocktails beyond dirty martinis and spicy margaritas. I just needed to remember one or two good white wines to suggest to day drinkers, as well as enough knowledge to bullshit over the microbrews. That was all it took for me to make a little more money than I had pulling shots of espresso. I'd learn a few little things about the hops, talk about how I met the brewmaster the previous week when he came in, and

say things like, "You can't beat a milk stout, especially on a day like today," because I had to feel as though I was giving it my best when all I really wanted to do was go home and write. Then I'd twirl the pint glass in my hand sort of like a drumstick, and most of the time I wouldn't drop it on the floor. Tom Cruise's character in *Cocktail* had to start somewhere, I reasoned as I imagined maybe becoming a career bartender. It didn't seem like such a bad gig.

But with the job change came a whole different set of responsibilities I didn't want, namely that newer bartenders had to work the parties the restaurant sometimes catered. This was usually called "The Shift of Doom" because people at open bars rarely tip, and those events almost always descended into total shitshows since the bar was paid for up front. That meant that Drunk Bob in the bad suit could keep getting drunker, could keep asking us for another Jack and Coke since he wasn't the one paying for it, then come back a few minutes later for another one because he'd set down his last one and couldn't find it, just like the one before that. We'd see the rising tide and the eventual crash of the evening with people crying, people swearing, people vomiting, and others making very regrettable life choices that made me wonder if I should get into the blackmailing business.

But this night was different; not your normal company party. It was a small event to cater the ribbon cutting of a new batch of luxury apartments owned by Berman Holdings, the company owned by Harry Berman and his son Micha, who, when we were both six, would do things such as lock me in the women's bathroom, or hold me under the surface of the pool as our grandparents played mahjong on the patio nearby. We grew up spending the long summers of our childhood drenched in the over-chlorinated waters together, but he was finally out of my life for good around

my tenth birthday when my grandma and grandpa packed it in and moved to the other Jewish Promised Land of Boca Raton. Now here we were again. Obviously I had done something to deserve this. *You should have just stayed in New York,* I reasoned to myself. I could feel the perspiration that forms above my upper lip when I'm nervous as I prayed in my head that he wouldn't recognize me at the party. The only thing I could do was just watch him and his three frat-brothers-turned-underlings as they raised their cups to the sky while grinding their crotches on women who I assumed weren't their wives. They chanted along to the chorus of "Get Low" by Lil Jon & the East Side Boyz, yelling out the only lyrics they seemed to know: the "skeet skeet" part.

When the song ended, and Coolio's "Gangsta's Paradise" came on the playlist, his Neanderthal friends let out a synchronized chorus of "OHHHHHH SHIIIIIIT" as if they'd been waiting *forever* for this single song from their teenage years to come on. Micha staggered over to the bar, his dress shirt unbuttoned almost to his navel. He was sweating the gel out of his spiked-up hair.

"'Sup," he said reaching out his hand to my coworker and trying to do some sort of handshake with Sam, who reluctantly played along because it was our job to make sure Micha and his friends had a good time. He slowly tried to follow the twists and turns of Micha's hand, going for a standard shake, to the tips of both of their hands, back into the classic pose, index fingers sticking out, and finally, the blow up. Micha's hand pulled away and he made a sound like a bomb was going off. Sam just laughed at that part. You can only be so professional for so long.

"You look familiar," Micha said to me as he pointed to the bottle of Grey Goose and then to his red plastic cup. My stomach gurgled, a bead of sweat dripped down the back of my neck, and there was this cold feeling in my armpits. I looked around at my

sterile surroundings: the lobby of the soon-to-be-occupied building where a restaurant I once ate at with my grandpa after a Cubs game once had stood. Now it was filled with ugly furniture that was supposed to convey "urban chic," and a stroller parking area for the young families who were scheduled to move in at the end of the month. Just a decade earlier it had been the place where a Greek guy made me a perfect grilled cheese and they served up Italian beef sandwiches that my grandpa said were the best in Chicago. He told me one day I'd take my own kids to eat there after Cubs games. Now it was Micha's shitty apartment building and they were celebrating its completion.

"I just moved here from New York," I told Micha.

"I hate that place," he shot back. I told him I could understand why as I filled his cup with straight vodka.

"So why'd you come here?" he asked in a vacant way. "The 'Second City' to you New Yorkers." As he disdainfully repeated "Second City," I realized he didn't remember me. I was safe.

"I'm writing a biography on John Hughes."

Micha crunched on some ice. His eyes widened.

"Oh, no shit. I know that guy. We sit near each other at Blackhawks games and I think he's a member of one of my country clubs," he said. "I like his movies a lot. *Home Alone 2* is hilarious."

I handed him his cup. "A total classic," I said with a smile.

"Here's my card. I'm sure you know how to get in touch with him, but if you want an intro, I could make it happen." He dropped his card into the tip bucket, which still only had the five singles Sam and I had put in there to help remind people to toss us a buck or two for the free drinks, as he fixed his gaze back toward a blond girl in a tight black dress. He then walked away from the bar without another word.

I looked at the card for a moment, and then at Micha again;

he had the girl in the black dress bent over as he pretended to spank her with one hand. There were certain limits I had to set for myself; dealing with Micha Berman was one of those.

I flicked the card into the trash beneath our makeshift bar.

"Good idea," Sam said to me as "Fight for Your Right" by the Beastie Boys came on, and the Berman Holdings celebration got turned up to another horrible notch. "That guy is just drunk and wanted somebody to impress."

THE LATTE TASTED perfect, but not *good*. It was perfect in the corporate way where one or two buttons get pushed, an internal timer that says the milk is ready shuts off automatically, and the result is a uniform beverage made without what I'd been taught by a dozen managers was a skill, a craft. It was a latte made by a machine while the human held the milk pitcher, and I forked over my cash for it even though I didn't really want a latte. I just ordered it because all the other people ahead of me in line at the Northbrook Starbucks were getting espresso drinks. Like they'd know I didn't belong if I'd just ordered a coffee while everybody else got one-pump, sugar-free vanilla drinks and pumpkin spice lattes made with soy. The latte was my concession.

Although Shermer is a mishmash of towns, Northbrook was Shermerville until the early 1920s when they changed the town's name because, according to Wikipedia, it was "notorious for rowdy gatherings at its five saloons." The rebranding worked. More upstanding citizens made Northbrook their home, and eventually the Hughes family would as well. I found myself visiting the village almost once a week, going to the library to look at old photos of what the town would have looked like when he was a kid, and trying to see what, if anything, was so special about it, or so boring, that Hughes would create his own, better version.

Sure, some neighborhoods had nicer houses, Evanston and Lake Forest had the colleges that looked like Midwestern cousins of the Ivy League schools in the East, and no part of the village touched the lake. There's something charming about it.

"A lot of Jews here," my grandfather would say as we drove to the synagogue in Northbrook for our yearly appearance during the High Holidays. I could never tell if he meant it was a good or bad thing that so many of our people lived in the houses we passed by, but Northbrook used to be one of the few places that didn't fill me with dread the second my body crossed the city limits. Now it was the place I found myself driving around the most to see if I could understand how Hughes came up with Shermer, to find what it was about this place that inspired him. That was crucial.

But as I sipped on my latte that went from hot to lukewarm in an amount of time I felt to be a little off, something else didn't seem right. I could feel my heart begin to race and a lump form in my throat. I could sense a change in the air the way some animals know a natural disaster is about to strike.

I turned around and saw a face, a very familiar face, maybe a little hairier. I thought quick—I could feel my body pulsing, like something bad would happen if I didn't leave, so I did. I brushed past the guy I recognized as another kid from high school, one of the jerks who used to call me "orphan," a minor jock, the type that was never the pack leader, never really great at any sports, but rode the bench for nearly every team, one that would jump on you any chance he got in an attempt to show the rest of the group what he was made of. They were always the most vicious ones.

On my way out I bumped several people as I tried to not make eye contact with the guy. I could still feel some tiny bit of fear inside of me, either that he could physically harm me, or worse, recognize me and tell me how good it was to see me. We'd have

some moment where he could make some half-assed apology for being a jerk to me and my friends when we were kids, but that was all in the past now.

I rushed to my car and tried to catch my breath, shocked at how something so small could rattle me so much. It didn't take long, but as I pulled out of the parking lot, it felt like my ghosts had caught up with me.

I'D WAKE UP, write, go to work, then come home and either spend my time alone reading or watching movies, or I'd drive. That was my life, and the simplicity and regimented way I was living it made things easier for me to focus on my number one task. I'd pieced together everything I could about Hughes from his life as a young man to his time in Hollywood in the '80s and had temporarily given up trying to talk to actors, deciding instead to reach out to producers, set decorators, and anybody else who might have some anecdotes from the movies Hughes was involved in—a plan that paid off handsomely. Some gave me the typical fluff, telling me how nice he was, or how they didn't have that much interaction with him but remembered he was really fond of sneakers and dressing like some hybrid preppie and New Waver, while others didn't hold much back. He was tough to work with a few told me: "That's the nice way to put it," one person said. "A control freak," another told me. A few had their theories on the extent of the relationship between Hughes and Molly Ringwald ("Nothing *too* weird, I guess," one said), while another, an assistant director, told me that Hughes got along really well with John Candy, almost as if they were old buddies from college. "It felt like he didn't like anybody else but Candy," the one person who worked on *Uncle Buck* said.

I was finally getting somewhere, slowly piecing together the

story I'd wanted to tell. And I felt patient, as though I didn't need to rush getting an agent or selling the book until I had something I was completely satisfied with.

Of course, I knew that once I sold the book that it would be easier to talk with the people I really needed to get to, that people would take me more seriously; but part of me also thought that if I could just bump into Hughes at some point maybe that would be all I needed, so I kept driving and hoping our paths would cross. And the more I drove around his suburbs, the more it dawned on me that I was driving around the places where my own memories were born, how his life and mine, although over thirty years apart in age, shared a similar geography. Right up the road from the home he'd lived in as a teen in Northbrook was the deli I'd sometimes accompany my grandpa to. I'd sit there in silence as he talked in Yiddish to other men his age, other widows and survivors who just wanted to be around people who were familiar even if they didn't know one another's names. On my way to Glenbrook North High School to see the spot where Bender pumps his fist at the end of *The Breakfast Club,* I stopped by the playground my mom sometimes took me to after she and my father separated.

I was looking for Hughes, but subconsciously I was starting to understand why I felt such a deep connection to his films, and also why I'd decided writing his book was my destiny: I wanted to live in a John Hughes film. I wanted everything to turn out just right, and I wanted to feel as though no matter what, if my parents forgot my birthday or if a principal was trying to hold me back, that everything would be fine. And the more things in my own life didn't turn out the way I had hoped and planned, the more I'd cling to his films and their portrayal of the fictional universe that looked so familiar to my own world and the life I

thought I wanted in it. The worse things got, the tighter I held on to my unreasonable expectations, all while falling deeper into depression because I wasn't one of the kids in a Hughes film. Maybe I had a chance to have something that resembled their lives at some point, but it all went up in smoke somewhere, along with the idea of having some semblance of a normal family life. Things just didn't work out as they do in the movies, I should have realized that; what they did do is go really wrong and totally off course, and writing a book, *his* book, I convinced myself, might right some of those wrongs. I told myself that getting into his life and putting something into the world, that was what I needed to make all of my problems disappear.

Driving as therapy. Each mile that turned on the odometer felt like a stride toward a new kind of clarity; it felt as though I was getting somewhere without even trying. *People pay a lot of money for this kind of breakthrough,* I thought. And then it hit me: I had to go back to the one place where I thought things could have turned out differently. I'd avoided it for nearly a decade—like some force was holding me back—but at that moment, I knew that I needed to see my father's house up on the hill, the one with the brick fireplace and the big backyard where I'd just plop down on the grass during the summertime and stare up at the sky in one of the rare times I didn't feel sad or as if something in my life was coming to an end. I felt as though all I needed to do was look at that house for a moment, just get close enough for a few seconds, and I'd be free of something I'd been carrying on my back for years.

The drive there was quiet, peaceful. I had on some talk radio show and they were discussing an old comic that used to run toward the end of September in the *Chicago Tribune* called "Injun Summer." Our teachers or grandparents would read it to us, the

paean to summer's last gasps of hot air during those early days of fall, and how they're actually the ghosts of Native Americans who'd been pushed off the land long ago. It's all old-timey and quaint, but also offensive enough that the newspaper eventually stopped printing it in the early '90s, and the man on the radio was talking about how we need traditions and how by denying those things that are parts of our culture that society and everything great about America slowly collapses.

Good riddance, I thought. If society was going to crumble to pieces because a newspaper doesn't publish a comic, then so be it. I turned off the radio and drove with the windows down, inching closer and closer to my destination. I could feel a slight quake in my stomach, and the memory of going home after my third-grade teacher read "Injun Summer" to us crept up on me. I remember that day was the first one where I really started to appreciate the beauty of the season. We had class outside and ate freshly picked apples from an orchard a few miles away from school; most of the leaves had turned from green to orange, and a light breeze would knock a few off the branches every couple of seconds and send them flying through the air. We sat around our teacher on the ground with our legs folded as she asked if any of us knew what tradition meant. My hand shot up.

"Things you do with your family," I answered.

"That's right, Jason. What are some of your family's traditions?"

I didn't have any answers for her. Something about that filled me with sadness.

The road as I drove to my father's old house recalled that day: the faint smell of burning piles of leaves and brush in the distance, the sun somewhere between daytime yellow and setting fire orange, and the air that couldn't tell if it wanted to be warm or chilly.

I passed the little pond where I used to catch tadpoles, the plot of land that had been barren for years but now sported a newer McMansion that was an eyesore among the older, more stately looking homes, and then I hit the wooded area that led to my old house at the top of the hill that was just sitting there waiting for me. I thought back to the last time I'd seen it.

"Wʜᴀᴛ ᴅᴏ ʏᴏᴜ want, *big boy*?" the Santa who smelled like butterscotch asked. He had a wheezing cough that I could hear even before I got into line. I prayed to myself that he didn't hack up anything on me and ruin my Christmas spirit.

"What do you suggest?" I asked, having not really given much thought to what I was going to ask Santa for since I wasn't expecting any gifts. Against my father's wishes, my mother had taken me to visit the fat man as a kid, so I wasn't a total stranger to the somewhat creepy custom of sitting on a costumed stranger's lap and nicely asking for things, but it also wasn't something I was used to. I was a little rusty.

There was a pause, because I don't think Santa had ever been asked to suggest gifts, and especially not by a sixteen-year-old. He knew what I was there for.

"Well," he started. I could hear a cough rumbling deep in his lungs. "You look like a rock-and-roller. How about a guitar?"

I figured I'd been on the guy's lap for a minute more than was appropriate, and the fun was over. I told him a guitar would be fine, thanked him, and started to get up to leave. It seemed he didn't know what I wanted from him. My Christmas was totally ruined now.

Waiting for a friend who had told me I could spend the holiday break at his house to pick me up, I was trying to kill as much time indoors as possible without having to spend money doing it.

The hustle and bustle of holiday shoppers going from one store to the next meant that nobody would pay much attention to me and my dyed black hair and denim jacket with punk band patches poorly sewn into it, as long as I didn't look like I was trying to shoplift anything, so I tried my best not to go into any stores. As I walked around and heard all the songs and looked at all the decorations, I couldn't help but understand why people love the holiday so much. I thought of Kevin McCallister, who despite being a kid and home alone, cut down a tree in the backyard because he needed it inside, all filled with blinking lights and glass ornaments.

What I really wanted was some pot. I remembered hearing you could buy it from somebody who either worked for Santa or Santa himself, and I figured I'd give it a shot. Sure, I was at least eight years older than a lot of the other kids in line, save for the two goths about fifteen people behind me all decked out in their black lipstick and Marilyn Manson shirts. And yes, I don't celebrate the holiday, but I'm a fan of tradition and sitting on Santa's lap felt like part of that. I was lost and scared and always looking for something to grab on to, some little bit of joy that Santa Claus is supposed to represent, and the next thing I knew, Santa was basically telling me I hadn't been good enough over the year to get what I wanted. Dejected, I started to walk away until one of the elves, a pretty girl with dyed black hair, motioned for me.

"You looking for something?" she asked.

"Uh, yes?" She stared at me and I realized she either had weed to sell me or I was about to be arrested as part of a really lame sting operation, an attempt to bust teenage stoners who were gullible enough to try to buy drugs in the mall. I took the bait. "Can I get some pot?" I asked as if I were ordering a Big Mac at a McDonald's drive-thru, forgetting what I knew about dime bags

and nickel bags—which was to say, not a whole lot. I'd heard kids at school "go in" on "an ounce" or a "dub sack" before, and I'd just sat around grinning as though I had any clue what was going on. Now here I was in the middle of a mall I used to go to when I was a little kid, buying weed from an elf, exchanging money for a baggie under a table in the food court.

I told her to have a merry Christmas as I got up to leave.

"I'm Jewish," she said with a slight laugh.

I rushed out of the mall with the bag of pot in my pocket and my head down. My friend picked me up, I asked if he could take me somewhere I could smoke weed since I knew he wasn't into it and his house would be off-limits. We drove to a forest preserve nearby. He told me not to take too long, that he'd wait in the car. I could tell he was annoyed. I'd stayed with him before, and it was obvious he felt sorry for me but didn't want to lie to his parents again about why I was staying at their house for two weeks. I told him I would give him extra gas money as I got out of the car.

I walked the trail into the forest, avoiding the off-the-map one that every local kid knew about because, according to urban legend, a Nazi gang had their initiation ceremony down there; and then there were the storm drains a few hundred feet to the other side, where a friend of a friend's uncle said was where the Satanists held their rituals, which included human sacrifice in the 1960s, and where the ghosts of whatever they killed still hang around. Even though there was no record of any of this—no bodies turning up with 666 carved into their skin, nor any Swastika-wearing skinheads stomping into town—I really didn't want to find out for sure if those were all just local myths. I kept walking over the virgin snow that had fallen a few hours before and had only some deer footprints stamped in it. I came upon a gazebo that looked out over a small pond. Figuring I could hear if anybody

was coming and could see clearly in all directions, I decided to make that my spot. I took a hit, started coughing wildly, and began to worry that I was going to die right there choking on my own stupidity. They'd find my frozen body with the joint right next to me, and they would turn me into some cautionary tale. I'd become an urban legend: the burnout in the woods. The kid who couldn't hold his weed.

I calmed down and caught my breath, took another hit, and stood motionless for a second just staring at the scene in front of me, where everything was beautiful and silent. No hikers around crunching the snow beneath their feet, no birds flying above, no Nazis, no Satanists, only the scent of cold mixing with weed floating up into the ether, nature, and me. For a moment I was at peace. Stoned, but at peace. I realized that it was one of the first times I'd had a moment to myself, when I wasn't tied to when a friend's parent was coming home and I had to leave, to my school schedule, a crappy part-time job, or somebody reporting me to the authorities because I didn't have a permanent place to live. I didn't spend any of my few fleeting seconds thinking about any of that, I just stood there and listened to my breath until a branch cracked nearby, startling me back into the reality that I had less than a couple of hours before the sun went down and the dreaded wind off the lake would start kicking up. It was nothing, but it was also enough to get me to head back to my friend's car.

We spent the day just driving around like good Midwestern kids do. From Lake Cook Road to Sheridan, down through the North Shore neighborhoods. I could see into windows, happy families sitting down to meals. Up through Evanston, onto Lake Shore Drive, where it felt like we had one of the greatest roads in the world all to ourselves, save for a few lonely truckers and stragglers who were leaving work late, probably trying to finish

up a few things before the holiday. The sky was black, but the street lamps and billboards in the frosty dark made it almost seem eerily light out, the shadows of skyscrapers and signs of commerce everywhere. We drove south into the city, then at some point, looped back around toward the north to see the Morton Salt girl painted with the words "When it rains it pours" next to her. There were other logos that had dominated the same drive I was taking since I was a kid: Wrigley's, McDonald's, the Magikist carpet cleaning lips sign that used to be all red and illuminated against the black sky was unlit but noticeable, like a creeping shadow; billboards telling me to drink Coca-Cola or Budweiser, faded advertisements painted on the sides of brick buildings, and numerous signs wishing me a Merry Christmas. I was tired and edgy but my eyes wouldn't close because of all the cheap gas station coffee I'd ingested earlier in the day. I was burning up from sitting in the heated car with my jacket on for too long, but it was barely in the teens outside. I wasn't thinking totally right.

That's how I made a decision. It was the type that only the most desperate, stoned, and coffee-soaked person would make. I asked my friend to make one last stop. It wasn't far from his house. It would only take a second, I said. I wanted to see my father's house.

We arrived almost at the stroke of midnight. It was one of those bright winter nights when the starlight reflects off the blanket of snow. The car hummed as we let it move by itself without my friend's foot on the gas. That terrible Paul McCartney holiday song, "Wonderful Christmastime," was playing on the radio. There were no lights on and no movement in the house. No doubt the family was somewhere warmer for the holiday, and the house next door sat empty, a FOR SALE sign trying desperately to hold its position against every gust of wind. I told my friend to kill the

engine a few feet from the driveway and crept up to the garage to find one of the cars was gone; a sign that told me it was parked at some airport for the next few days.

My father always told me I was going to fuck up at some point. He'd laid out all of my options when I was a kid, and although none of them seemed like paths I wanted to explore ("bum," "loser," and "a zero" were pretty common possible outcomes according to him), he never actually said criminal, at least that I could remember. He never told me that instead of being Kevin McCallister, I'd end up becoming one of the Wet Bandits from *Home Alone* trying to break into a house, albeit my house, or a house that had been mine until the courts ordered my father to stay away from me. I figured I'd take my descent into a life of crime one step at a time: if the code to open the garage was still the same as it was last time I was there, then that was the first step. If the door that led into the house was unlocked, that meant I only had to see if I could disable the alarm. If the alarm was set, that meant they were out of town because that was the only time they ever used the system. I was surprisingly good at breaking into a house, a fact that unnerved me a little.

The piercing beep sliced through the quiet; I hit the numbers on the keypad and silenced it. The alarm echo disappeared and I stood there for a few seconds as melted snow dripped off me onto the floor, but it felt like an hour as I took in the sight of the place once so familiar to me, now just a house I had entered without permission. I took a second, thought about the layout of the entire place, my old room with all the hockey and basketball team pennants, the family room where I watched movies by myself, the window a few feet from me where we would watch for deer to come sprinting through the yard. I loved that house so much once, and then it wasn't mine anymore. The place where I was

standing was no longer a place where I belonged. I turned around and walked out. The fumes from the coffee and the adrenaline from doing something I knew was wrong mixed together and I had enough energy to get back to my friend's car and collapse into the seat. He didn't ask any questions and didn't say anything to me the rest of the way to his home. It was obvious he was pissed. He knew I had come close to getting him into trouble. I wanted to tell him how much I loved that house, to try to explain what it symbolized to me. It was an intangible thing I longed for. I tried to find the words, but I could feel my body crashing, I could tell he didn't want to hear anything but the latest Christmas song on the radio. That was fine, I had nothing left.

THIS HOUSE MEANS *nothing to me anymore,* I said to myself as I pulled away. All the memories from my childhood, the good and the really bad, and from that one winter night when I was a teenager all rushed through my brain. I was an adult now; the house had belonged to some other family for years by the time I was taking another shot at Chicago. It was just a house, nothing more. I told myself to grow up as I headed back toward the city.

After that, it felt as though I'd seen everything I needed to see in the name of "research." I still took rides, one time driving near where I knew Hughes's home in Lake Forest was, letting myself think for a second that maybe if I just slipped into his mailbox a note or copied pages of everything I'd written that I could get him curious enough to get in touch with me; that was going too far, I told myself. I took a day trip up to Michigan to see the Detroit suburb where he'd grown up before moving south to Illinois, but that didn't get much; the people I talked to were familiar with his work but didn't even realize he was from there since other than *Mr. Mom,* which debuted in theaters a week before *National*

Lampoon's Vacation in July of 1983 and takes place in Detroit, Hughes didn't write or direct any movies that took place in his native state. He's from Michigan, but claimed Chicago, although he was unable to shed a few trappings from his childhood, those little hometown quirks that implant themselves inside your brain at an early age and never leave. There's one tribute that stands out: a nod to his favorite hockey team, the Detroit Red Wings. In *Ferris Bueller,* Cameron wears a Gordie Howe jersey, the childhood hero of probably every kid from his generation who grew up within a hundred miles of Detroit. Similarly, a ride up to far-northern Illinois—a part of the state where I spent some time in my teens dodging gigantic mosquitos off the Fox River—was planned but never happened. A friend who I'd shared an apartment with for two months when we were both sixteen had mentioned she was sure Hughes owned a farm in a dairy town just a few miles from the Wisconsin border, but again, there was no reason to go up there; that was his retreat. I had come so far with my writing, getting past the point where the rift between Hughes and Molly Ringwald and Anthony Michael Hall had started to take place.

On one hand, perhaps Ringwald telling one of the biggest magazines in the nation that the working relationship was over and Hall turning down both *Pretty in Pink* and the role of Ferris Bueller had soured Hughes. It killed his enthusiasm to try to *create something.* After that, he was simply making films—it was his job, and he was fine moving farther and farther away from the camera and more into the role of businessman. On the other hand, I reasoned that Hughes was just a savvy guy who knew what worked and when it was time to move on to the next thing. The teen movies were good and helped establish him, but as he closed out the 1980s writing, directing, and producing *Planes,*

Trains and Automobiles (1987), *She's Having a Baby* (1988), and *Uncle Buck* (1989), it was as though Hughes was maturing along with his audience, as if that was the plan all along. But was he growing up, selling out, or both?

The films he made starting in the '90s, while more polished and lacking the urgency of his earlier work, still retain the wide-eyed and well-intentioned characters that made me believe that Hughes himself was a big kid with good intentions, only that at some point he realized he had a formula and that formula could make him a lot of money. Get yourself a misfit—it could be a dog or a cherubic little kid—and let them get into all sort of trouble and mischief until, finally, the misfit saves the day. Everybody is happy, all is right in the world, and, most important to the Hughes formula, there was always a happy ending.

However badly I wanted to know his motivations for his more formulaic 1990s output, I was torn between desperately wanting to reach him by any means necessary and respecting the privacy (which, I suspected, was what he'd really been building toward his whole career, a desire to not really be in the spotlight, or at least shield his family from it). I decided that if I was going to meet Hughes, then it would be the right way; I wasn't a hardened detective on his trail, or worse, a stalker.

But what was the point of me being in Chicago anymore if I was hitting my stride with the book but also deciding not to try to search for John Hughes? If I wasn't going to drop his name to all the baristas at all of the Starbucks I visited that were within the little triangle of his proximities I had on my wall, all in hopes of seeing if they'd divulge any bit of information, then there wasn't any point in sticking around. Why couldn't I just go back to New York where I had people and friends I knew instead of letting my old Illinois demons drag me down? What was holding me back?

I just needed a sign, I reasoned; and I got three the following week.

#1: I LIVED almost like a monk and never had visitors, but when Michael needed a place to crash as he made his way up toward Michigan to stay with friends, I finally realized how my living situation must have looked.

"Do you ever leave this place?" Michael asked as he surveyed the hundreds of pieces of paper scattered throughout the apartment; the DVD cases thrown on the floor, the old magazines I'd bought on eBay for research stacked on a pile of notebooks, and my little glowing laptop nearly buried in the middle of everything, the little Apple logo the only sign that it was there.

"Book stuff," I said, not really noticing that I'd finally hit my sloppy eccentric phase.

"You need to go back to New York," he said with a laugh.

I agreed with him, but said it would probably take me months to figure out a way to get back.

#2: "DEAR JASON. As somebody who grew up at the same time as the teenagers in his most popular films, I'm intrigued and excited about your proposed John Hughes biography: *Don't You Forget About Me*."

Did I want to continue reading? Was it just going to be another agent saying, "But I'm not looking for new clients," or "I don't think you're the person for this book," or just a flat out "No."

"You think big, in fact, sometimes a little too big for a proper proposal." Shit. Why did I keep reading? OK, read more, I told myself.

"But that's what a writer is supposed to do." Yes! Yes it is!

"If you don't already have representation for this exciting project, I'd love to get coffee or a drink to discuss some ideas."

I WOULD LOVE TO GET COFFEE, DRINKS, WHATEVER THE HELL YOU WANT!

I'd tried to contact so many agents that I'd forgotten who this one was, yet I still wanted to go to the nearest liquor store, buy the cheapest bottle of cold champagne, and pop that sucker open. When I looked at his agency list of clients on the Internet, it was a few diet book authors and people who wrote legal thrillers that I'd never heard of. I wasn't sure where I'd fit in among that list, but then I thought back to one of the message boards I'd read about trying to find an agent, how a few of the people on there agreed that there was some element of timing as to when you could expect to find an agent, and the dead of winter, after the entire industry had come back from their December breaks and were looking for new projects, was maybe the best time of the year for that.

"I'd love to meet. When and where works for you?" I responded in an e-mail, prepared to board any bus or train the next day if needed be.

#3: "DID STEPHANIE tell you your guy was just in here?" one of the servers came behind the bar and asked me.

I shook my head. I had absolutely zero clue what he was talking about, as I'd just come in from the freezing February weather to work a night shift and was trying to warm up.

"You walked right past him when you came in," Stephanie, the server with the raspy voice of somebody who'd been smoking since they were in middle school, yelled out as she counted her tips a few feet from where I was sitting. "John Hughes! He was just eating in here. If you would have picked your head up when

you walked through the door you would have seen him. Really friendly guy."

"Seriously?" That was all I could muster. They had to be messing with me.

Everybody who worked in the restaurant had something else they wanted to be doing, and I constantly let it be known that I was writing a book on John Hughes, just to reiterate the fact that I had other things going on, and maybe because I felt bad that I never went out for post-work drinks. I figured my *real* job, writing, was a good excuse for being antisocial. I'd composed scenes of Hughes dipping out of Hollywood parties to go write; something somebody that knew him back then told me he did.

This is it, I thought right there as I looked down at my apron that had dried tomato soup stains from the shift before crusted on it. I'd come all this way in my search to find him, said it if it was meant to be then it would happen, and here he was, and I'd missed him. There was some metaphor to be pulled out of the fact that he'd been right there next to me, and I hadn't even noticed, as if I'd had my head down my entire life or something deep like that. There was probably some word in German that could describe the sensation. I wasn't going to stand behind a bar and make small talk with drunk customers who would surely sit on their barstools as long as possible so they didn't have to go out into the frozen wasteland that awaited us just outside the door.

"I'm leaving," I said as I stood up with my jacket still on. I walked out the door five minutes before my shift was supposed to start, went home, and started to figure out who in New York would let me sleep on their couch for a week or two while I figured things out.

W*hat's next?* That's a theme that runs throughout every John Hughes film worth its salt, and really, it's something you think about when watching almost any film from the 1980s. What will happen next? Not just in the next scene, but in general, even after the cameras are finished rolling. There's a feeling running through '80s films that you must accomplish something in a proper time, because if you don't, then you're going to miss your opportunity; either that cute guy or girl is going to walk out of the mall's food court and you'll never see them again because the Soviets are going to launch missiles across the ocean and then you'll have a few long minutes left to think about what a failure your life was because you didn't seize that one moment. Wouldn't that be terrible? All that Cold War worry led up to that moment, and you screwed up. Don't regret anything: "Carpe diem, seize the day," as Robin Williams says in

Dead Poets Society. It's the friends from *The Big Chill* all getting back together after a suicide, Kevin Costner in *Field of Dreams* and all the things he never got to say to his father, or *Stand by Me*'s epilogue where Richard Dreyfuss finishes his memoir by saying although he hadn't seen his recently murdered friend (played perfectly by River Phoenix, one of the teens I sometimes dream could have ended up in a Hughes film) in ten years, that he'd still miss him forever. You can tell he's filled with regret for letting things slip away, specifically his youth and his friendships. The movie ends with the message that you never know what's going to happen next, so say and do the things you want when you have the time; you might anguish over it later if you don't.

That idea hangs over all of the Hughes movies: What's next for the members of the Breakfast Club? Will Ferris and Cameron stay friends and will Ferris keep dating Sloane who is still in high school? Do you really think Buck will go back to Wisconsin to see Cammie, his summer crush in *The Great Outdoors*? Then there's Kevin Bacon's Jake in *She's Having a Baby* who really doesn't seem to want to be married. Even though there's the beautiful montage at the end where she does what the film's title implies she's going to do (spoiler alert: she has the baby), it isn't totally wrong to wonder if things will work out with the young couple with the added pressures of a child to go along with everything else, including the fact that Bacon's character wants to quit his job and become a writer. Things might seem temporarily fixed, but what about the future? Will the teens get into the right schools and get the right jobs after they walk out of Shermer High School for the last time? Will the adults be able to overcome their issues and live happy lives?

Even if I end up selling the book, let alone actually finishing it, I reasoned with myself, *I have no clear idea what to do after that;*

there was no backup plan, no post-book idea. Would I go on to become an official expert on Hughes? Could I make a living from lectures and speaking engagements? Did I even want to do something like that if I could? I wanted to write, obviously, but I wasn't going to become some hardened reporter chasing down stories, and I knew I didn't have the chops to become a novelist. Was I even a good writer? I'd never been critiqued or workshopped. All those thoughts swirled around in my brain as I stared out the window of my new apartment back in Brooklyn at three in the morning while taking a break from looking over a dozen interviews with John Candy for the one little quote I needed to make a paragraph about the filming of *Uncle Buck* just right. I had all of my notebooks and research, my computer, and a box of books, but I left everything else in a storage unit in Chicago, figuring I'd pick it up at some point when I was ready to go back. I thought about how much I'd already put into this one attempt to write a book and how little it had yielded, then wondered what the hell was next for me. That's when the fear set in. My mind went into panic mode.

"I THINK I want to become a rabbi," I yelled at Michael over the 1960s reggae song at the small Williamsburg bar just a few blocks away from the BQE overpass.

"You want to what a what?" Michael yelled back.

I repeated myself, basically screaming over the Big Star song that had started to play. Michael didn't say anything back for a moment. He looked at his watch and pointed out that happy hour was ending and we should get drinks before that happened.

I've never been religious. My dad once described the lox at my bris as "life changing," but found the ritual itself "pretty disgusting." My bar mitzvah was basically me crying over a cheat sheet,

and I walked out of a grocery store job at fourteen yelling, "Fucking fascists," after the kindly old owner asked me to turn my Bad Religion T-shirt inside out. Faith had never really played a part in my life, yet there I was, over a decade later, sitting in a bar and telling my friend that I wanted to become a holy man. It wasn't hard to understand that he didn't get it; I hardly did.

So how did I decide that becoming a rabbi would be my post–John Hughes biography profession? Simple: I woke up one afternoon after staying up until four in the morning, writing hardly anything at all, and said to myself, "I want to be a rabbi." That's it. There was no vision of Moses in my toast, no sudden and inexplicable interest in ancient Jewish texts; I just wanted to be a rabbi. It sounded like an admirable profession, like how some people wake up and decide they don't want to be a stockbroker or some other shady profession, that instead they'd rather do something good.

"You know rabbis can write books," I told Michael as I tried to explain to him that even though I was planning on looking into how to enroll in rabbinical school as soon as possible, I was still the same old Jason. I was still cool. The only difference was that I couldn't hang out on Friday nights anymore and that I had decided to go kosher, so eating anywhere was an issue—but still pretty much the same guy.

"I think you need more sleep," Michael said. "Your brain is fried, you're cracking."

I brushed him off with a laugh.

"You don't even believe in God," he pointed out.

I corrected him, saying that I believed in *something*, it just wasn't some old dude in a robe sitting on a cloud. "I believe in a *higher power*," I said.

To me, it seemed logical. Rabbis are supposed to be wise and learned, and I told myself I was going to be a cool rabbi, one who

was just as interested in pop culture as he was kosher foods and weekly Torah portions. I'd be the type of rabbi people liked and wanted to confide in. And so what if I didn't believe in organized religion? History was littered with people who went against the grain and shook things up for the better; I'd be a punk rock rabbi.

"Whatever," Michael said as he got up to order another round of drinks.

"You'll see," I said under my breath. "I'll show you."

I did not, in fact, end up showing him.

What I did do was weird out a lot of friends by wearing a yarmulke, taking note of how each of them looked at me when they noticed I was wearing the little flat disc atop my head, squinting their eyes to make sure they were seeing it right, followed by an awkward smile. I also alienated my roommates by clearing space in the cabinets for my own set of dishes that I would only cook vegetarian meals on and by asking them to try to keep it down on Friday nights because it was supposed to be a restful time for me. I spent five hundred dollars on Hebrew lessons from a former Israeli soldier named Tal who smoked cigarettes nonstop and would end our class every single time by saying, "This is finished. Now you go." I walked two miles to a synagogue in Queens every Saturday because I wasn't allowed to take the train, and I started studying Torah, trying to learn all of the things I didn't pay attention to in Hebrew school—all of that while still trying to write the book. My brain was bouncing back and forth between trying to figure out if Hughes was more of a Duckie or Ferris in high school, and trying to understand the Talmudic dispute Rabbi Akiva from the first century was having about the sale of seeds to a neighbor.

"It takes a very long time to become a rabbi," Zev told me. Zev was the rabbi I'd been studying with: a jolly guy with a big beard

and a belly to match. Zev was more concerned with me living a "good Jewish life, a kosher life," than me trying to get into his profession.

"Yeah, yeah," I answered. "I'll get there."

He looked at me and gave me an unconvincing smile.

"How's your book coming?" he asked.

I told him I was stalling, trying to fix a part from earlier in the book, something important about Hughes growing up and the impact it had on him as a writer and filmmaker, while also trying to abide by the laws of my newfound faith, not working on the Sabbath, giving up all those hours of free time to rest.

"I've seen his movies," Zev said. "You know Ferris Bueller is a Jew."

I smiled and corrected him: "The guy who played him is a Jew. I don't think he is."

Zev adjusted his yarmulke and thought for a second. I liked his pauses; I appreciated him thinking things through before he said them. I'd always been too impulsive and just blurted out whatever and really respected people who took that extra second or two before letting the words out of their mouth.

"Sure. But Ferris has got a Jewish head, a Yiddish *kop*," Zev reasoned, using the old country term I'd heard my grandpa use when describing a smart Jewish person. "He's always trying to outsmart people who have more power than he does."

"His parents don't look Jewish," I reasoned.

"Ah, but his sister, the actress from *Dirty Dancing*, she's also a Jew," Zev said. "Maybe they're adopted? That could be the sequel: Ferris and his sister find their real parents. We could write it together."

I liked spending time with Zev, but shortly after that, I drifted away from my dream of being a rabbi and back to my book. I kept

my cookware separate, maybe out of pride, not wanting to show my roommates that I was backing out of my self-righteous commitments and statements I'd made about how I just wanted to live a better and fuller life. I needed my Friday nights and Saturdays to think about teen movies, not the Torah.

A month later and I was still getting settled back into New York, trying to get my savings back up after moving away and back; writing the occasional freelance piece about indie bands, and working two days a week as a server at a restaurant. I fell into a deep mental slump. My anxiety was triggered by a revision to a piece on Hughes just at the point where he was trying to move away from teen movies and into more adult narratives. It was a career crossroads for him, a moment in which I pictured him standing alone, back in Chicago after a few miserable years trying to live in Los Angeles. He looks up at the tall trees in his backyard, hears nothing but the gentle gust of wind blowing past him (and not the L.A. traffic jammed up for miles as he'd grown accustomed to) and he wonders what's next for him. He feels as though he has a kindred spirit in John Candy, with whom he's set to film *Planes, Trains and Automobiles* in a few days. And by that point in the mid-1980s, Steve Martin was already a comic legend and box office draw. Yet there's this worry that maybe he's going to the land of no return.

"FUCK THIS THOREAU STUFF," I scrawled next to the part where Hughes was looking up at the trees. I wanted to capture the moment of a person trying to find solace as he anticipates changes, but I noticed I was trying to build Hughes into a person that he wasn't. I was painting a picture of a quiet man, somewhat stoic and contemplative.

Sometimes I have flashbacks, not from taking mushrooms on Halloween and running around in the woods as I did during my

freshman year of high school, but from my childhood. It just hits me; some smell or sound could trigger it, but mostly it's from a buildup of things just feeling out of place. That's when I start getting depressed, when I feel like that helpless kid. I'd been running around so much over the last few months that maybe I just didn't notice how I was feeling, but there I was again: Jason the Failure. That old familiar feeling took over. I had no idea what to do next.

I had never gotten along with anybody named Tristan before.

There was Tristan #1, a kid at my summer camp when I was nine who locked me in the girls' bathroom overnight. Tristan #2, an older kid in my high school, wasn't so bad. He had a ponytail, wore turtlenecks, and drove a Mustang that he sometimes gave me rides home in after school because he was trying to sleep with my friend's sister. And although I never met Tristan #3, a girlfriend in my twenties started dating him right after she broke up with me, as if they'd been planning on getting together the whole time.

Tristan was a bad luck omen. Yet there I was in a trendy SoHo restaurant with a menu full of locally sourced foods, and lots of reclaimed wood on the walls, laughing at Tristan's always bad, sometimes offensive jokes. Yet I didn't care how unfunny he was because I was finally face-to-face with an agent and I didn't

want to screw it up. I could feel myself selling out, like some cartoon devil was waiting for me in the bathroom with his pitchfork and hellhounds, all ready to tell me, "You finally sold your soul," before disappearing into a cloud of smoke. I was forcing myself to laugh as Tristan spouted all of these horrible things about people I didn't know because I so desperately wanted an agent.

He didn't seem that much older than me, but I was listening to him talk and never interrupting because it was of the utmost importance to soak up every little bit of information he gave me. I poked at my pan-roasted Cornish game hen nestled in a bed of hen-of-the-wood, shiitake mushrooms, and veal bacon, its little claw sticking up at me as though it were flipping me off. I'd originally ordered the chicken salad, since it looked to be the cheapest thing on the menu and I wasn't sure if Tristan was supposed to pay or if I was, but they screwed up my order and brought me the angry hen so I shut up and took it.

"How much money do you want to make?" he asked as I took a sip of my lager.

"I just want to write," I told him. I didn't mean to sound like some kid in a movie telling a coach that all he wants to do is *dance,* but I was being as honest as I could. I only wanted to do one thing with my life and I hoped the biography I'd been working on would be just the start of that.

"You're so goddamned Midwestern. I love it!"

That sounds like an insult, I thought as I spit one of my bird's tiny bones into my hands and placed it on the plate. Tristan looked around as if he was trying to find somebody; I'd seen plenty of other agents and writers do that look at events I'd gone to, like they were getting ready to talk to the next, possibly more important person. I tried to pay it no mind and forced myself to laugh.

"So I think this is a brilliant idea. Can't miss. People who grew

up on John Hughes are getting on in the world. They have cash to spend and there's never been a book like this for them to spend it on. Let me ask you something." He talked really fast and with sort of a California surfer dude dialect that betrayed the New England prep school upbringing he mentioned. "Who's going to play Hughes when they turn this into a movie?"

I shook my head. I had no idea.

"So fucking Midwestern," he said again. He seemed to really get a kick out of saying that.

I laughed again, this time adding a "Yeah" for good measure. Whatever he was thinking, I agreed with.

"I don't know why, but I picture Steve Carell," Tristan said as he stood up to go outside and smoke. "You just need to make this a bit edgier, you know? I see Hughes as a man against the world, a man born to make art in the plastic 1980s."

"You really think that you can make this book, *my* book, into a film?" I asked him as I swallowed a piece of the bland mashed cauliflower (which I almost thought of spitting into my napkin and hiding away like I did when I was a little kid).

"Not a doubt in my mind," he said with a wink. "Order us some shots while I'm outside. It will take the edge off having to go back to the office."

For a second I felt like a real big shot, day drinking with the guy I just knew was going to be my agent. I ordered the shots. My job could wait.

An hour later, I was back to reality, back to my desk. But I felt good; I was drunk. I started to think of what the premiere for the movie adaptation of the book would look like: all the flashbulbs going off, and me walking down the red carpet with the lead actress by my side. My mind immediately went to Natalie Portman, but I could also see maybe about getting Scarlett Johansson

a part since I'd be both the writer *and* the producer of the film. I was in the middle of thinking of my dream cast, which included parts for Mary Stuart Masterson and Alan Ruck, when a big pile of folders crashed on my desk.

"Sorry to interrupt," Rebekah, the rabbi-in-training who taught Hebrew when she wasn't busy in rabbinical school or giving me the stink eye, said as she loaded me up with work to be done over the rest of the afternoon. I gave her a smile; she looked at me as though she knew I was up to something, and then walked away to leave me to my typing.

Using knowledge I'd acquired during my brief stint as an aspiring rabbi and a few articles I'd written for a magazine aimed at young, hip Jews, I'd found a job at a Jewish day school. Initially they'd told me I'd be working with the kids, but when they realized I hardly knew any Hebrew and that I couldn't play the guitar and sing quirky songs like Uri, the handsome Birkenstock-wearing guy who everybody had a crush on, they demoted me to answering phones and buzzing people in.

That wasn't a bad thing, of course: I was still making double what I'd ever made in coffee shops or serving people food, and I worked on my book from ten in the morning when the nannies (and on rare occasions parents) dropped off their kids (many of whom were named Noah, Eli, or Sari) until around three when they were picked up. They were the children of stockbrokers and high-powered executives who were chauffeured around the city in shiny black SUVs. They had dietary restrictions, some of them medically diagnosed, many of them in step with food trends their parents deemed acceptable. They were loud and the teachers didn't dare tell them to quiet down, lest they suffer the same fate as Esther, the sixty-eight-year-old former head teacher who decided to tell a boy named Benjamin to take a time-out. Benjamin,

it turned out, was the son of one of the school's biggest donors, and he didn't take too kindly to some old lady telling him what he could and couldn't do. When Benjamin's father sent his assistant to a parent-teacher meeting, Esther told her, "Benjamin won't ever learn if nobody disciplines him." After a few days, Esther was phased out. She'd shown up to find a younger teacher had taken her place, and within a month of the conversation, Esther walked out the front door with a box of her things. She stopped at my desk in tears and told me, "This place is *disgusting*!"

I'd flashed a weak smile of solidarity at her as she walked out the door since I knew the hip young rabbi from California that they'd hired to run the place (and who I could just tell didn't like me) was standing in the doorway, ensuring that the departing teacher didn't make a scene. I wanted to say how sorry I was and that she was a good teacher, but I didn't. I was in my late twenties and finally had a steady job with a salary and insurance; I didn't have to go home smelling like an old cup of coffee anymore, and I was nine chapters into the draft of my book and feeling pretty good about it. I didn't want to jeopardize anything. It was an act of cowardice, but also the type of pragmatic decision I wasn't used to being in a position to make, not wanting to lose my job or shake things up. *Cosmically,* I thought, *things are going well for me.* One slight move could screw up everything just as I was looking at the light at the end of the tunnel that was my first draft, which was due to Tristan at the end of the month.

They rarely gave me tasks at work, so I figured it was smart to always be looking at the computer screen, acting as if I was doing something that earned me my paycheck, but I started typing again after the rabbi walked away. I was sketching out something for a tenth chapter, the one that would find Hughes totally re-settled in Chicago in the early 1990s. His last few films were

flops. Janet Maslin of the *New York Times* gave 1991's *Career Opportunities* a lukewarm review that compared it to *Home Alone* for adults. *Only the Lonely, Dutch,* and *Curly Sue,* all of which were also released in 1991, could be considered minor works at best. Reading Maslin's review, I could infer that film critics didn't take his work seriously, even back then, no matter how popular they may have been. He was the guy who made a few good teen films, and one of the highest grossing comedies ever with *Home Alone,* but he was not one of the greats or important filmmakers in the eyes of the critics. I often wondered if he ever thought about that and tried to incorporate it into the biography without speculating too much. Maybe it bothered him to an extent, but ultimately he felt he was doing his job as an entertainer, and if the critics didn't like his movies but audiences did, then that was what mattered.

But the audiences *didn't* like the films he put out after *Home Alone,* and that led to a 1993 article in *Spy* magazine titled "The mega-auteur Hollywood hates," a searing profile that painted Hughes as a tyrant, a man with zero loyalty who'd fire a person for the tiniest mistake. The piece went on to posit that if *Home Alone 2* (which was hitting theaters just as the reporter turned in the article) hit big at the box office and gave him another hit, Hughes would "grow even larger, ever more demanding and petulant." Fifteen years later, it almost reads like prophecy considering the sequel netted over $300 million worldwide. After the second *Home Alone* came the *Dennis the Menace* adaptation, then the widely panned *Baby's Day Out,* and the surprisingly good if somewhat depressing 1994 remake of *Miracle on 34th Street.*

Hughes abandoned his little American town of Shermer, Illinois, for different settings like New York City. There was no more Breakfast Club, no more Ferris Buellers, Molly Ringwald characters, or teens and their problems; there were just surefire

moneymakers. In his mind, Del from *Planes, Trains and Automobiles* lived up the street from John Bender, and all of his Shermer stories were part of one little universe. But by the early 1990s, Shermer was just a ghost town sitting on Blockbuster shelves. Hughes had long since moved his mind away from there, and the thing Hughes rallied against the most in his early films ended up happening: John Hughes grew up. Making movies became his job, and not so much his passion. I could tell that just by looking at his filmography as it started to get thinner toward the beginning of 2000. He didn't *need* to make films after a decade of success, so he didn't. What I wondered was if he *wanted* to. If he could go back to the way things were and it was possible and economically feasible to write movies about the people from suburban Chicagoland, would he have done it?

I thought the answer lay somewhere within a detail mentioned in the *Spy* article: his notebooks, dozens of them filled with his "hot" and cold" ideas. It was something he'd done since his days at the ad firm; if you had an idea, you jotted it down, because while you might not use it today, tomorrow it could come in handy. Hughes was an idea man; his brain was filled with hot oil and kernels that were turning into popcorn all the time. I had spoken with one person who had worked with him around 1993, and he'd mentioned Hughes had a habit of pulling out one notebook, looking at it, and then deciding the idea in question belonged in one of the other notebooks. Every idea had its place.

That was the key to me understanding Hughes as he lurched toward self-exile, I thought. He was a man on fire for years, always writing, working into the wee hours of the morning, success after success, one after another, and that "Fuck 'em" attitude when critics sneered. I was always drawn to people like that; trying to figure out what drove them to run that hard without trying to

catch their breath, having to be successful, needing to have it all. It reminded me of my father in many ways, and that frightened me. I found Hughes's work ethic, and eventual burnout, to be fascinating, but I was also put off by it and the person that I couldn't figure out if he always had been, or the person he ended up becoming.

Once I began pondering that, I really started to have trouble. I couldn't quite frame the days leading up to the release of *Home Alone 2*. I likened it to a company that had found success with a certain kind of product and the boss was frantically throwing everything against the wall in hopes of one thing sticking, one new idea to prove he was more than just lovelorn teens and a precocious kid who might actually have been a sociopath protecting his suburban home from two moron burglars who really should have—at the very least—been unable to walk to the police cars after they're finally apprehended, thanks to a number of falls and the shots to the head they've just taken. Inevitably that new thing was simply repackaging the Kevin McCallister story, only this time he gets on the plane. That was Hughes in the 1990s, but I couldn't quite dig into the why. Was he just tired and overworked, or did he plan it all out like that? Did he really plan to push out all of those great movies in just over six years and then go on cruise control? Were all those movies I loved only part of some big scheme, some play on the emotions of viewers like me? Was the idea to get us hooked, convince the movie studios he could get the job done, and then move on to the bigger gigs? Or even worse, was the thought that maybe Hughes cared at some point, but then the money started rolling in, and he decided he didn't care anymore as long as there was a paycheck with a lot of zeroes. I needed to figure out if Hughes sold out, bought in, was just sick and tired of everything, or if I just thought way too much about a

bunch of movies that were just meant to be watched, not obsessed over and studied.

I told my new doctor (now that I had insurance), Alex, that I was feeling constantly depressed again. It was a combination of things, including the lapse in communication with my agent who, I added, had yet to give me a formal contract to sign. I needed to produce a phenomenal first draft, a first draft that Tristan wanted to see. I was writing for him, my audience of one. The stakes were high, and my stomach hurt all the time.

Alex looked like he was practically a baby, and the diploma on his wall was dated from just a few years earlier. He wasn't exactly the wise old shrink who had been practicing for decades and had seen and heard it all, but he listened and that was all I really needed him to do. I also loved calling him my analyst. I felt like such a New Yorker, and seeing a doctor to talk about my problems felt right. I'd been doing it for so long it almost felt unnatural not to have one to go to.

"You obsess over things and let them eat away at you. Silence seems to trigger that. You want communication. Your parents didn't really know how to communicate with you if I recall," he said.

"They didn't," I told him. But I was fine with that. Not communicating meant I wouldn't get hit or told I was worthless by my dad, most of the time.

"But your mother used to purposely ignore you for days at a time as a form of punishment, so you feel as though people are trying to punish you when they aren't communicating."

It got silent as I let that sink in. He was right.

"My book is also depressing me," I said as an attempt to steer the conversation in a different direction. It was therapy, but whenever we talked about my parents, something started to bubble up

that I wanted to keep down. I was attempting, through the safe distance of the Internet, to forge an adult relationship with both of them for the first time in my adult life, but I worried that talking too much about the past would make that difficult. I'd hit SEND on a reply to one of their e-mails and feel gross, as though I was betraying my younger self. I didn't know how or if I should try to fix things. I'd read that some relationships are just so toxic that you shouldn't have them in your life. I wondered if people changed and we could make up for all of those years, or if I was just setting myself up for more disappointment and pain.

On top of all that, I found myself disliking a lot of things about the guy who was supposed to be my hero, Mr. Hughes. "It makes me feel terrible," I told Alex.

"The more you know about him, the more he lets you down," Alex said as time ran out and he told me we'd continue the next week.

I walked out of the session feeling even worse than when I'd walked in. After all the time I'd spent watching his movies and piecing together his life story, one big question about John Hughes, trying to figure out that huge why, felt like more than a question for my book; it felt as though the belief system I'd built up for myself, the idea of a better life that I wanted, all hinged on me figuring out what really happened, why he either sold out or just faded away.

THE WORD "CHANGE" was everywhere I turned, on bumper stickers, buttons, T-shirts, television commercials, and spray-painted onto walls. In the months leading up to the election there was indeed a sense of change in the air, but still plenty of anxiety leftover from years of war and financial Armageddon that people whispered was approaching. I was in my mind most days, inching

closer and closer to the part of the book that I knew I couldn't write without getting to Hughes. I'd send e-mails to Tristan at 3:00 A.M., knowing he'd probably never respond. I kept a little pocket notebook of "tweaks," things that I realized when I wasn't near the manuscript but needed to fix up as soon as possible. I'd tell myself not to edit until everything was finished, but I couldn't help it.

I'd been tuning out the world, concentrating on my work, but election fever was hard to avoid. As I rounded the corner to my office on a quiet morning pre-school-day rush, I crossed the street and a Honda Civic with a Florida license plate and a bumper plastered in John McCain campaign stickers ran a stop sign and nearly mowed me down, as if the driver were out hunting for people they thought might vote for Barack Obama.

Not exactly the best way to start the day, I thought as I kept walking toward work, nerves frayed. I sat down at the desk, pulled off my headphones in the middle of a really bombastic instrumental moment by Explosions in the Sky, and felt uneasy about the silence. Usually by the time I turned on my computer there was some sort of commotion, teachers getting ready for the day, or a few children running around and screaming. I realized, just as the first parent walked in with her blond-haired kid, hugged him hard, and said, "Everything will be fine," that something was wrong.

I asked the security guard, a tall guy named Tony from Staten Island, what was happening.

"Some more shit about the stock market. Like Lehman Brothers collapsed or something like that. It's all crooked. Keep your money under your mattresses like my grandma did. These rich assholes are all worried about their nonexistent money and I'm going to be drinking a beer while floating in my pool a few hours from now because I don't mess around with that stuff."

I smiled. It was admirable how confident he was just at the moment when things seemed to be heading down the drain, as if the money would be worth anything if the economy collapsed. I logged on to my various social media accounts to see my friends making snarky comments welcoming the death of capitalism, and others pleading for leads on jobs. Was it really that bad? Times didn't seem horrible to me, considering I'd gone from making around $1,300 a month to being able to say, "I've got this," every once and a while when the tab came. And besides, I reasoned, I worked for a Jewish school and we'd dealt with everything from a wicked pharaoh to the Nazis. What was a little economic collapse?

A few hours later I was reading a Wikipedia entry about Edmond Dantès, the protagonist of Alexandre Dumas's novel *The Count of Monte Cristo*. Hughes sometimes borrowed his name for a writing pseudonym, and I was trying to uncover the reasons why. Iris, the most powerful board member and parent of two of the loudest children in the school, walked frantically toward my desk.

"I need somebody to take some notes. Let's go," she said as she hurried out the door. "Come on," she turned around and said to me. "They don't need you for a few hours, believe me."

We walked up the street to a little brasserie that was popular with artists and writers in the 1980s but now looked a little dated. It was barely afternoon, yet every single patron looked to be having a cocktail, while some already looked wasted. Some drank whiskey, others drank martinis, and one stately and content-looking older man in a white linen shirt and a white beard to match sat reading a book and was working on a bottle of wine all by himself. The men in expensive suits seemed frantic and nervous, but the guy in the linen shirt seemed to be the picture of content-

ment. *It doesn't seem like a bad life,* I thought as Iris gave the hostess a peck on the cheek. We found our table and I tried to imagine Andy Warhol and Jean-Michel Basquiat sitting within earshot of literary lions like Norman Mailer and George Plimpton nearly thirty years earlier, but couldn't really picture it. It reminded me of a place out of Jay McInerny's 1984 novel *Bright Lights, Big City,* but not as cool, because it was real and not fictional. Filled with yuppies, cocaine, and sadness, that book was like a little window into the world I thought I'd be entering when I left the suburbs behind and started making a living as a writer in New York City, maybe sans the drugs and the models, but definitely the glamour of it all. I'd read about McInerny and the "literary brat pack" that included Bret Easton Ellis and Tama Janowitz, the other darlings of the Reagan era. Hughes and those writers were like a yin and a yang for the 1980s. The way I saw it, Hughes was childhood while McInerny and Ellis represented edgy early adulthood. All that grit and glamour was as attractive to me as the quieter, far less hedonistic Midwestern life Hughes portrayed.

Iris and I sat down and she put up her finger, motioning for a server.

"I'm just going to get some oysters," she said to me. "I had a big breakfast so you eat them and start jotting down everything I tell you."

She was the perfect specimen of the fast-talking, fast-thinking New Yorker that the rest of the country found so despicable. She smiled when the waiter brought her martini, then ordered her half-dozen oysters and "a couple of salads," and pointed at me to indicate I should order whatever else I wanted.

"Water is fine," I said.

She shot me a look, even though I was on the clock helping to watch her kids, so I said I'd have what she was drinking. She shot

me another look. I couldn't tell between what was right and what was inappropriate.

"So where was I?" she said after downing almost half her drink in one gulp. "Oh yeah: Dear parents"—she twirled her freshly dyed light brown hair around her finger—"With recent events taking their toll on our nation's economy, we regret that the center will be suspending all scholarships for the 2009 school year."

My drink came and Iris pointed at her glass. She needed another.

"How does that sound?" she asked. I took a quick sip of my gin martini, the taste of olive brine swelled in my mouth, so I needed some water before I could answer. I was still processing the fact that scholarships were being cut back.

The booze started working its way through my bloodstream quickly. I felt a little bit brave and suggested that maybe she beef up the intro a little so she could provide some buffer. Maybe talk about all the great things the school had accomplished in the last few years, and all the things it wanted to do as it looked toward the future. Her next drink arrived and so did the oysters.

"That's pretty good," she said. "You're a writer, aren't you? I think somebody told me that." She took a smaller sip of her second drink and sat back in her chair. I was going to make a joke, asking if she could smell a writer a mile away, but she kept talking. "I wanted to be a writer. I moved here and spent all that money to go to Columbia . . ." She looked down at her drink. "And then I met Michael and we had the first kid, then another, and then suddenly some guy I had turned down a date with once had a bestseller and I . . . well, I am raising three *beautiful* children."

I didn't know what to say or if I should say anything at all. I definitely didn't want to say that the general consensus around the school water cooler was that her kids were the worst.

"So what do you write? Fiction? You look like you want to be a novelist." She poured some cocktail sauce onto an oyster and just let it sit there for a few seconds before she picked it up off its ice bed and ate it.

Unsure what a novelist looked like, but feeling like it was a bit of an insult on her part, I told her I was working on a biography of John Hughes.

"The director?" she asked in a way that told me she actually knew who I was talking about, not the architect or the seventeenth-century English poet with the same name. She shook her head. "I don't like any of his films."

I said they were an acquired taste.

"No"—she lifted her drink to her lips but paused it there before she took a sip—"his films are just bad. I guess maybe it's a generational thing. How old are you?"

"I just turned twenty-eight."

"So young. You weren't a teenager when those films came out. That's probably why you don't understand," she said as she put the drink back down without taking a sip. "He didn't speak for *me*."

"I was a teenager once," I told her, not wanting to tell the same tale I'd told a thousand times about growing up where he'd made his films.

"I guess" was all she said as she told the server to take away the plate of oysters. "I feel terrible eating shellfish. I'm the head of the board for a Jewish nonprofit for God's sake." She stabbed her fork at one of the salads and shoved a heap of lettuce and raw onions into her mouth. "I hated being a teenager so I guess I associate his films with that time in my life," she said. I smiled at her as I thought of telling her I felt the same way, but that his films gave miserable fifteen-year-old me some sort of hope. It got quiet at our table. A man in a suit at a nearby table was trying to keep his

weeping as quiet as possible while tears streamed down his red face. I could hear him telling the other guy in a suit across from him that he'd given the goddamned company his life.

"You should write a novel," Iris said as she tossed a hundred-dollar bill and some ones onto the table. "A biography is a full-time job."

I sat back down at my desk after the lunch, a little buzzed from drinking down the martini so fast. Tony the security guard walked over to me.

"She thinks she owns this place just because she's a founding member. Didn't you tell her you had work to do?"

"I don't really have work to do," I said with a laugh.

"Maybe you could angle to become her assistant. I think her old one just moved to a yoga commune or something like that."

"I'm happy in my current situation," I told him. I was just fine where I was, to which I heard him mumble something that sounded a lot like, "Don't get too comfortable," as he walked back to his post at the front door where he sat on a stool reading the *Daily News.* The front page said something about a crisis. I paid no attention to it.

A WEEK LATER I was fired.

The rabbi asked me to come into his office after Iris and the other board members strolled out of an emergency meeting with one of them proclaiming, "I need a drink ASAP."

"Like my great-grandfather, who was a butcher, always said: we have to trim the fat," the rabbi started.

He was trying to play the part of a Sholem Aleichem character, a folksy man of God in a Patagonia fleece who was letting me down the easy way, telling me that I could have my insurance for a few months and that I was getting a full severance package even

though I'd been there less than a year. I wanted to reply that my own grandfather always said a piece of brisket didn't have a soul unless there was some fat on it. But I decided I'd take their free money and shut up.

"This is a good thing," he said as I got up to walk out. "Now you'll have nothing but time to work on that book."

Even though I wanted to tell him I thought he was a sucky rabbi so I could feel like I got the last word in, he was right; it wasn't so bad. I had nothing but time and the severance money was more than enough to tide me over for a few months if I was resourceful. Of course being thrifty in New York City is not easy, especially since there is no better time to be able to wander around the Big Apple than autumn. I spent those first few days sitting and reading on a bench in Central Park, gazing up at classic buildings like the Majestic and the Dakota, drinking a beer and eating a hamburger at P.J. Clarke's for lunch, and then another burger with a martini at J.G. Melon for dinner, kicking up leaves as I sipped my hot coffee while meandering from one street to the next. I had the chance to try to be relaxed while living and writing in a city that never stops. It was blissful, almost meditative, but also expensive. I went home and watched movies like David Lean's 1965 take on *Doctor Zhivago,* a film that Hughes claimed to have seen every day as a teenager until it was no longer playing at the theater, saying he'd always been a sucker for romance. I was doing nothing but I felt like I was doing everything.

I woke up with a hangover even though I'd hardly had much to drink the night before. *What a horrible tragedy,* I thought: a hangover without any real fun attached to it, just two beers and a dry bedroom that probably didn't help things much. My head throbbed, but I had time to lie around before getting up and

going to the local bodega to get an egg and cheese. Fighting off the terrible feeling was something I could do at my leisure.

There were a lot of e-mails when I finally sat down to my computer, but there was only one I cared anything about. I opened Tristan's, the first I'd heard from him in a few weeks. My eyes sunk to the bottom of the e-mail like little anchors being thrown overboard into the shallow water, as if they were being pulled in that direction instead of starting from the top. It took a second for me to makes sense of things.

```
I think the book is going to be great. I
can't wait to read it and toast you at your
release fête.
    Best of luck,
    Tristan
```

It didn't seem necessary to go to the start of the e-mail, but I did anyway, back to the beginning where he did the job quickly, saying he was giving up publishing and moving out of New York, that things were tough but I'd be great. Blah, blah, blah, the agent life is just no life for him, blah, blah, blah, if one of his colleagues at the agency has interest in my book idea then they'd contact me within a few days, blah, blah, blah. "I don't think you should have any problems. It's a great idea and you have a lot of passion."

I knew his colleagues wouldn't come calling. Tristan was the one agent who was interested in me, and now he was gone. Sure, it sometimes seemed as if he'd never seen a John Hughes film, but that didn't matter; he was *my* agent even though we had only met face-to-face twice, talked on the phone once, and he had only answered five of my twenty-three total e-mails.

The next day, I was sitting in my psychologist Alex's office, staring at the wall.

"You feel abandoned," he said. "Does that remind you of something?"

He wanted me to say, "My parents." I'd been to enough shrinks in my life that I knew when they were rounding things back to discussing the parents, how everything could be traced back to them, that parents were the root of every problem.

"It's not the same thing," I snapped.

Time was almost up in our session, so I figured I'd utilize the rule that I didn't have to talk if I didn't want to and I ran the clock down. There was only breathing and a construction worker outside the window yelling "Ayo, honey" every few minutes until I walked out of my psychologist's office and decided the therapy just wasn't helping anymore. It was probably for the best, since my insurance coverage was about to run out.

There were times when I'd felt low: waiting outside in the cold in the early hours of January 1st, because a friend had told me I could crash at his house but didn't show up until three in the morning to let me in after I'd left a party early to meet him. I sat on his steps drunk, freezing, and thinking about just going and taking a nap in the snow for two hours—that wasn't much fun. Taking a room in a retired old guy's house the summer when I was seventeen by lying and saying I was nineteen, then having to listen to the old guy and the other boarder (a car salesman in the room next door to mine, who wore tucked-in polo shirts and had the kind of smile that said he was definitely lying to you about something) talk in the other room about having sex with prostitutes, then sneaking out after that first night and sleeping in my car for the next few days—that was another bad batch of days where I wondered what the point of my life was.

There were bad breakups and friendships ending, mistakes coming back to haunt me, the lingering knowledge of people I'd screwed over for the dumbest reasons who would probably never talk to me again, weird things I ate while hungover that I worried would never leave my body, and various moments where I had to wonder what the hell was I going to do to fix this massive mess I'd made of my life. But the lowest I ever felt was sitting and staring at the lake when I was sixteen, withdrawing from whatever antidepressant I was on at the time. My mom was gone, I had nobody to turn to, and I was sweating and shaking and thinking about how Virginia Woolf put a bunch of stones in her pockets, walked into the river, and drowned herself. At that moment the idea of sinking to the bottom of the lake in front of me and never coming back up was a refreshing idea.

The days after Tristan's good-bye e-mail, although not as painful and devoid of any suicidal thoughts, I hit a new bottom. I was numb and didn't see how I could fix things. I had no job and now no agent, I'd spent four years working on a first draft of a book that I hadn't even finished yet, and to top it all off, my thirties were looming on the horizon. "Thirty is the new eighteen" I'd read a few days earlier, but things had sucked when I was eighteen, and as I worked through my twenty-eighth year on the planet, every few minutes I was forced to take an inventory of everything I'd accomplished in my almost three decades alive, and I didn't come up with much.

I'd leaf through my manuscript, wondering who the hell would care about eight pages theorizing on the relationship—or lack thereof—between Hughes and Matthew Broderick on the set of *Ferris Bueller*, how Hughes had a harder time working with the twenty-three-year-old seasoned actor who had already made a name for himself on Broadway than he'd had with Molly Ring-

wald and Anthony Michael Hall before they wanted to branch out and try other things. I felt as though that was important, but would anybody else? No other agents seemed interested, and although Tristan had spoken highly of my plans for the book, it occurred to me that he'd only read a small snippet along with that long proposal I'd chiseled out over the course of a few years, and really didn't have much else to go on. There was never any contract, nothing that legally stated he was my agent; we'd had some mediocre food and a few drinks that he paid for on the company card, shook hands, and he gave me a little advice. In my shame spiral I realized that Tristan wasn't ever really my agent, he'd never said he was; I just assumed it. I was just an excuse for him to buy lunch. I had a book that I'd been working on for a few years, one that I'd spent money I didn't have on, lost jobs chasing interviews I didn't end up getting, moved halfway across the country, all because I'd told myself it would all be worth it in the end.

I went on to have an extended lost weekend that stretched into about three weeks of being depressed, drunk, or both. I was at least frugal in my choice of on-sale pinot noir, which I suspected was being made in the basement of the liquor store due to the strong scent of gasoline in every gulp, buying up all of the five-dollar sale bottles they had and going so far as to ask if they offered a case discount. I wandered around a lot, didn't talk to anybody, and picked up a copy of *Moby-Dick* from the Barnes & Noble at Union Square. I considered stealing it just so I could get caught. A writer everybody was talking about at the time had written about walking into an American Apparel and getting caught trying to shoplift a shirt. I calculated the risk versus reward in my head as I looked at a display filled with busts of Socrates and other important thinkers that people bought to

try to look smarter. I decided to just buy the book. I walked out of the store paranoid that the security guards could tell I'd considered ripping off their employer, walked across the street to the park, and started to read a book that I'd lied about finishing my sophomore year of high school.

A few days later, bored, uninspired, and with little to do, I was through a good chunk of the book, right around when we first meet Ahab, when a second class reunion notice came in the mail saying that the big night was right around the corner and that I had one more chance to accept my invite. I could almost hear the chipper voice of the girl who was head of the committee listing off some of the great achievements of my classmates ("Paul followed in his father's footsteps and owns a car dealership now. Amy has two beautiful sons. Jim is still Jim, except now he's a litigator at Bernstein and Paulson. A lawyer, what a shock!"). *Nobody ever wants to see me,* I thought. (I pictured dramatically setting fire to the invite with the flame from the stove. It would be cathartic.) And I sure as hell didn't want to see any of them. Why the hell did I update my address in the database anyways?

And then two days later, one of those people e-mailed me.

"Buddy," the e-mail from Spencer Hill began. He was a guy I never had any real opinions about, good or bad. "Reid told me you're writing a book on John Hughes. Let me know the next time you're back home and I can help you meet him."

That was it? Some guy who I'd really never talked to in high school just up and e-mails me to say I could meet John Hughes? That was all I had to do? Just be friendly to people I had tried my best to run away from and things would be easier?

Without much hesitation, I e-mailed him back saying I'd love to, that I'd be in town in two weeks, and he should let me buy him a drink.

As I HIT the state line from New York into New Jersey in my rental car, all I could think of was the mission ahead of me. This was a work trip. I was on my way to Chicago with a suit in the trunk, a few changes of underwear, and a plan.

To think I had come so close to giving up! I was one step closer to John Hughes, one step closer to making my biography a reality (I was now calling it *Will You Recognize Me: The Life of John Hughes* after a lyric from the Simple Minds song that you hear and automatically think of John Bender pumping his fist in the air at the end of *The Breakfast Club*). My old agent that never was would end up being a casual joke I tossed off at my book party, no, my book *fête;* Tristan would earn maybe one line in my future memoir, my Horatio Alger story of picking myself up by the shoe-laces of my Chuck Taylors and turning myself into a writer.

And then I got a flat tire just outside of Jersey City, surrounded by smokestacks, like a living Bruce Springsteen song. I waited by the side of the road for two hours while the rental agency sent somebody to pick me up since there was no spare in the back, got to the rental car place, got my new car and was on my way again. I cranked up "Where Eagles Dare" by the Misfits as I screeched out of the parking lot and was on my way to my first destination.

Somewhere between Spencer Hill's e-mail and picking up the rental car I had decided that on my way toward Chicago I was going to make a stopover in northeastern Pennsylvania, in a sleepy little town best known for its annual Labor Day fair and fireman's picnic that people came from all over to attend in the summertime, but that had come and gone and things were quiet as the air turned colder. It was, at most, twenty-five minutes out of my way; a very slight investment for a big payoff. I was going to find Michael Schoeffling, the actor who had played Jake Ryan in *Sixteen Candles*. He had dropped off the face of the earth at the

start of the '90s, forever the question mark in the '80s heartthrob "Where are they now?" articles that pop up online every so often. I was going to find Schoeffling and write about him. I wagered that some big magazine would buy the story of the former *GQ* model turned generational icon and why he just gave it all up to go and make furniture in rural Pennsylvania. The idea was to sell that story, then entice agents and editors with it, telling them that I also had the full story on the decade's most reclusive icon, John Hughes, and it could be some lucky publisher's for the right price.

Jake Ryan is supposed to be the Hughes übermensch: he's handsome, rich, and he drives a Porsche. His hair is perfect, he gives his blue jeans just one roll to expose his cool brown leather work boots, and he doesn't have any issues with anybody in school. Jake Ryan is suburban perfection (save for that one kind of rapey scene where he serves up his passed out girlfriend to Anthony Michael Hall's sober character). Hughes probably saw it as harmless, good, clean fun, but it's really not; Jake is trying to dump the prom queen who can't fend for herself onto anybody because he needs to go find Molly Ringwald's character, not really thinking about any consequences, bragging to a dweeb that he could do whatever he wanted to her body since she'd had too many Old Styles. We're supposed to think it's fine because he thinks he might be in love with a girl he doesn't really even know. That's just the kind of person Jake is. It always made me wonder if Hughes thought he was writing about harmless teenage fun, or if he was making some sort of subtle statement that rich people don't care about consequences because they don't have to.

His name showed up in a few notable films post–*Sixteen Candles* (1985's *Vision Quest* and 1990's *Mermaids*), but then Michael Schoeffling, dream boyfriend, just gave it all up, leaving writers and fans to wonder what happened to Jake Ryan. People on

message boards wondered if he just wanted to be alone with his family or if he had suffered some horrific injury that had ruined his perfect face; they couldn't contemplate why somebody would just want to give it all up, and neither could I.

My plan was to try to find out where he'd been all those years after he abandoned his chance at bigger fame, and as I drove from the industrial part of New Jersey to the lush, greener part of the Garden State that people often forget to mention when talking of mobsters and "broken heroes on a last-chance power drive," I had to figure out exactly how to go about doing that.

According to most accounts, Schoeffling had totally just walked away from everything and ended up in the small town not too far from where he'd grown up. There were no recent photos to show if he'd gained a ton of weight or lost his hair, no name in the phone book, no listing for his business, no address on the Internet. All of my amateur detective skills were falling short. I couldn't figure out a plan beyond just going to this small Pennsylvania village of a few thousand people and trying to find him.

I paid for a cramped room in a motel on the outskirts of town, the kind of place where the comforter had holes from cigarette butts in it and there was a dripping sound I just couldn't locate. It was about thirty-five dollars a day. I noticed a sign for an hourly rate above the desk when I walked from my room back to the main office to ask if there was anything to eat nearby.

"There used to be an Arby's down the road," the night clerk told me without taking his eyes off the Steelers game—or telling me what happened to the Arby's. I slunk back toward my room just before the rain started, first in sporadic taps, then in a steady pounding against the roof like a thousand BB gun pellets echoing all through my room. I switched on the old black Zenith and it took a moment to warm up before a full picture

accompanied the sound. On the wall, there was a sign in marker that read, "No cable. VCR for rent. Adult movies available. See clerk." I hummed the Guns N' Roses song "November Rain" to myself as I flipped through the five channels that worked. Finally I landed on a channel that was showing the end of *Planes, Trains and Automobiles,* and it dawned on me that Thanksgiving was coming up on the calendar and that I'd end up watching the same movie from the start and eating a takeout meal by myself. So I switched over to some sitcom that drowned out the rain and helped me fall asleep before my big day of trying to find Jake Ryan.

Driving to where he supposedly lived, I couldn't get something out of my head: I was having a hard time thinking about Jake Ryan and not Michael Schoeffling. He's the Hughes character I've equally loved and hated the most. I knew I could never look like him; I've always felt too ugly and strange. A lady once told me I couldn't get the kind of haircut I'd asked for because I had "Jew hair." Kids in high school called me "Frankenstein feet" because I was a size thirteen by sophomore year, my parents would routinely tell me my body had a "weird shape" without explaining what that meant. And my forehead has always seemed too big. I tried to exorcise from my mind what Jake Ryan represented to me and concentrate on the real life guy, the one who disappeared, and who I was on my way to meet.

I had started to wonder if it was time to give up the ghost, maybe put *Will You Recognize Me: The Life of John Hughes* away in a desk and take it back out in a few years when I had things a little more together.

But then everything felt as if it was lining up. I had the chance to meet these two men who were connected, and who had both

traded fame and notoriety for a more private life with their families. It dawned on me that I might just be disrupting what they'd both worked so hard to find and considered giving up so they could keep that privacy, but a little bit of resolve swelled up from inside of me, so I followed it to Newfoundland, PA.

Newfoundland, frankly, felt like the middle of nowhere, like the exact place one goes when they want people to say "Hey, you're that guy from that thing" one time and then never bring it up again.

I pulled into a gas station and asked to see the phone book. Unsure exactly what Michael Schoeffling's professional title was, I tore out entire pages for local carpenters and also furniture companies. I asked the attendant if he knew of a local furniture maker, but he shook his head. I got in my car and drove to another gas station. This time I got Pete, a massive mound of muscle with a pockmarked face and bloodshot eyes as though he got stoned in the back any chance he got.

"I think so," he said when I asked him what I'd asked the last guy, then said nothing else. His silence spoke volumes; he either had no clue who I was talking about or he didn't want to tell me, as if there was some local pledge to protect the town's lone celebrity resident.

I told Pete if he saw the furniture maker to please give him my number. I wrote it down on a piece of paper I had no doubt he'd lose within three minutes of my leaving. I purchased a Snickers bar as a sign of goodwill, and was out the door.

Small-town conspiracy, I thought. *Lucky me.* I probably wound up there the afternoon before they did some sort of annual public stoning of a random local like in Shirley Jackson's story "The Lottery," or a human sacrifice to appease the pagan gods for the autumn harvest or something. I felt as though people were just

staring at me, that they could smell the out-of-towner as I passed. All eyes on me, they knew I was snooping around.

Driving aimlessly, just as I always did when I lived in Chicago, the houses all began to look the same. The fields of nothing, the leafless trees, the blue sky being slowly preyed upon by storm clouds in the distance. I didn't want to be there past dark. Not that I thought the residents of Newfoundland actually turned into zombies or anything, but because I knew I didn't belong and I could tell as I got out of my car to go to a diner in an old barn (the kind of place where locals had their coffee cups waiting for them in a wooden shelf when they walked in) that the residents of the small town also knew that. I looked as though I was up to something because I was.

I ordered an omelet even though I wasn't hungry. I was chasing down a phantom and I didn't even know for sure that this was where he lived. Maybe he just had his shop here, or maybe he'd left a few years earlier when some other person came looking for him. "That was twenty years ago," he'd tell them. "I just want to be left alone." I tried to think about exactly what I'd say to him if I actually found him, what pitch I'd give him, tell him I didn't want to be too much trouble, but I'm a big fan of his work in that one film. Sure, I'd seen the other ones he'd been in, but Jake Ryan, *that* was a great role he'd played. And then what would I do if he said that he'd talk to me? I had some basic questions, but was I ready to go through with it? I didn't even have an editor lined up interested in a piece, and as the runny-looking omelet was put down in front of me, I wondered if the batteries in my tape recorder even had enough energy left.

I had wasted half a decade. I was sitting there with that untouched plate of food in front of me, in a town I didn't know, jobless and close to being broke, and I was stalking the guy who

played Jake Ryan even though my book was about the life of John Hughes. I'd been going about things the wrong way, I thought. I'd become a total creep, and to be honest, I wasn't even sure I wanted to keep doing this anymore. I was coming to the conclusion that I was looking for the easiest way in the door to being a writer, but I was maybe taking the longest and most complicated and nonsensical way to get to that door. And just as I was about to pay for my uneaten omelet, get in my car, and drive in whatever direction got me out of town the fastest, I saw him. I saw the man who played Jake Ryan. Or I thought I did. He was leaving, and he turned around and we locked eyes for a second. But something inside of me said it couldn't be. It just was not possible. It was too much like some parable, the story of Job. I'd been pushed to the very limits of my faith, to the breaking point, and then when what I'd been searching for was revealed to me right there in that little diner. I stood up, started walking toward him, totally living in the moment and not giving any thought to how weird it all was: me, some guy who tracked some 1980s hunk all the way to his quiet little town. I could feel myself moving fast, but I wasn't in control.

And then I just stopped in my tracks. I watched him walk out, stood there frozen as he got into his pickup truck and drove off. Everything around me was off; I could hear the clanking of dishes and little bits of laughter, but it all sounded so far away. I could see everything going on around me, servers moving with trays of food and other people coming in the door, but all I could think of was that I'd just let something slip away.

I feel uncomfortable just about everywhere, but there, in that little diner, I was paralyzed by something deeper. Something in the back of my brain told me to stop right where I was, that I didn't belong there, that I was doing something wrong. If I went

through with just walking up to this person who may or may not have even been the man I was looking for, I was crossing a line that I didn't want to cross. If it was Schoeffling, I didn't want to be the person that intruded on the life he'd built by just going up to him and discussing his past. He walked away from the life I wanted to know about for a reason. Who was I to impose?

I stood there for another second as everything came into focus.

THE RAIN HAD started up again as I made my way to my motel room. I got soaked in the downpour and decided to wait it out in my room. I peeled off my shoes and socks, turned on the television to *Wheel of Fortune* just as a man in an army uniform was going to try to solve the puzzle, but was interrupted immediately by an alert from the Emergency Broadcast System warning of lightning and flash floods across the area. It was my last chance to get out, I thought. If I stayed a second longer, I could end up like Bill Murray in *Groundhog Day,* forced to repeat the same day over and over again, unable to leave because of an approaching natural disaster. Maybe at least then I'd have the courage to go up to that guy and just ask if he was in fact the former movie star I'd driven out of my way to meet. Maybe then I'd be able to right all my wrongs.

The signal stopped and there was Pat Sajak grinning at the camera as though he knew something I didn't. I turned off the television, then the lights. I crawled into bed, pulled the cover over my head, and I began to cry. It felt as if I had gone as far as possible on my journey that I reasoned had been parts Quixotic and Kafkaesque now mixed with a Lynchian twist for good measure. I'd exercised every resource and maybe it was time to try something new with my life, proof that you really *can't* do anything if you put your mind to it, want it bad enough, or work

really hard. I'd been spinning in a wheel, round and round, and as I sat there in the darkness, the sound of my neighbors having sex mixed with the claps of thunder, I started to cry because I wanted to give up, but a small part of me kept fighting against that urge. I'd come so far, maybe this was just a test. Maybe this was the last trial. I was clinging to whatever little last shred of hope I had, it felt like if I gave up on the book then I gave up on everything.

There was stillness, as though the last few minutes of terrible rain and wind were products of my doubt. Maybe, just like in a John Hughes movie, this was just the arc of my story, and I'd come out of it having learned something and grown a little. I let myself think that for a split second, let myself believe that this too would pass—and then a tree came crashing through the roof of my room, tearing a hole in the ceiling above me. I just watched as the ceiling kept giving in to the weight of the tree and the hole got bigger. I saw the darkness of the sky above and the rain dropping down onto me, and then, after a few minutes, gallons of water and other unknown liquids that must have been sitting on the roof for months or years pouring all over me. Everything smelled like toilet water and chemicals and all I could do was just lie there, covered in whatever it was, and admit to myself it actually was the end of the road. I wasn't going to meet any actors or John Hughes, I wasn't going to Chicago again and I wasn't writing the damn book. All I could do was go back to New York and try to find another job in another coffee shop once the storm stopped.

W hat's important is that you gave it your best shot," Reid said as he waved, trying to get the server's attention. I appreciated his ability to multitask, I told him as he tried to give me a pep talk that I didn't really ask for. "But you know that already," he continued. "You always knew that. That's why you were always a good teammate growing up. Even if you weren't the best, you gave it your best shot."

Reid had kept asking me out to lunch even though I kept putting off invites, him asking me to get drinks, dinner, and an eventual housewarming party for the place in the West Village he and his fiancée, May, had purchased. Eventually, needing simply to have some contact with a familiar person, I scrolled through his Facebook profile to get caught up on his life, hit the "Like" button on pictures of the two of them raising glasses of wine at a vineyard in California, riding horses on vacation in the Caribbean, and picking pumpkins

on what looked like the perfect autumn day at the farm all the kids used to go to back home. After months of ignoring him I finally responded that I'd love to get lunch.

He listened as I complained about shelving the book project after all that work, but I still wouldn't have dared to call him a friend. I was riding the wave of my teenage pretention well into my late twenties. But I was really taken by the digital snapshots of his life, the images and status updates, the great sweaters I knew he wore while hiking through the woods, the old Jeep Wagoneer he'd purchased and parked at his parents place, saying he'd pick it up when he and May finally bought a weekend house. He was aging from the kind of young man I never would have admitted to wanting to be into the adult I acted as though I hated but was totally jealous and in awe of. He was the guy with his shit together. That's probably why I finally agreed to meet up with him. That and I needed to get out of my apartment. Part of me hoped that something would rub off on me during lunch, that I'd walk out, forget about the book I'd been trying to write, and say, "You know what? It's time to get my life together; get a career, get married, and have some damn kids."

As we sat there and he talked, I had a memory: me at fourteen in the locker room before a hockey game against one of our rival teams. I'm puking all over the floor from a mix of bourbon chicken and Bud Light my teammates and I had smuggled away from the adults at a pre-game team party. The puke looked almost neon pink as it hit the black floor, illuminated by the bright lights.

"DO YOU SEE THAT?" my coach yelled at my team. We'd started out the season strong, but since the beginning of November, had started playing really spotty. A few of the players, including myself, had started drifting away from the game, toward girls, toward pot, and toward trouble. I didn't really want to be there

anymore. I wanted to be practicing skateboard tricks and smoking weed out of an apple in my friend's heated garage as the Descendents blasted out of a tiny boom box, but no, I was in a locker room in Barrington, Illinois, puking my guts out.

My coach continued his pep talk, trying to help get us ready and turn our season around. He kept pointing his finger at me, violently, in a motion like he was cutting through jungle bush with a machete.

"THAT IS A MAN. THAT IS WHO I WANT TO BE IN THE TRENCHES WITH. THAT IS A LEADER," he yelled.

I stopped throwing up for a second.

A leader? Did he call me a leader? I was stunned. Even though I was throwing up because I was drunk after drinking warm beer and trying a few gulps of whatever liquors we could mix into a cup of lemonade, and not nervous about the big game as my normally rock-hard coach thought, it got him to pay me a rare compliment. It was the proudest I'd ever felt, and the rush of adrenaline from the speech and throwing up so much made me shoot up in my skates and yell, "LET'S GO KICK SOME BARRINGTON ASS!" I could feel another round of vomit speeding up my throat, but I choked it back like a leader would.

We hit the ice like Terminators on skates. I was ready to crack skulls, drink blood, and all sorts of other badass things you think you can do when you're drunk. I was pissed and ready to hurt or get hurt; things had been escalating at home—I couldn't have imagined then that they'd get even worse, but I still just felt nothing but teen rage and cheap beer coursing through my veins and felt reckless. Despite everything, on that snowy night a few days after Thanksgiving, I felt good, as though great things were going to happen, starting with me picking up a loose puck that bounced off one our rival's sticks just as I was jumping over the bench and

onto the ice for my first time during the game. It was all me, I was basically alone with the defensemen behind me and only the goalie in the net to stop me from scoring. And I had that bastard's number; I'd scored on him before and remembered his stick side was weak. I pushed my right skate forward as the adrenaline surged through me. I couldn't see my coach, but I could feel his pride, could hear his scream of "THAT IS A LEADER" echoing in my ears as I pushed off on my left side, the puck at the tip of my stick's blade. I pushed once more from the right, hoping that the first burst would propel me forward just far enough so I had an extra second to fake out the goalie, maybe make him think I was going to try something between his legs or up high, some little bit of English to seal the deal. But as I tried to push off again, my legs went dead and the last thing I remember before coming to and vomiting all over my face and jersey, was one of the players on the other team laughing at me as he scooped away the puck before the whistle finally blew.

Reid and another teammate helped me to the bench. Another player pushed my helmet along with his stick, not too keen on touching it since it was filled with sick.

"I thought you had a stroke or a heart attack or something," Reid said to me as he helped me sit down and handed me a towel.

"No," my coach said. "He's just pathetic." I could tell he knew it wasn't just nerves anymore.

As I got back into the conversation sitting in that restaurant with Reid all those years later, I wanted to use that moment as ammo against his corny claim that I always gave things my best shot; I screwed up that game when we were kids and I screwed up my chance to write a book as an adult. I was a fuckup. That was it. I had screwed up so many opportunities, so many relationships, and I was at the point of no turning back.

"Let me get this," he said as he grabbed the check before I could. I was thankful since I hardly had any money left in my bank account, and then Reid reminded me I'd made a promise to him that meant I'd be spending even more cash I didn't have.

"I'm really happy you're coming to Chicago for the wedding. It will be fun," he said.

"Yeah." I paused for a second to ponder what to say next, thinking I should just tell him I couldn't make it for reasons out of my control. "I can't wait," I said.

REID PROVING HE was a much better person than I could ever be by inviting me to his wedding was killing me. I'd obviously been wrong about him all those years. What else had I been wrong about? I had some notion that we were on different sides because of the clothes we wore or the music we liked, so I had totally written off a good and decent guy. *I* was a jerk to *him,* and not the other way around. I ignored him when he tried to reconnect, and yet he still invited me to the most important day of his life. The worst part was that even though I'd sent in the RSVP card, I was still thinking of not going. I was thinking of excuses to get out of it until an e-mail popped into my inbox.

"I heard you're going to be in Chicago for the wedding," the e-mail from Spencer Hill read. "Let's go find John Hughes since it didn't happen last time." He ended without any kind of signoff, no "Bye" or even a "Peace out." So cocky.

"Well, maybe I don't want to meet fucking John Hughes," I said as I hit DELETE and circled my finger around on my laptop's trackpad for a few seconds, watching the little arrow swirl around. It was something I found myself doing more often than not while sitting in front of my computer and trying not to think of the book I'd been trying to write. I'd quit cold turkey, stopping just

short of dragging the file to the trash and throwing out my little backup disc. All that time wasted on John Hughes, I didn't want any reminders of it. I didn't want to doze off and dream about chapters I'd written over and over, the scene of Hughes hovering around the set of *Pretty in Pink,* not directing, but standing over the shoulder of the guy he'd put in charge of that task, Howard Deutch, taking notes that he'd pass on to the rookie filmmaker at the end of each day of filming. Except in my dream he was taking notes that he was going to give to me. Bits of advice or some deep and profound wisdom, perhaps? I wouldn't know, because just as he turned to me to let me know, "Here's what I got," my alarm went off, the heinous buzzing alerting me that it was four thirty in the morning, time to wake up and go open the coffee shop where I worked two days a week. I was making a living between that and a review or two a month.

"At least you're writing," one of my coworkers at the coffee shop said to me after I complained to her for fifteen minutes about how stagnant I felt. "I can't even get editors to get back to me about writing for free for their blogs."

Yes, I was writing, and I was making half of my living doing it. That was a big change that had taken place over the last five years. Sure, there were no instances where I overheard somebody quote something I wrote or felt as if anybody was even really paying attention to my musings, but it was out there. I still opened my mouth and heard myself tell my coworker, "It's not writing," and then watched as she shook her head and walked away from me, the snob who couldn't just be happy with what he had, drowning in his own privilege.

I started to think of and talk about the book like an old love. We had a deep and intense relationship for a few years. Sometimes it had seemed like the real thing, other nights we were throw-

ing dishes at each other and screaming about how much we both wanted out of the insanity. So many of the most important relationships in my life were like that. They were doomed to fail. I had a few close friends. I didn't really talk with my family. I'd date a girl for a few months and things would never work out. And then there was the book. All told, my John Hughes biography was the best and longest relationship I'd had as an adult, and thinking about that made me queasy. We spent long nights together, sometimes I'd confess to it through my writing, letting parts that were supposed to be about Hughes become more about me, my own views, my own thoughts, and my own fears. Sometimes I'd write for hours into the night on whether Hughes was an auteur or a smart salesman who was aware of what the crowd wanted, informed by years trying to find the exact words that would make the ad campaigns he was working on. I'd go back to edit it the next day, not sure I was pleased with what I'd written, and find six thousand words that would make me go, "I really relate to this." Was I writing the biography because I cared about the craft and wanted to put something great into the world, or was I doing this to prove something, to make a name for myself? Was I a biographer, or just some young writer obsessed with the man's films who had big dreams of paying some kind of tribute to him?

AFTER A FEW months never opening the file that contained the nearly 350 pages I'd written, edited, re-written, edited again and again, and not even completed, never really getting to the bottom of why Hughes dropped out of sight, I'd come to the conclusion that I wanted to hit a home run with my first swing of the bat and initially thought that it really worked like that, as though I could will myself to be a phenom and everything after that would be easier. Then I'd truly be a *writer*.

But that's just not how it goes, I'd learned. I was jealous of the success I saw other twenty-somethings having, people I knew and people I'd read about, the wunderkinds making a big splash in New York City with their fancy novels, essay collections, and jobs at magazines. They did things right with MFA programs and internships while I was foolish for thinking I could just jump into being a writer with this big, impossible book, and now I was sitting by myself at my desk in my small bedroom, a stack of library books that I swore I would open up and read, and a notepad that I was supposed to write ideas down on that was just filled with doodles and chicken scratch instead. When I looked at my computer screen, I just watched the cursor set against the all-white Word document blink at me for five minutes and decided I'd tried enough for one day. I got up and made myself a big lunch instead, some recipe I'd found online with too many steps, but just enough that it would take my mind off writing anything. I wasn't even hungry; I just didn't want to write.

It wasn't writer's block; I'd considered that, thinking about one of my writing heroes, Fran Lebowitz, and her troubles with getting anything onto paper, which she called "writer's blockade." I wasn't having that; I was just depressed. I'd fallen down a shallow wormhole of despair and couldn't be bothered to put any effort into crawling out. Instead, I'd make dishes from old cookbooks I'd bought at the Strand, using a dull chef's knife with a plastic handle. That was the only thing that was making me happy: my new hobby of cooking meals that I didn't really want to eat. A nice lasagna one night. Another night, a poached salmon and roasted vegetables recipe that may have made me really sick, since I spent the twenty-four hours after eating it waiting in the bathroom for the next round of vomit to shoot up.

"It beats writing," I conceded as I sat next to the toilet.

When I recovered, I considered writing Reid and giving him some sort of excuse about why I couldn't make it to his wedding, and I figured the best way to do that was to simply not go, just make a clean break from the whole thing. I didn't want to see all those people, didn't feel like being the weird kid again, dateless, pretty much jobless, and penniless.

I figured I'd wait a few days before bailing, to think it through. I found myself saying, "Do it for Reid," feeling some of that old team spirit he never let go of. I may have been a failure, but if I didn't go to his wedding, that made me a complete asshole.

"Bro?"

Spencer Hill was persistent. He followed up his first e-mail by forwarding it to me with that single word posed as a question. I hardly knew the guy and thought about just e-mailing him a simple "Fuck off" and being done with it. Of course I'd do that and find I was seated next to him at the wedding because life is funny that way, so I thought maybe it was better that I just keep on ignoring him.

It was the middle of the summer. I'd just started the last year of my twenties a few weeks earlier, and the only thing I had to show for myself was learning to make a meatloaf that wasn't dry. At least I could say I got that done in my twenties, my single greatest accomplishment.

"You're going to open a restaurant?" my roommate jokingly asked as he forked a load of lumpy mashed potatoes into his mouth.

I smiled and laughed, not letting on that I'd spent a sleepless night typing "How to open a restaurant" into Google, and taking notes on what I'd have to do, how much money I'd need, where I might get that money from, and all the other things one might

need to know if they were considering opening a restaurant. By the end of the research session that lasted until nearly four in the morning, I'd decided I probably wasn't going to become a restaurateur anytime soon, but I was open to almost all other options. Sadly, none were being presented. I was teetering on the edge of my thirties and had no plans; I couldn't write one or two reviews a month (if I was lucky) for twenty-five bucks a pop and work a few days at a coffee shop for the rest of my life. I closed my eyes and envisioned myself as a lonely and bitter old man because I couldn't write a damn book, the neighborhood eccentric who had nothing to his name. And then one day they'd find me dead, buried beneath countless manuscripts, the meowing of my hungry army of cats the only thing that alerted the neighbors there was something wrong. I could hear them telling the police as my body was wheeled off to the morgue that they had no idea I was a writer, but that I often cooked things that smelled good. That would be my entire legacy.

I started a blog.

Correction: I had started a blog a few months earlier and pretty much just let it sit dormant, but on a hot summer day, with an iced coffee by my side and an army of NYU students around me, I sat in a coffee shop where I'd once been employed and just started to type. I wrote a short essay on the joys of reading Flannery O'Connor's dark, Southern-based stories when the weather was hot and muggy and you actually felt as though you were deep in some tiny Georgia town, where the air was thick and it always felt as if something bad was going to happen. It was about five hundred words. I typed it out and didn't really look it over, and then I hit publish. Rereading it a few hours later, I noted a number of grammatical mistakes and weird phrasings, but I

didn't care; it was the best I'd felt in the months since I'd put my book away. I'd written something because I wanted to, and I wanted to write more. I enlisted a few friends to also contribute. Maybe it would begin a meaningful virtual conversation. Maybe not. At the very least, it was something to do.

The focus of the blog, for the most part, was supposed to be books, but I decided music and movies were also allowed. I'd wake up and scan the Internet for news, a short story published in the *New Yorker*, some bit of info I found funny about an established author that I could write a short, snarky post about. I'd hear about a literary adaptation being made and I'd write a one-sentence post with a funny headline and click the PUBLISH button. It wasn't an ambitious project. I wasn't writing the Great American Novel. None of these pieces would provoke thought among those who read the cool literary journals that threw the best parties and designed the best tote bags. Maybe it was sloppy, maybe I threw posts together without doing any kind of editing, and maybe I had around twenty-five readers on a good day. But I felt good writing about the joys of finding old paperback copies of *Miss Lonelyhearts* and looking back on weird '90s film adaptations of great novels.

The other plus was that I started getting a lot of free books not long after publishing a few posts, which made me feel as though people at least cared about what I was doing. There was some thrill in going home to my apartment one night and finding a note from my neighbor that the mailman had delivered a huge stack of envelopes containing hardcovers, and her asking me when I went to pick them up if I was a professor or something.

"Actually, I'm a book critic," I said with an air of self-importance that almost made me gag.

I didn't tell her that the bulk of my reviews were self-published

and that most of my readers were probably spam robots launched from some island nation in the Pacific. None of that mattered since I felt as though I was doing something again. It wasn't a career; in fact, I'd technically lost money buying the site's domain name and hosting, but it was something, and that was all I needed. I just needed *something*.

ONE BOILING NIGHT, as Michael and I sat at an outdoor bar called Gowanus Yacht Club with a handful of other friends, we were having one of those insufferable conversations in which a few drunk people at a bar in Brooklyn discuss things such as Alfred Hitchcock films and preferring Nabokov's short stories to his novels, most of them having no idea what the hell they're talking about. We probably sounded terrible to the people around us, but as the night cooled off and the beers kept coming, our mouths kept moving.

"So how's the book coming along?" Michael asked after we ordered another round of beers. I took a sip of my fresh Old Milwaukee, choked back the tears from the bitterness of the lukewarm beer, and remembered he was one of the few people I hadn't yet used the "I'm working on a new project that I can't really discuss" excuse on. He didn't know that I'd given up.

"I hit a wall with it," I said. That was the answer that felt better. I hated saying I was finished completely, hated the feeling that I might never watch another Hughes film again because it was too painful, let alone write about them. If there was anything I'd learned in the many hours of my life I'd spent reading and writing, watching, and thinking about his movies, it is that my relationship with Hughes was more complicated than I had thought when I started out, and I liked that. I liked that I found fault in his work and in the man himself, how I was on the fence about whether he really

cared about his craft or was just a 1980s Svengali, getting people to feel a serious emotional connection to the teens he wrote about for his own personal gain, and also how he whitewashed an entire decade, keeping the suburbs a place closed off from nearly anybody that didn't fit the white, middle-to-upper-middle-class background. My feelings on Hughes and his work went from obsessive fan to obsessive critic, but I still felt an undeniable link to him and his movies. They had helped shape me.

"There's so much about Hughes that needs to be written," Michael replied. The two of us had talked at length about Hughes, thought about the many nineteenth-century novels that may have inspired the script for *Pretty in Pink,* discussed the museum scene in *Ferris Bueller's Day Off,* each piece of art, from the trio of Picasso paintings that the friends each look at on their own at the same time to Ferris and Sloane making out in front of Marc Chagall's *America Windows* (obviously Cameron looking closely at the dots that make up *Sunday Afternoon on the Island of La Grande Jatte* by Georges Seurat is meant to represent how tiny he feels; we'd both agreed on that). All of those conversations, in some way or another, filtered down into what was supposed to be my book. I sat there at the Gowanus Yacht Club and thought about how damn hard I'd worked on it, how much it meant to me no matter how much I was trying to distance myself from it. And Michael, one of the people whom I'd talked to the most about Hughes, a human inspiration board that I was going to thank somewhere near the top of the book after my agent and editor, I looked at him and thought about how much I wanted to sign his copy "You should be considered a coeditor" on the book's title page, then cross out my name in print and put my signature right below it as I'd seen a number of famous authors do. All of that mixed with the beer, and I became overcome with emotion. I excused myself,

made my way down the dangerous staircase that led to the dank little bathroom, and I began to cry my eyes out. I cried because I felt as though I'd failed myself. I thought of everything in seconds, all the people who'd told my parents that I was going to be a criminal when I got older if they didn't pump me full of medications in elementary school, about my parents who'd told me I was never going to do anything great with my life, and I thought about all the times I'd been unhappy growing up, and how working on that book had given me some purpose. It was important to me, more so than any college course I'd taken because it was required, more than any job I'd had, more than any of my relationships; working on that book had made me feel like somebody, and after nearly a lifetime of never feeling like I belonged, moving from one place to another, I had that book and that dream.

Somebody banged on the door.

"Come on," he whined. "I've really got to pee!"

I gave myself a second, dabbed my eyes with a wet paper towel to try to relieve some of the redness, walked back upstairs, paid my part of bill, and walked out of the bar. I sprinted all the way back to my apartment with a purpose, not giving a thought to the massive amount of beer I was sweating out. I made it home in half the time it would normally take, and I composed an e-mail I would have probably never sent if not for the courage supplied by the Old Milwaukee.

THERE WAS AN e-mail from Spencer Hill waiting for me when I woke up the next afternoon.

"That's great. Let's meet at the Market Square Starbucks on Saturday at noon."

I checked the time stamp on my e-mail I'd sent to him a few hours earlier, the one in which I told him I wanted to meet John

Hughes when I was in town for Reid's wedding. It said 2:42 in the morning. My memory was hazy. I recalled leaving the bar and running the mile back to my apartment, and I remembered talking with my roommate and his girlfriend for a few minutes; but I couldn't recall the actual composition of the e-mail. I had felt really good when I'd arrived home. I was feeling the exact opposite as I tried to remember composing the e-mail to Spencer. It read, "Buddy, dude, broski. Let's fucking do it. Let's meet that man. I'm looking forward to it. Just tell me when and where."

I was locked in. I'd spent rent money to buy the plane ticket to Chicago while drunk, but it seemed justified when I sobered up: I was going to meet John Hughes. It was hard to believe that just a few weeks earlier, I was trying to figure out a good reason for not going to a wedding, not convinced that just saying, "I can't make it," would work. Now I was maybe going to Chicago to meet Hughes. It was difficult to believe. What would I say to him? I could shake his hand and say, "Hello, Mr. Hughes. Big fan. I was working on a biography on you, but I shelved it. If you were interested in somebody being your biographer I'd gladly volunteer my services." I had to ask myself if I was willing to go back to trying to write his story, or if I just wanted to meet the man. Maybe shaking his hand and getting him to sign a slip of paper in my notebook would be enough. Maybe I could do just that and say I had closure. When I'd finally meet John Hughes, I'd leave it up to fate. I could just be another fan, or I could tell him I really wanted to know about him, why he just started making movies that were palatable to viewers of all ages, and why he vanished after that. "Where did you go, John Hughes?" I could ask.

EVEN THOUGH HIGH school English teachers drilled it into our heads that April is the cruelest month, I don't think T.S. Eliot

spent too many August days in New York City. All it takes is one ride on a Q train without air-conditioning to get anybody who thinks otherwise to understand why month eight on the calendar is the worst time to be in the city; it's a disgusting pit, and I usually spend the thirty-one days until September starts totally miserable. All I do is focus on getting through it.

This year was different. I felt good about August and being days away from finally meeting John Hughes face-to-face. For the first time I could accept what a fortune cookie from the Chinese takeout place near my house had told me earlier in the year: the future was truly unwritten. For a person who feels as though everything is totally out of control and spins into a depression if the mental five-year plan I'd put together looks as if it's going in a different direction, I was totally feeling at ease about not knowing what was going to happen, or if really anything was going to happen at all. All I knew was that I was about to finally close one big chapter of my life. As though the life I was living was about to get the gray filled in with some color. Maybe not the happily ever after, Samantha and Jake kissing on the table over the birthday cake kind of perfect ending to my story, but at least I'd be able to move on. Maybe I would just shake his hand or tell him thanks.

"HUGHES IS DEAD."

I had a new Blackberry phone I'd purchased a few days earlier. It made me feel like a professional. I'd just started working two days a week temping in an office in Midtown instead of getting another coffee shop job; I was sitting behind a desk and buzzing people in every hour or so, sometimes stuffing envelopes, but mostly just messing around on the Internet. The buttons were too small for my fingers, so I had to type carefully.

"Hahaha. Shut up," I typed back very slowly.

I waited a minute for a response from Michael. I spent thirty seconds just staring at the phone, totally tapped into the electronic world, waiting for the person on the other end to respond because that's what we crave when we talk to somebody electronically; we want a connection, that was more important than the answer. The next thirty seconds brought the realization that I didn't exactly know Michael to be a person who would make jokes of that nature. It dawned on me that it wasn't some sort of empty statement and I started to panic, I went cold. I was sitting on a big comfy couch in the Bushwick apartment of a girl I'd been dating and suddenly all I could hear was my breathing dancing in time with my heartbeat. Everything was moving in slow motion as I typed "John Hughes" into Google and saw the result: "BREAKFAST CLUB DIRECTOR JOHN HUGHES DIES."

It was sudden and unexpected, as any fatal heart attack tends to be. It was a Thursday, almost one week before I was supposed to fly into Chicago to meet him, but when I read that he was actually in Manhattan visiting his family when it happened, that's when I decided I needed to go for a walk. It was a long and aimless trek that eventually took me from Brooklyn to Manhattan, then all the way up to the Midtown location where people on the Internet were speculating he had passed out after complaining of chest pains before being taken to Roosevelt Hospital where he was later pronounced dead. *It's so crazy how people could piece all that together in such a short amount of time,* I thought as I wandered around 55th Street. There was nothing to mark where it had happened (although, in a few days, a movie blogger would find the exact spot and place sixteen candles there in memoriam), but that wasn't necessary for me to start my mourning. Hughes was dead and all I could think about was all the things I could have been so close to asking him. I felt so selfish. How

close I'd been and I didn't even know it. He was right there, and then he just wasn't.

"What's important is that you gave it your best shot," I heard Reid say in my head as I bought a pretzel to shut up my stomach from making noises to tell me I needed to put something in it. I took my pretzel and found a bench and sat down. I sat there for hours without ever taking a bite. All I could do was think of everything I'd missed.

I like the idea of living life without regrets and wish I could stand triumphantly in front of a bunch of microphones proclaiming, *"Non, je ne regrette rien,"* just as the final curtain falls on my life.

But I have many. My regrets, as I told Karen, my latest psychologist (who I was paying out of pocket for because I didn't have insurance), two days after John Hughes passed away, were almost all tied to people I didn't get to say good-bye to. Family members, friends, Mrs. Donovan, kids I knew in high school who overdosed or died in car accidents. Those deaths gnawed at me. I didn't know what I regretted precisely, but it was something I'd never be able to make right, and sometimes I'd see those people in my dreams but they wouldn't say a word to me.

"And your grandfather," asked Karen, who I swore was the actress Dianne Wiest playing a psychologist.

"Yes, my dad's father. But also my other grandfather, my mom's dad. Both grandfathers, really," I said.

My mother's father had been the one guy in the mess of my family who I'd trusted. He'd been tall and solid, talked slowly but assuredly, worked hard. Everybody who'd met him liked him. He'd been my hero. I'd wanted to be just like him and I'd wanted him, more than anybody else, to be proud of me. Him getting sick when I was twelve had always felt like the beginning of the downfall, the end of the possibility of the picture book life I'd envisioned. The cancer had spread, and we'd all started to fall apart around him.

"So when we showed up to visit him in the hospice, what did I do to show him how much I loved him? I took one look in his room, saw him all sickly and shrunken from the radiation treatment, and didn't set foot in there again. I never spoke a word to him, no hello or good-bye, and he died two days later." This was my greatest regret.

Karen was quiet for a moment. I wanted to interrupt the silence and ask her if that was something they were taught in shrink school: allowing a few seconds to let whatever was just said sink in.

"And you feel that way again? Like you didn't get to say good-bye?"

"I didn't even get to say hello," I said with a laugh as I looked at my watch, trying to figure out how to change the subject and fill the next twenty minutes with more talking to get my eighty bucks worth. All I wanted to do was go back home and go back to sleep. I was in mourning.

"You cared about him. You can care about people you don't really know, and you can be sad when they pass away. It's completely normal and you have every right to grieve," Karen said. I

could feel my eyes getting puffy and cold in the sides, the tears forming. But I pulled them back the way I'd taught myself to do as a kid. I'd hold my breath and concentrate on fighting back. Maybe a single tear would breach my defenses and roll down my cheek, but I was good at making it look as though I was scratching an itch on my face and wiping it away.

The session ended in silence. I hadn't even told Karen that I'd spent all that time working on a book about Hughes. I'd just told her I was sad without giving her much context, babbling on about all these obscure facts about him as if I was some obsessed fan, which, I realized, I was. Perhaps I should have mentioned that I'd spent the last few years trying to turn his life into a story. Maybe we could have gone a little deeper into the problems I knew I had, the things I couldn't let go of, the fears that were blocking me from moving forward, and the regrets.

I WAS LITERALLY living in a tiny hole-in-the-wall of a loft after the room I'd been promised had fallen through. There were no windows, and I had to remember not to hit my head on the ceiling when I woke up in the morning. It was hot all the time, but in the winter, without any heat and little insulation, it would be nearly the same temperature inside as out. One of the roommates would talk loudly on the phone about how much she hated the rest of us, but she had no other options since she wasn't a U.S. citizen yet. The lady running the illegal loft made really terrifying puppets just downstairs from my hole. I'd often bump into them on nighttime trips to the bathroom, and sometimes I had nightmares about them. She'd once lived there in the 1990s, but had long since moved to one of the new condos near McCarren Park; she just collected all of our rents that I knew she was overcharging us on. Twice a week she'd show up to work on her terrifying creations, and would talk

about her rich husband and how terrible her kids were. It wasn't the most ideal living situation, but I felt I'd dealt with worse.

Reid's wedding was coming up fast, and I desperately didn't want to go; I just couldn't deal with any more weirdness. My fingers hovered over my keyboard as I considered typing the words "I can't make it. I'm sorry" in an e-mail to him. Normally I would gladly drink all of his champagne, and I'd get real drunk and force myself to smile at people I hated in high school, but I couldn't this time, I didn't have it in me. I wasn't a writer. I was the weirdo failure they'd all taken me for.

I typed the e-mail, made up some plausible excuse, but hesitated to hit SEND. I stared at it for a few seconds: "Hey man, I'm really sorry, but something came up with work and I can't make it to your wedding. You know how things go? I'm so sorry. Hopefully it doesn't put a damper on your big day, but I'm sure it won't." I deleted it. I thought about being funny and typing my favorite quote from *Better Off Dead* (another film people mistake as a Hughes movie), "My grandmother dropped acid and she freaked out, and hijacked a school bus full of penguins, so it's kind of a family crisis," but figured that route also wouldn't really work. Whether I went wouldn't matter to Reid; his inviting me was just an act of kindness, and I knew I was horrible for trying to figure out a way to tell him I couldn't make it. I had to at least give it a try.

The one thing I liked about my little hole was that it was dark and quiet. I could hear myself think in the small space a friend had dubbed "the tomb." The loft itself was already tucked far away from any main streets, so there were no cabs honking, no drunken frat boys yelling after a night out in the neighborhood they'd probably move to in a few years and ruin, and not a whole

lot of construction on the forgotten avenue. Between the tight fit, the toxic chemicals I was probably inhaling, and the fear that we could get kicked out at any moment, the quiet was really the only good thing the place had going for it. People in lofts all across Brooklyn were being unceremoniously evicted with only a twenty-four-hour notice for reasons from leaky gas lines that could cause a massive explosion to an illegal matzo factory being run in the basement. There were exposed wires and sharp things sticking out of random spots, all kinds of God-knows-what float-ing in the air—from lead paint to asbestos—and the way the electricity went in and out, I feared the space heater I had for the winter months would stop working one night when I was in a deep sleep and they'd find my totally frozen corpse weeks later. Injury, death, and all of the other possibilities went through my head, but they were combatted by the five hundred dollars a month I spent to live in that little hole, where my roommates paid two hundred more than me to have actual rooms. Those kinds of prices are impossible to come by anywhere in New York City, but I was constantly weighing the money I was saving against the hazardous conditions. If I'd found the place a year earlier, when I was working on the book, I reasoned that then maybe it would have made sense. I'd have peace and quiet to work on something that mattered, and not just writing blog posts that a few people read and write-ups about events with overpriced drinks that I was getting paid basically nothing to churn out. But as I'd proven to myself—planning on meeting Hughes only to have him die a week before—timing was not one of my strong suits. I had a cheap place to do my work, a rare find in New York City, but I didn't really have the drive in me to work on anything new. I'd wasted all of that.

I'd spent all of that time, nearly two thousand days, completely obsessed. I was mostly fixated on the idea of the book, not necessarily the writing part of it, but the idea of the finished thing itself. I envisioned the acclaim and the parties, the people recognizing me in the street as the author of the John Hughes biography they had just finished, and Hughes himself writing me a letter to thank me for doing such a great job on retelling his life. It took Hughes passing away and me sitting in my little hole in the wall, breathing in air coated in thick dust, but I was starting to understand what a privileged little shit I'd been the entire time. I'd told myself I was working hard and all that toil had to pay off, like when I'd done a subpar job mowing the lawn or raking the leaves as a kid, but still completed the task and *deserved* my reward. "Hard work and dedication always pays off," my hockey coach would tell us at the end of practice. "Those who put in the effort are rewarded in the end. That's a fact." That, as I learned, was just fiction. You might feel good about all of the hard work, that old Puritan work ethic that's ingrained into our American DNA; but that doesn't mean you'll get something out of it in the end. There was that old Theodore Herzl quote on a sign in my Hebrew school class: "If you will it, it is no dream"; that's a nice sentiment, but you can't really will *anything* you want into existence. You can't really do whatever you want as long as you put your mind to it. You can do a ton of things, but there are impossibilities.

What did all my hard work get me? I wondered as I clicked on the folder containing the unfinished book for the first time in months. It felt as though I was going back to the scene of a crime I'd committed, trying to not think about it, breezing right through the yellow police tape and surveying the damage I'd caused all on my own. It was something I just needed to do. Some lines I hadn't read in over a year or longer, paragraphs I'd

written but didn't totally remember; moments of Hughes's life that I'd spent too many moments from my own life trying to turn into a story.

* * *

He was no longer "the man who brought you Mr. Mom *and* National Lampoon's Vacation" *anymore, even though that's what the poster for* Sixteen Candles *read. He was a bona fide director now. No more taking jobs like he had two years earlier, writing films like the swashbuckling pirate flop* Nate and Hayes, *the kinds of projects that he needed to take more than he wanted to, the kinds that paid the bills. And while it came in number 2 opening weekend behind the premiere of the breakdancing drama* Breakin', *the reviews were largely positive. He'd never lacked confidence in his ability, the script for* Sixteen Candles *had been written over a weekend almost immediately after Hughes saw a headshot of the teenage Molly Ringwald, her face burned into his mind, he wrote the part and the story around her.*

* * *

Well, that was garbage, I thought as I moved backward, inching toward the start of the book.

* * *

Northbrook was the village of the future, the kind of place families moved to after the Second World War to start

things over. No longer tied to the cities their ancestors may have lived for generations or had just come to a few years earlier from across the ocean, it was the perfect little leafy suburb that wasn't tied to the past like the places right beside the lake. You didn't need to have your family roots firmly planted into the local soil, didn't need a name of a famous product, company, or law firm. John Hughes Sr. appreciated that; it was the right place for the Hughes family to grow. He'd seen the writing on the wall in Michigan: Grosse Pointe was nice, but you needed to be some bigwig at one of the car companies in order to make things work in the quaint little city just on the border of Detroit. It was easy to see that Northbrook was on its way to becoming something like an Illinois version of the little Wayne County city, only with more opportunity, the likes of which you could only find in America, but that you had to really search and sacrifice for. It was the right choice as he made the move into the next phase of his career, and just the right time for John Jr. to start in a new place before high school.

* * *

"Crap. Total crap," I said as I highlighted and hit DELETE on large chunks of text, wiping them out like a tyrant ordering bombs to be dropped over wide swaths of enemy land. I surveyed paragraphs about Hughes hanging out at the *National Lampoon* office in New York City, aghast that I called it "a frat house for society's rejects," wondering if I could have been any cheesier in my descriptions. My thoughts on Hughes working on *She's Having a Baby* were mostly based on assumptions and theories, less on facts

because the movie is such a dark horse in his 1980s output—not bad, but not beloved like some of his other films—that I had difficulty filling in the gaps. I couldn't get in touch with Kevin Bacon or Alec Baldwin, and all the reviews were neutral, not really slamming it or praising it. So I worked off of a hunch: that of all of his work in the 1980s, *She's Having a Baby* was really his most personal, that Kevin Bacon, just like Hughes, doesn't finish his education in a school out west and returns to Chicago where he wants to be a writer, but needs to work as a copywriter to make sure the bills get paid. I explored how this was Hughes telling *his* story. It was uninformed and just downright bad, which was the way I saw most of the book. "Amateur hour," I kept repeating as I scanned through page after page that had taken me so long to write. *What a massive waste,* I thought.

It's in the nature of a writer to be unhappy with things they have written, the wrong tone, too much rambling; but I was downright disgusted with what I was reading. I felt ashamed and the only thing I could do was pull the little "Hughes Book" file toward the trash bin, drop it in there, wait for the clicking sound signifying it was now in the cyber rubbish pile, and turn off my computer. I had to get packed for Chicago; I had to use that ticket.

"HOLY SHIT, MOTHERFUCKER," Spencer Hill yelled as he walked in the front door of the suburban Starbucks, right past an assemblage of about six little kids and three mothers, who all shot a disgusted look at the tall, dumb, and handsome guy who was yelling into his phone and cursing as he greeted me in person for the first time in a decade. I noticed his hair was thinning a little in the front and he'd gained a little paunch, but otherwise he was just as I remembered him.

"Yeah. Hey, that's great," he said into his iPhone. "Listen, bitch, I gotta go. Yeah. OK. I'll talk to you later."

I imagined he wasn't really talking to anybody.

He hung up and sat down. It dawned on me before he started talking that, even though we went to school together and had talked on the computer a handful of times, Spencer and I had never had a real conversation in person. We had been on different sides of the teenage fence growing up, but now we were both adults, and although I could sense we still had nothing in common, it felt as though growing up had balanced things out. I probably didn't make anywhere near as much money as he did, didn't have a wedding ring on my finger, didn't really have any family ties to speak of, no stocks, very little money in my bank account, and no assets save for maybe my laptop that I could pawn, but I thought it was time to pack away the high school resentment as I listened to him talk. I was going to try my damnedest.

"Getting ready for the fantasy football draft. My wife says I pay more attention to my team than I do her," he said in a way that made me think he knew she was right. "So you're a writer now. That's really cool."

I didn't really believe he actually thought that.

"So let's get out of here and go find your boy. We can take my car."

Huh? What boy was he talking about? I was just there to fulfill my promise that I'd meet up with him when I was in Chicago. I'd told him we could catch up and felt as though I needed to start coming through on promises. Was he joking around?

"Hughes. Let's go meet John Hughes," he said.

Was he drunk? His eyes were bloodshot. Surely he was just fucking around with me even though it obviously wasn't funny.

"You mean in the ground," I joked, but all I got was a blank stare. I wished I could take it back—it felt so wrong to try to make light of Hughes passing away.

"Dude, don't you want to find John Hughes? Isn't that what your book is about?" he asked with such sincerity that I could tell he really wasn't pulling my leg. I realized I was the one who had to deliver the news.

"John Hughes is dead, dude," I said. "Nobody told you?"

He looked even more confused.

"Oh man. That sucks." The flat way he said it wasn't the typical response you'd expect from a person who'd just found out somebody they knew had passed away. I told him I was shocked he hadn't heard since it was literally all over the news.

"I've just been so wrapped up in work and getting my fantasy team together" was his excuse.

"I'm sorry to have to be the one to break it to you," I told him.

He shrugged. "Nah, bro. I'm sorry for you, you're the one writing the book about him. I didn't even know the guy."

Suddenly I was in the middle of the most bewildering conversation of my entire life. What the hell was he talking about? I wanted to ask if maybe he'd hit the soccer ball with his head too many times.

"I didn't *know* him. I used to see him at the grocery store all the time, and my wife's dad knows—sorry—knew him somehow, I forget. Anyway, I thought I could help you get to him. It could be fun. I always wanted to be a reporter, but my dad said I had to go to law school."

I felt my eye twitch. It was something I'd developed around the time when Tristan had told me he wasn't going to represent me as my agent. It wasn't anything noticeable, just a slight tremble on the side of my right eyelid I could feel when I was getting

really angry, the type of anger that, if held in, would make my entire body explode into a billion pieces right there in my seat.

"So wait." I paused for a second as I tried to believe what he was saying to me. "You didn't actually *know* John Hughes? You never met him? The plan was for us to basically stalk him?"

Spencer shook his head. "I don't think that's stalking," he said. "That's, like, reporting. That's journalism."

He was going to have me come all the way to Chicago and we were going to hang out in the grocery store parking lot for a few days in hopes of seeing John Hughes pull out a cart and go buy some milk and eggs? His whole idea was a stakeout. It was just another of the many maybes and half-assed attempts that were the basis of my so-called biography. At first I felt blind rage that I'd been so stupid as to not ask exactly *how* Spencer knew John Hughes, and my eye twitched faster and faster to the point where Spencer asked if something was wrong with it.

All I could do was laugh. Spencer started to laugh along with me, then asked what we were laughing at.

"I have no fucking clue," I told him.

AFTER SPENCER AND I parted ways at the Starbucks, I spent the day driving; it seemed fitting. That's how I got to know the place I was from, and when I'd lived there a year earlier in my attempt to find John Hughes, that's how I'd gotten reacquainted with it. Now it felt like an apology tour.

Beautiful Chicago and your suburbs, I always wanted us to get along. I've always loved the way you looked, moved, and sounded, but I never felt as though I belonged. Oh, how I longed to live and die beside Lake Michigan. I wanted to write you love letters the way Hughes had said *Ferris Bueller* was his to our mutual city. Instead, I ran away because I just didn't think I'd survive if I

stayed. I needed to go; yet something kept pulling me back time and time again.

I would say it was Hughes and my attempt to put his life story into words, but it wasn't so much that. I kept getting on a plane to O'Hare because I'd wanted to see if things could work out. I'd wanted to see if there was any possible way of having that life I thought I could lead when I was young and I'd watch the quirky, but well-adjusted, families in movies like *Sixteen Candles* or the Friday night sitcoms with the bad jokes and laugh tracks, many of them influenced by Hughes and his aesthetic.

Despite everything, I'm an eternal optimist. It's both a strength and weakness. Some days I'll wake up and think that yesterday was terrible, but today just has to be better, as if it's a scientific fact; other days turn into years of me not being able to let go of something, thinking that I could write my Hughes book and everything would just change, that I'd find peace and contentment. Yet if there is one positive thing I came away with from the whole experience, it's that life isn't anything like a television show, a novel, or a movie.

We read and watch those things because we want to fit the idea of perfection into a little box and insert ourselves into it for a little while. I used those John Hughes movies as my roadmap for life. You should never do that. Life might at times mirror the Kafkaesque, the Dickensian, or even the trappings of Hughes's clean-cut, little slice of America; but novels aren't guidebooks, movies aren't models for life. It took me nearly thirty years to come to that conclusion. I lived through those books, songs, television shows, and movies—the way the characters talked, looked, acted. I thought that could translate over into reality, that I could make their world my world. I wanted so badly to run away from my life. But you can't bury yourself in other people's pages and

scenes. You aren't David Copperfield or Tom Sawyer. Those love songs on the radio might speak to you, but they're not about you or the person you pine for. Life is not a John Hughes film.

I drove for the next few days, by the houses from my past, gas stations and fast-food places, and various adolescent landmarks. I stopped and ate a hot dog around the time when Reid was probably giving some eloquent speech right before he placed the ring on his bride's finger. I was running away from responsibility, running away from friends, running away from writing, and I wasn't sure how to make myself halt; my legs were moving, but I couldn't get them to stop. My father had sent me a message on Facebook a few days before Hughes passed away and I'd felt frozen, unable to respond. The shock of Hughes dying didn't exactly help kick me in the pants to get back to my dad any faster. We hadn't seen each other in almost ten years, and then, unprovoked, after a few messages, he felt the need to remind me I was still the same screwup I'd always been. It was an ambush out of the blue, something that I knew was more about him and his problems, but it put me right back in a place that mentally I thought I'd never have to revisit. At least when I was working on my book it felt as though I had some purpose and direction, as if I was really doing something real; all I had as I crossed from Evanston back into the city was that old familiar feeling of complete aimlessness. The one that I thought John Hughes would cure. All of a sudden I was that fucked-up kid again, and that was all I'd ever be until the day I died.

Sorry, my family, friends, Chicago, and John Hughes. I've failed you all yet again.

SUMMER CAME TO a close. I moved my couple of boxes out of the hole in the wall, put them in a black Town Car, and gave the driver my new address. I had lived in seven apartments since

moving to Brooklyn, worked in nearly a dozen coffee shops, had almost as many spoiled relationships, and trashed a book that I'd spent what felt like thousands of hours not finishing. I'd started to resign myself to the fact that I was never going to leave New York, that I was barely employable there but virtually unemploy-able anywhere else. "The only job skill I have is writing," I'd tell people with a bit of pride, while also wishing to myself that I'd gone back to school or considered learning a trade like welding. But writing was what I'd said I wanted to do, and as I climbed the stairs to my new fifth-floor walkup that I was going to share with my friend Michael, I could say that what little money I was making was mostly made from typing out sentences. I was on the verge of being able to tell people I was a writer when they asked me what I did and not feeling like a complete phony doing so. I still had to work in a coffee shop, but something told me that if I kept at it that wouldn't last forever.

My new apartment was spacious and had a lot of light. I had a large bedroom where I put a desk, and in the living room there was a big red couch that looked out over a courtyard. I'd start sketching out ideas or outlines for short stories that I intended to write, one based off the Russian book *The Master and Margarita,* except in mine the devil comes back during the twenty-first century, finds himself replaced by capitalism and technology, and suffers a crisis of identity because he feels suddenly irrelevant. It was unlike anything I'd written before. But I liked the idea enough that I'd think about it before bed, how it didn't have to be long, and that I didn't have to sell it to anybody, but at least I'd be writing something I wanted to work on.

I'm a work in progress, I'd tell myself.

I took a lot of walks in my first weeks living in the south-ern part of Park Slope, not too far from the famous Green-Wood

Cemetery. I'd lived next to a famous cemetery when I'd lived in Chicago—Graceland—and I'd gotten a lot of work done there, so I considered that maybe the close proximity to the dead had some sort of effect on me. Perhaps it forced me to think about how I wanted to get work done before I was dead or something deep like that. I wanted so badly to write something again, and felt the need inside of me that was percolating and would soon boil over. But every time I felt some surge of inspiration, I'd just start to stare out the window or at my keyboard after a few minutes. I was fighting off a new bout of depression almost daily, and I'd usually succumb to it and decide to just put my head against the pillow and take a nap.

Tiny little steps, I'd remind myself. I couldn't forget that.

"KIDSINAMERICA," WAS THE name of the file. It was tucked away inside a folder in another folder on my desktop that I found as I searched to see what I should transfer over to the new laptop I was buying.

I remembered the story. It was the one I'd originally written as a teen and had tried to bring to the writing workshop that I never went back to. "We're the Kids in America." I read the first line out loud.

It gets loneliest at night down by the convenience store.

That sounded so familiar to me. I'd typed it, but it came from somewhere or someone else; it wasn't mine. I repeated the line over and over to myself to try to pick up on what was so familiar, chanting it.

Jawbreaker! It was a lyric from a Jawbreaker song, a band that I'd first heard when I was fourteen after an older kid had told

me I couldn't be punk if I didn't like them and dubbed one of their CDs onto a cassette that I listened to so much I warped it within a month. They had meant everything to me. A girl who was a senior when I was a sophomore told me they were "our generation's Smiths" and that the lead singer, Blake Schwarzenbach, was a punk poet. As an adult that sounded so corny, but when you're young and you're trying to find something that adequately takes the mess of feelings rushing through your being and turns them into something manageable, it's *everything*. That first line from "We're the Kids in America" was my tribute. I thought I was being sly when I wrote it, but deep down I wanted so desperately to connect with people. I wanted somebody to read that story so badly and realize why I'd opened up with that phrase. All I wanted was connection.

I kept reading.

> *Ryan Jacob sat atop his skateboard, pushing it side to side. He looked across the street at the Walgreens where all the jocks hung out.*

Wait, wait, WAIT: Ryan Jacob? Did I really name the main character that? Did I purposely play off Jake Ryan to get to that name? It was too funny, but also really sweet. I was so young when I'd first written the story, totally inexperienced and having never been edited when I revised it for the workshop I wanted to present it in before giving up on my dreams of being a fiction writer. The story wasn't by any means good, but I delighted in reading it, something so simple and silly. I'd written it because I wanted to. I'd originally written it when I had nothing, when I was crashing on floors and on moldy old couches in basements, hardly ever eating, and wondering if I'd have a place to sleep the

following night. I used to write to survive. I did it because I had to, because it was all I had. How freeing that had felt, sitting at some diner until the sun came up, hardwired on bad coffee with too much sugar in it, scribbling away line after line, and how light my mind had been when I finally could say I'd written enough, my hand hurting because I'd been gripping the pen for so long.

EVEN THOUGH I may have been excessive about it, taking fiction to heart in such a way that I'd tried to live through the work, when I was a teen, the movies John Hughes made served a purpose similar to Jawbreaker and writing until I couldn't anymore: they'd given me a chance to dream when everything felt hopeless. Things felt so rotten so many times, but I could always go back to writing, or certain bands, or Hughes movies, whether watching them or just thinking about them, wondering what would Ferris Bueller do or how Andie from *Pretty in Pink* would handle a specific situation. And when I first decided to start working on the life story of John Hughes, sure, I'd wanted to *write a book,* but I was trying to get out of my dull life that had felt like one never-ending coffee shop shift; I was dreaming of something else.

In the months after he died, I tried hard to not think of John Hughes, let alone watch his movies. It felt as though I'd abused something sacred to gain some abstract notion of everything being OK, as if I'd write a book about John Hughes and suddenly I'd have the kind of life I saw the people in his movies living without the little worries of everyday life. That was my logic and it had never once seemed weird to me while in the process of working on the book because I'd been so swept up in the grand *idea* of writing a book. After months of mourning, I was finally ready to move past that. It was time to be honest.

I'd been dragging things along with me for so long: my anger

at my parents, my hatred of the people I'd grown up alongside for things that had happened years earlier, never having any money in my bank, always feeling weird, different, and perpetually out of place; I had added John Hughes to that list of something or somebody that meant so much to me that then turned into another painful memory I couldn't let go of, and it was totally nothing he did. I'd screwed it up, I'd tainted it, and I needed to fix it.

Sick of being angry and tired of being sad, I looked at that stupid little short story I'd written so long ago. The mourning period was finished and I needed to stop feeling sorry for myself. I missed Shermer and the faces I'd grown up watching, the stories that had made me feel better and given me hope. I decided I needed to go back, not because I needed to research certain scenes for clues, but because I wanted to.

Fall was closing in, and Thanksgiving was coming up. No better time to dig out my copy of *Planes, Trains and Automobiles* and revisit my annual tradition.

I HAD STARTED seeing a girl that fall and I felt good about it. I didn't have the anxious premonition that things would be over in six months. She made me feel comfortable and balanced. Winter came and we were inseparable. I was happy all the time. The best part was she'd only seen the first two *Home Alone* movies and *Ferris Bueller's Day Off*, so I could introduce her to a bunch of my oldest friends. I didn't have much to offer her in terms of money or a family to introduce her to, but we could watch those movies that had always meant so much to me.

Then one day she called me first thing in the workday.

"The editor at the website my company owns just quit. Would you be interested in taking her spot while my bosses look for a replacement?" she asked me. I had planned to sleep in, but they

needed me in the office that day if I wanted the job. So without much hesitation, I pulled on my pants and shirt, put on all my winter gear, and headed out to the office where the boss explained that they'd taken over a blog—a Jewish pop culture site—and needed somebody to run it, posting two or three stories a day. Within a month I was the full-time editor of the site, with a salary, insurance, and business cards with my name and title, editor-in-chief, on them. I was officially a working writer. That was all I did; no more coffee shops, no more serving vegan sandwiches to kids in Park Slope. It was what I'd wanted, what I'd moved to New York to do, and I was going to put everything I had into it.

"It's like Ferris Bueller said . . ." My friend Michael took a swig of his beer before he said the words I knew that were about to come out of his mouth, the perfect answer to me talking about how shocked I was that I was happy and feeling an amount of contentment I'd never been used to as we celebrated my new employment status. It was the one quote that everybody loved so much, yet the one that annoyed me the most because I thought I knew there were better quotes out there, or maybe because I didn't know much of anything at all; maybe it was a great quote and I was just being foolish. I hadn't thought about it in months; just like I'd attempted to block out of my head nearly any thought of John Hughes or his films, it was just easier to function that way. I had work to do. So in the seconds before Michael could follow up with the most famous line uttered by Matthew Broderick maybe in his entire career, the one I'd heard my high school principal quote to one of my fellow students who looked to be going down the same nowhere path I'd always felt as if I was walking toward but had somehow avoided, I thought of Hughes and I was happy.

John Hughes movies are always headed toward a happy ending—that's something you can count on. Viewers aren't sup-

posed to be like me and wonder what happened after the credits rolled, because there is no after; a movie ends and it's over unless somebody decides there needs to be a sequel. The happy ending isn't real. That's not cynicism; that's just the truth. Life is full of constant sadness, and the world can be a cruel place. Yet what Hughes offers in his films is the idea that one single day can be great, and that's all you need if you live in the moment. That one great day can turn into a second, and third, and many more consecutive great days. There will be pitfalls here and there, chemicals in your brain, unforeseen tragedy that you can't prepare yourself for, or tyrannical vice principals trying to hold you down, but the trick is to open yourself up to the idea that great things can just happen, that the good is just as much a part of life as the bad.

Life had moved pretty fast: I was heading toward thirty. I was in love, I was working, and I was not living in a hole in the wall. I was becoming an adult and it didn't feel as though my heart was dying. I'd spent years failing, but I realized I had basically failed upward. As I sat in a dimly lit bar with colorful concert posters on the wall, eating free popcorn covered in Old Bay seasoning, realizing that things were working out, I had to admit to myself that, yes, life does move pretty fast. One day you think you have a great idea, then five minutes, hours, days—or in my case—years later you finally realize that maybe it's time to put it away. Sometimes you have to fail in order to succeed. If you don't slow down, if you let your obsessions and anger and fear stop you from looking around, you could miss some really important things.

It was time to start paying attention because I didn't want to miss anything else. I didn't find John Hughes, but instead I found the things I really needed.

2014

Midtown has this way of being the busiest part of Manhattan and also the coldest and loneliest at the same time. You can walk around for blocks and people just zoom past you in their suits, on their way to another meeting or mid-afternoon martinis for the closing of a deal; celebrities brush past tourists without notice; people sip coffee or stand outside smoking, looking as if they really don't want to go back to whatever their job is, back to the little cubicle. The constant honking of horns starts to blend together and sounds like one never-ending buzz. It's the part of the city that locals want to avoid and out-of-towners feel the need to see because they want to experience the massive, glowing advertisement that

is Times Square. They want to stand in line for fifteen minutes to eat the chicken and rice from the Halal Guys cart, they haven't really seen New York unless they go to at least one museum and take pictures of the art hanging on the walls, and they don't want to go too far from their hotel or where the Broadway show they're going to see later that evening is playing because they wouldn't want to get lost.

And then there are the teen tourists, the sullen ones. Just look at them you can tell they *do* want to be in New York, but not with their parents. They dream of leaving their home someday, getting out of their suburb in Wisconsin or South Carolina, or maybe even the part of Chicagoland that I once called home, their place on the map where all the houses look the same. Of course, Chicago is the place of my birth, but it's not my home. I'll never go back; too many ghosts and really not much for me there. I made my peace with it, and I learned that you're going to spend a few years looking back at the place you're from and thinking nothing but bad thoughts no matter what your origins are, but eventually you might realize that it's the place that made you, that it's part of who you are and who you always will be. I look for the angry teens who haven't figured that out yet, and I want to tell them that their time will come, that they'll get out of there. I want to tell them to try to enjoy home while they can, but only if they can; if they can't, that's also fine—I sure didn't.

After six months of taking the B train from my apartment in Brooklyn to the Rockefeller Center stop—give or take a half hour of commuting, enough time to either finish listening to a podcast or read about forty-five pages of a book—I'd grown used to all of it. I'd go to my job and the only person I might talk to until there was some sort of meeting in the afternoon would be the person I bought coffee from: the hello, the order, and the thanks.

Despite having to go to Midtown five days a week, I was happy, probably the happiest I'd ever been: my wife and I had celebrated our second wedding anniversary a few months earlier, we had a dog and two cats in our nice apartment, I was working at a national magazine. My checklist of places I wanted to write for that I'd compiled when I'd first moved to New York only had one or two outlets left on it, my therapist routinely said I was making good progress, and I even had an agent who was confident I could sell a book. I liked the unusual feeling of stability, but was always ready for things to get rocky again.

"WANT TO GO with me to a birthday party called 'Death of my 20s/Death of Irony' tonight at Guy Fieri's restaurant?" my friend asked in an e-mail. I replied that I couldn't, that I had an interview and I wanted to get it transcribed that night, but I hope he enjoyed the "Guy-talian nachos and the Mötley Crüe ribs."

I'd done a hundred interviews in the last few years, but was particularly looking forward to speaking with the director who'd grown up a few towns over from me and played hockey with a lot of the same coaches I did. I wasn't planning on bringing up the old neighborhood or anything like that; I just liked the idea of talking with somebody else who was where I was from and created things I found interesting.

I walked out of my office and down 6th Avenue. It was five thirty and totally dark out. I could feel the early winter storm we were supposed to get approaching as I rushed thirteen blocks down to where the meeting was, past all the slow-moving out-of-towners who were looking to see the tree at Rockefeller Center, to some building that I'd passed a thousand times and never gave much thought to. Everything bleeds together in the middle of the city. You don't have time to think about much as you're duck-

ing past taxis and bikes and baby strollers. When I got inside the building, I stood for a moment and gawked at the glorious Art Deco lobby, all bronze and marble, almost like a temple or church, not what I would have expected from the outside, where the front of the building was covered with scaffolding. New York still had its secrets, and I was just as excited to discover new ones after over a decade of living there as I was on my first day living in Brooklyn after I took that long Greyhound bus ride to Port Authority.

SOMETIMES INTERVIEWS TURN into conversations.

We'd been talking about some of the books he'd acquired the rights to, a few of my favorites. About one, I told him, "If I was going to write any novel, I'd want to write that one."

"So are you going to write a book?" the director asked midway through the interview.

I laughed and mentioned I had tried to write a book, that I'd spent five years on it, but eventually abandoned it. The director asked why, I told him I couldn't remember even though I knew very well the reasons.

"But I ended up writing some good articles about it," I told him. "One for the *Paris Review* and another for BuzzFeed, so that's not so bad."

He asked what the book was about.

"You know the director John Hughes?"

He didn't answer. I didn't know if that meant yes or no.

"I tried writing his biography, but then he died and . . ."

He pulled out his phone and started scrolling frantically.

"Holy shit, dude. His son is my friend. I'm going to call him right now. You should talk to him. He wants people to write about his dad."

I looked at the director's publicist in the corner of the office where we were doing the interview and half expected him to walk over and say that time was up. When that didn't happen, I just looked at the iPhone, at John Hughes's son's name, and number in front of my eyes. "I'll call him right now and introduce you," the director said with a level of excitement that betrayed his Hollywood persona. For some reason, he was serious. The director wanted to call James Hughes, a person who I knew, not just as John Hughes's son, but also as somebody who I'd come to admire for his writing and editing a magazine I was a fan of. This was the chance I had hoped for years earlier. There'd been an article in *Vanity Fair* less than a year after John Hughes's death, with his two sons talking about the hundreds of notebooks their father had left behind, all the ideas and sketches, movies that would never come to fruition, short stories, drawings, observations, and so much more. I'd spent weeks dreaming of what was in those notebooks. Then, a few years later, there was an article by James Hughes himself, "John Hughes's Day Off," about Hughes as a Red Wings fan living in Chicago. I read it and remembered seeing somebody I thought was him in a grocery store over a decade earlier, how I was stoned but curious about his Red Wings hat, how, if I could do it all over, I'd tell him that I was conflicted about my own allegiance toward the team from Detroit, but how the Blackhawks were such a terrible team with a rotten owner. I thought about John Hughes constantly, only things had changed: I was happy. I had the life I wanted.

But I still wanted to write a book and I couldn't figure out what that book was. Maybe this was my chance? Maybe I could tell the director to call his friend and I could tell him what a massive fan I was of his dad's work, and how that could turn into

something. This was an old dream coming true, one that I had put away years ago.

I shook my head.

"No, it's cool," I said. I changed the subject, steering it back to the director's work. The interview lasted another ten minutes, but all I was doing was asking the questions I had written down. I couldn't stop myself from thinking of what I'd just passed up, the possible opportunity that I'd said no to. What kind of a fool was I?

I walked halfway home after the interview, from Midtown to Lower Manhattan. Cold and tired, I hailed a cab for the rest of the journey. It had been a long day and I was exhausted.

As the cab maneuvered its way through Chinatown, I looked at all the lights of the city. New York was my home, and Chicago was a world away. I joked with my wife that we could move to Chicago and things would be cheaper and easier and our future kids could have backyards and good schools. But I couldn't leave New York; it was where I really grew up after the messy blur of my childhood and teenage years. My life was in Brooklyn, and my wife's was also. *We're a family,* I thought. *I have a family.*

We hit the Brooklyn Bridge. Over the water, the cab zoomed past a slow-moving tour bus filled with people snapping photos of the skyline. I couldn't blame them for wanting to capture something so beautiful.

The cab got off the bridge and took me to my apartment. When I got upstairs, my wife was waiting for me. She asked me how the interview went, and I told her fine. I didn't mention anything about the offer to call John Hughes's son. I didn't think it was necessary, and I'd let it go somewhere between Manhattan and Brooklyn. I was no longer searching for John Hughes or the world he presented; I was my own person and I wanted to tell my own stories now.

Acknowledgments

Nothing would be possible without Emily Goldsher-Diamond. You're my rock, hero, best friend, and always my first editor. I think I say this at least once a day, but I figure I should use this chance to put it in writing that I love you more than anything in this world. I'm so proud of the life and home we've built together. I want to thank Harriet, Barry, Lacey, and Tessa Goldsher for taking me in and making me part of your family, you'll never know how much that has meant to me. Nina and Greg, having you guys back in my life made me realize I'm not alone. My editor, Margaux Weisman, you made my dream come true by saying you wanted to put out my book, but your guidance through the process was what made it really work. It's been an absolute pleasure having you as a partner for this thing and I'm happy to call you a friend. William Callahan, my amazing agent, thanks for sticking this out and dealing with my neurotic ass. Everybody at William Morrow and HarperCollins for getting behind this: Kelly Rudolph, Tavia Kowalchuk, David Palmer, Emily Homonoff, and Elsie Lyons. Michael Crowder, your friendship has been a huge inspiration for me. Maris Kreizman, I can't tell you how much it meant to me to have you on Gchat (or Hangouts, or whatever the hell they call it now) whenever I had some sort of issue come up. You graciously always said "Of course" when I asked if I could ask you a question and that meant everything to me. Tobias Carroll, you're the most perfect friend and partner a person could ask for. Sara Harper, you're in or around this book whether you're mentioned or not. Stephen

Billick, thanks for the countless hours talking about Hughes and whatever else. Steve Kandell at BuzzFeed and Sadie Stein at *The Paris Review* who both edited and hit publish on pieces I wrote about Hughes, thank you both. Jami Attenberg, you inspire me, I'm glad we're friends. Lisa Lucas, you're the perfect burger buddy. Thanks to Isaac Fitzgerald, Tyler Coates, Jen Vafidis, Ryan Chapman, Summer Smith, Jesse Fox, Lincoln Michel, Margaret Eby, Benjamin Samuel, Natty Adams, Nick Curley, Ryan Chapman, Aaron Lefkove, and all the other people that stuck around for another drink or two when I really needed it. Thanks to Brandon Geist and everybody at *Rolling Stone*, Tyghe Trimble and everybody at *Men's Journal*, and thanks to Judy Berman, Tom Hawking, Pilot Viruet, Jill Mapes, Michelle Dean, Jason Bailey, Alison Herman, Elisabeth Donnelly, and the rest of my old Flavorwire crew. Thanks to Jennifer Gilmore and Rosie Schaap for letting me bug them with pre-book questions. That helped me a lot. Aaron Bisman and Jacob Harris, thanks for giving me my first real job as an editor, and Lilit Marcus for being a great person to follow. Thank you to Penina Roth for being a tireless champion of literature. A big thanks to Housing Works, WORD, Community, BookCourt, McNally Jackson, The Strand, and all of the other indie bookstores that let me host events in your stores. Thanks to all of the great editors at a bunch of publications who really taught me how to write. Abbie Torgeson for hooking me up with my first apartment when I was sixteen and going to bat for me ever since. Special thanks to all the people that helped me out when I needed it the most, even if I was ungrateful when you were being kind to me, I recognize now that a lot of people were there for me and I think about that every single day I'm alive. Most importantly,

thank you to John Hughes. I like to hope you'd accept this book as a tribute from a fan whose life you shaped and changed in immeasurable ways with your work.

And if you're reading this then I also want to thank you. Hope you liked it.

About the Author

Jason Diamond is the founder of Vol. 1 Brooklyn and sports editor at *Rolling Stone*. His work has been published by the *New York Times, The Paris Review,* Pitchfork, *Vice, Bookforum, Mc-Sweeney's,* and many other publications. He lives in Brooklyn.

About the author

About the book

Insights,
Interviews
& More . . .

AUTHOR'S NOTE

HI READER. Thanks for buying this book. In true John Hughes fashion I'm going to break down the fourth wall and say that I think that the point of a memoir is the writer is supposed to recall things as clearly as they experienced them and write those experiences and thoughts down in a way that's interesting to the reader, so that's what I did for this book. I wrote it as I remember it, but I should probably mention I changed the names and little identifying details of people because I wanted to make sure this stays my story and doesn't end up embarrassing anybody else other than myself. ∽

So I mention a "broken-down old bowling alley that was dusty and smoky and looked as if it hadn't been working for over a decade" that I used to go to when I was younger to see punk shows. That place, the Fireside Bowl, was really my number one refuge for the five or six years when I needed it the most.

Originally opened in the early 1940s, I'm not sure exactly when people stopped bowling there and the shows became a full-time thing, but sometime around 1994 the Fireside hosted one, sometimes two shows a night. I feel like every kid that grows up going to punk shows has a spot that will forever live on in their memory as one of the few bright spots in an often dark part of their life, but I dunno, I like to think Fireside is special. It was a *bowling alley*. How much more midwestern can you get?

I'd say there is a generation of Chicagoans that called Fireside a second home in the 1990s into the 2000s, up until the bowling alley shut down around 2004 and reopened as, well, a bowling alley. No longer the place where countless underage kids from the suburbs could use their fake ID to get drinks and verbally abused by a stumpy guy with a high-pitched voice named Hammer who worked behind the bar before they nearly died from heat exhaustion and dust inhalation, the Fireside got respectable. Not that bowling alleys are ever that *respectable* ▶

(think about the scene in *Uncle Buck* where Buck takes the kids to Palace Bowl in Cicero and how it doesn't look like a place where you take somebody on a first date—unless that person is really cool), but a bowling alley that cleans up is sort of depressing. Fireside lost its character, and worst of all, it stopped hosting shows.

But when I went there, the Fireside was the greatest place in the world to me. I saw well over 100 shows there from 1995 until 2001. A lot of nights, a lot of shitty beer, and lots of other stuff that I won't get into here. But the thing that tied the all-ages venue together more than anything was the fact that Chicago bands almost always played. And in that time, while I didn't realize it, I was lucky to see a real moment in time when Chicago was really one of the great music scenes in America. It still is, but things just aren't local like they used to be. There was no Chicago sound, but there were the bands that, when I was growing up, you'd see on a flyer for a show and you'd think about going to the show. These Chicago bands were in many ways the soundtrack to a big part of this book while it was actually taking place.

Naked Raygun

So although I'm pretty sure they never played the Fireside, at least when I was going there, this couldn't start off without some sort of tribute to Naked

Raygun, who, as I was told by an older kid, "You can't be punk in Chicago and not listen to Naked Raygun."

Baxter

Today Tim McIlrath is in the very popular band Rise Against, but when I was fifteen, he was in Baxter. They played a really smart and fast brand of post-hardcore that really, eh, spoke to me. With song titles like "Burden" and "Redemption" it was hard for teenage me not to be like, "This stuff is deep."

Slapstick

Slapstick, and every band that the ska punk band spawned, including Tuesday, the Broadways, and the Lawrence Arms were all great. I think the band's lead singer, Brendan Kelly, is easily one of my favorite songwriters of the last twenty-five years.

Sidekick Kato

This band called their sound "drunk emo" and I think that's all I really need to say other than I'm surprised they didn't get really big.

Los Crudos

This band changed my life because, although I could hardly understand any ▶

of the lyrics singer Martin Sorrondeguy
screamed in Spanish, the things he talked
about between songs and the sheer
passion he delivered into every second the
band was on stage made me pay attention.

Cap'n Jazz

So I'm pretty bummed to say that I
never saw these guys at Fireside, but
they were definitely one of my favorite
local bands growing up. Weird and
whimsical, I think they hate being
called emo because of what that tag
ended up coming to signify, but they
were. Cap'n Jazz played weird emotional
punk stuff that so many bands ripped
off after they broke up.

Luke Skawalker

This band was totally not a ska band and
I thought that was the funniest thing in
the world.

Oblivion

These dudes played perfect pop punk,
with emphasis on the pop part. Good
hooks, sweet lyrics, and honestly the
band I figured was most likely to break
out of Chicago when I was sixteen. For
some reason it didn't happen.

Apocolypse Hoboken

These guys *almost* broke out, and I kinda
wish they had because Hoboken played
this really warped and strange kind of
punk that really can't be classified.

The Bollweevils

OK, truth be told I don't recall whether
I saw these guys at Fireside or not,
but I am *pretty* sure I did. Either way
The Bollweevils played fast punk that
sounded like Naked Raygun or Bad
Religion without the PhD. I find that
a little ironic since the lead singer quit
the band to go become a doctor,
but whatever. They were really great.

Charles Bronson

Besides Los Crudos, there weren't
many great hardcore bands from
Chicagoland except Charles Bronson.
They were fast and actually really funny,
but it kinda felt like not a lot of people
I knew cared much for them.

My 15 favorite films about teens *not* written, directed, or produced by John Hughes

The 400 Blows (1959)
Over the Edge (1979)
Risky Business (1983)
Class (1983)
Better Off Dead (1985)
The Lost Boys (1987)
Heathers (1988)
Say Anything (1989)
Clueless (1995)
Dazed and Confused (1995)
Can't Hardly Wait (1998)
The Virgin Suicides (1999)
Cruel Intentions (1999)
Superbad (2007)
Dope (2015)